Kodak
GUIDE TO
DIGITAL PHOTOGRAPHY

Published by Lark Books
A Division of Sterling Publishing Co., Inc.
New York / London

Kodak

GUIDE TO
DIGITAL PHOTOGRAPHY

Rob Sheppard

Editor: Kara Helmkamp
Book and Layout Designer: Ginger Graziano
Art Director: Shannon Yokeley
Cover Designer: Thom Gaines
Editorial Assistance: Cassie Moore and Mark Bloom

Library of Congress Cataloging-in-Publication Data

Sheppard, Rob.
 Kodak guide to digital photography / Rob Sheppard. – 1st ed.
 p. cm.
 Includes index.
 ISBN-13: 978-1-57990-969-7 (pb-with flaps : alk. paper)
 ISBN-10: 1-57990-969-8 (pb-with flaps : alk. paper)
 1. Photography–Digital techniques–Handbooks, manuals, etc. I. Title.
 TR267.S5337 2007
 775–dc22
 2007004832
10 9 8 7 6 5 4 3 2 1

First Edition

Published by Lark Books, A Division of Sterling Publishing Co., Inc.
387 Park Avenue South, New York, N.Y. 10016

Distributed in Canada by Sterling Publishing,
c/o Canadian Manda Group, 165 Dufferin Street
Toronto, Ontario, Canada M6K 3H6

Distributed in the United Kingdom by GMC Distribution Services,
Castle Place, 166 High Street, Lewes, East Sussex, England BN7 1XU

Distributed in Australia by Capricorn Link (Australia) Pty Ltd.,
P.O. Box 704, Windsor, NSW 2756 Australia

If you have questions or comments about this book, please contact:
Lark Books, 67 Broadway, Asheville, NC 28801 (828) 253-0467

ISBN 13: 978-1-57990-969-7
ISBN 10: 1-57990-969-8

Kodak
Licensed Product

For information about custom editions, special sales, premium and corporate purchases, please contact Sterling Special Sales Department at 800-805-5489 or specialsales@sterlingpub.com.

Kodak
GUIDE TO
DIGITAL PHOTOGRAPHY
Rob Sheppard

TABLE OF CONTENTS

CHAPTER 1

Possibilities—
An Introduction

Digital technology has revolutionized photography. Ten years ago, photography was something different than it is today. Oh, sure, the basics of photography are still the same. Just as in the days of George Eastman (founder of Kodak) in the late 1800s, you have to focus properly, expose correctly, find the right angle to your subject, and so forth, in order to get a satisfying photograph. Kodak has long supported the very important idea that photography can be a significant part of our lives. Photos have to mean something to you and whoever sees them—this was true in 1888 when the first Kodak camera was sold, and is still true today. This book is based on the same premise, that photography can be an important and fun part of your life.

That being said, many things about photography have changed. For the most part, those changes make photography better than ever for any level of photographer. Here's a list of 10 things that digital offers everyone:

1. No film to process. You know what you have photographed without going to a processing lab to have the film developed.

2. Instant viewing. You can see your picture immediately on the camera's LCD monitor after making the shot. You can see what the scene looks like as a photograph right away.

Digital cameras are becoming more sophisticated everyday, and digital technology has simplified photographic processes that were once complicated and inaccessible for most people.

3. You can correct your shot. With film, you did the best you could and hoped everything came out okay. With digital, you can check the results as you go, confirming that the photo is what you wanted while you are still in the situation, so you can retake the picture if needed.

4. Shooting extra shots costs nothing. You don't have to worry about paying for processing or using up film. You can shoot as much as you want (as long as your memory card has space).

5. There is no cost to experimenting. You can try any technique or idea you like. Remember a shooting tip from a book (like this) but can't recall it exactly? Try out what you do know, check the LCD, and see if you got it right. If not, try something else.

6. You can easily adapt to varied conditions. Now it doesn't matter if the light is dim or bright, inside or outside—the digital camera can be set to be more or less sensitive to light and to make colors look good under nearly any light for each individual image (something that is very difficult to do with film).

7. There's no end of the roll at 24 or 36 exposures. This can be a really big deal. With a large memory card, you can shoot the equivalent of many rolls of film without changing film or running out of potential exposures on a roll of film just as the best action starts.

Now, anyone can take great pictures. With LCD screens and instant viewing, you can erase any image that you don't want and take the photo again immediately. No more wasting film and waiting to see your results.

8. Bad photos can disappear. We all know what it was like to be disappointed in certain photos after we picked up our processed film and started going through it. Those photos immediately showed us all our mistakes and poor photo judgment. Now, as soon as you see a less than satisfactory image, erase it and it is gone from camera and mind.

9. Duplicates can be identical. In film, if you wanted to make multiple prints, you'd find they would change in appearance if not made at the same time. Pros would make duplicate copies of original photos, but could not depend on them being true duplicates. With digital, you can make identical prints every time you print, plus you can make exact copies of your originals that have no variance.

10. No fogged images from security scanners. You can travel with a digital camera having complete confidence that no matter how many times you go through security, your images will not be harmed.

MAKING YOUR OWN PHOTOGRAPHY BETTER— POSSIBILITIES

When George Eastman introduced the first Kodak camera, his motto was, "You push the button, we do the rest." He did not have a lot of automation in the cameras. Actually, the motto should have been, "You push the button—with bright sunlight coming over your shoulder—we do the rest." Still, he did a great thing by making photography fun and easy in an era when photography could be very difficult.

Cameras do so much with all of the automated features they have today—far more than Eastman's Kodak camera. But I suspect you are reading this book because you know you can do better than pushing the button and expecting the camera to do all the rest. Our world today is so photo intensive that we all have far higher expectations than the people of the late 1800s that purchased Kodak cameras.

You want better photos, right? Of course, you do. And this book will help you do that. But first, think about possibilities.

Today's digital cameras have amazing capabilities. Almost everything has been automated, making it easier to get better pictures. The camera can control everything from shutter speed to white balance if you want it to. Photo © Robert Ganz

Possibilities—what is possible with a digital camera? What is possible with the digital darkroom? Okay, so I can't show you everything possible on these pages; there are whole books related to subjects covered in one chapter in this book. But I can promise you that I will offer many ideas about integrating the whole process—from pressing the shutter to making the print ... possibilities. I will give you ideas that I know work for photographers that will help you use your camera, take better pictures, and use the digital darkroom ... more possibilities.

Through the years of transition from film to digital, one of my goals has been to make this technology accessible for all photographers. I am not interested in the technology for its own sake. Though you might hear some of the self-proclaimed digital elite tell you that you must do things their way, I am here to help you get

Photography can be a very personal thing. Certainly things like depth of field and focus don't change, but what you photograph is completely subjective. Whether it's a picture of a sunset, a child's birthday party, or a pleasant day in the park, the choice is yours.

great photos appropriate to your ways. You don't have to explain the technology of a sensor in order to get wonderful photos from it.

I also want to give you permission to have fun with digital photography. What does that mean? Give permission? Well, I have found over many years of leading workshops and seminars that many photographers are intimidated by the technology—that is to say, what they've been told they "should" know of digital technology.

You will indeed find books that make photography appear difficult. They proclaim everyone has to understand and use the technology in perfect ways. I am definitely not of that school. I would rather go back to the days of George Eastman—his idea of taking

photography from the "experts" and letting everyone become a photographer was a good one, one that is still very valid today. The point, I think, is that we are making photographs, not becoming digital technology experts.

This book will discuss some technology, but it is not a technology book. If you follow the ideas in this book, you will become a better photographer with more possibilities for taking pictures. This book definitely follows the ideals that George Eastman, the founder of Kodak, set long ago: making photography of any kind more accessible to everyone, and making photography about the image and the memories, not the engineering.

WHY PHOTOGRAPHY?

Why we photograph affects the decisions we make about taking pictures, from the subject chosen for the image, to the background, the light, the colors, and so on. Sometimes we decide on them arbitrarily, other times more intuitively, but decide we do. These decisions change with experience and for different needs, but even the basic beginner makes decisions before pressing the shutter.

Why we photograph also impacts what we think is a good or bad image. What is perfect for an engineer who needs a record of a project is not necessarily a great image for a photo enthusiast who wants a beautiful photo of nature on the wall. We'll examine a little more about what makes a good photograph in the next section.

So why photography? What does it do for us? Here are some ideas (more possibilities, if you will) that affect what we photograph and how we take pictures:

Record: Sometimes we photograph just to record things. We want a record of a valuable car for insurance, or maybe we want to capture a simple record of a place we've been. These photos are usually taken matter-of-factly. We don't try hard to be fancy in lighting or composition. In fact, such things can make the record less usable.

Document: Documentary photography has a long history. It is more than a simple record of a scene. It generally refers to images captured for a specific purpose, to "document" something happening in the world so that others know about it.

Family: We have numerous reasons for photographing our family, from a record of an important event, like a birth or wedding, to an evocative expression of our love for family members. Such photos can range from very simple to works of art.

Beauty: The world offers us great beauty that we want to capture in photos. This can be a challenge, though, when the subject is so attractive that the

Extraordinary beauty can be found in the most ordinary places. One of the wonderful things about photography is our ability to share our view of the world with one another. Photo © Jack Reznicki

photographer thinks that all you need is a better camera. That rarely really works, though, unless you just want a record of the beauty. The camera sees differently than we do, so we need to find ways of capturing beauty in the image that helps the viewer respond to that beauty, too.

Influence: Photography has long been used as a way of influencing others. Nearly 150 years ago, William Henry Jackson's photographs of the Yellowstone area helped influence Congress to make the first national park. About a hundred years ago, Lewis Hine's photos of children working in factories changed labor laws. And today, much of our news is seen through the eyes of photographers. Many photographers, pros and amateurs alike, use their photos to influence and change things in their own worlds.

Every photo you take doesn't have to grace someone's wall. Sometimes, taking pictures just to remember an experience is all we need from photography.

Remember: Photography has such a sense of reality that it helps us remember things. Family photos, vacations, important events, and even historical news are all remembered through photographs.

Creativity: For some people, photography is purely a creative medium. It offers a lot of great possibilities, from intensifying the reality of images, to creating totally new and unusual "realities" or fantastic photos.

Sharing: We see wonderful parts of our worlds and we want to share that with others. Photography is a terrific way of sharing. There is never a language barrier, and you don't have to be a good writer or speaker to use photographs to share something. Everyone responds and relates to pictures.

Business: Businesses today would be very different without photography. Photos are used for so many things, from illustrations for engineering reports, to product photos for brochures, to stunning creative shots for advertising, to com-

A photograph can introduce us to many things. A good portrait introduces the viewer to the subject, and hopefully establishes a connection, even if only for a moment.

parative pictures for product development, and so on. Different needs result in different photos, too.

Communication: Pictures are truly the universal language. You can understand photos from photographers around the world, regardless of their nationality. In fact, it is really interesting to visit websites of photographers from different countries—the photos always give something you can relate to even if the language makes no sense whatsoever. In addition, photographs communicate well with all levels of people, from kids to adults, those with limited education to those with advanced degrees.

Reveal: Photographs can reveal and illuminate all sorts of things. A high-speed flash photo will show off details of a hummingbird's wings, impossible to see otherwise. A long exposure of a stream will highlight flow patterns that can't be easily seen. A night shot can show off details not readily seen with the naked eye. Stopped action of a golfer's swing can reveal details otherwise unseen.

Promote: Over the years, photography has always been used to promote points of view. It has long been used and misused for propaganda by many governments, especially those that limit a

free press (which can show off alternative visions). In addition, photography is used to promote products through advertising, show off things in catalogs, and so forth. It is a very powerful medium for this purpose.

Fun: I would really be missing an important part of photography if I didn't include this. Photography can and should be fun! There are so many possibilities and reasons for taking pictures that everyone can find something fun about it. Sometimes it is in the sharing of special photos, at other times the satisfaction of being really creative, or sometimes there is that pleasure of mastering the mechanics of the gear in order to control the craft of photography.

Because photography can be very subjective, one person's throw-away might be another person's masterpiece. However, there are common elements that can be found in any good photograph, such as composition, light, and focus.

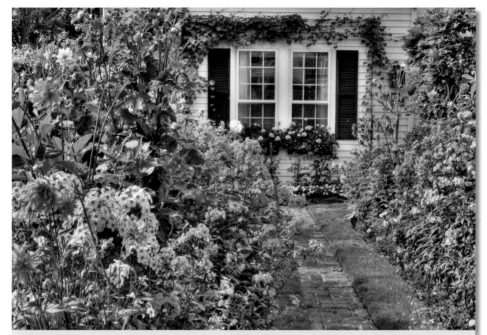

This garden at Martha's Vineyard is full of beautiful things to look at, but it also pulls the viewer into the scene by leading you up the path to the house. Notice where your eye moves as you look at the image. A good photograph will lead your eye back into the image as it moves towards the edge. Photo © Ferrell McCollough

WHAT MAKES A GOOD PHOTOGRAPH?

As you start this book, you may have some ideas about what makes a good photograph. That's a good thing. All photographers automatically look at pictures to see if they meet their needs or not.

This is not a simple thing, however. As the long-time editor of *Outdoor Photographer* magazine, I have often received letters from folks who are convinced certain choices are of "bad" photos. I once got a letter claiming I had to be smoking something to call a certain photographer one of the best landscape photographers working today (which was, by the way, not simply my opinion, but was a common idea among his peers).

So obviously a "good photograph" is a bit subjective. And what makes photography great for one purpose can make it awful for another.

In this book, however, we will look at photographs as something more than a mere record of a subject. We will consider a good photograph one that effectively uses the craft of the photographer and results in an image that affects the viewer in some way.

This is possible at some level for any photographer to achieve, from amateur to pro. The level of craft will vary, but as soon as you start making conscious decisions about your photography—from how to better frame a subject to what exposure is best—you are using the craft to control the photo. Then, when you show that photograph to someone and they react to it as a photograph, not simply as a good picture of a subject, you can safely say you have created a good photograph.

Better photos are about better use of the craft to control that image, which is what this book is all about. Better photos are also about the way a photographer interacts with the subject and creates a composition that goes beyond mere craft. The craft, from sharpness to exposure, is "easy" to critique compared to how a photographer interprets a scene, yet a photo with all craft and no real involvement of the photographer with the subject is generally a rather empty photo unlikely to affect a viewer. After all, if you don't care about your subject, why should the viewer?

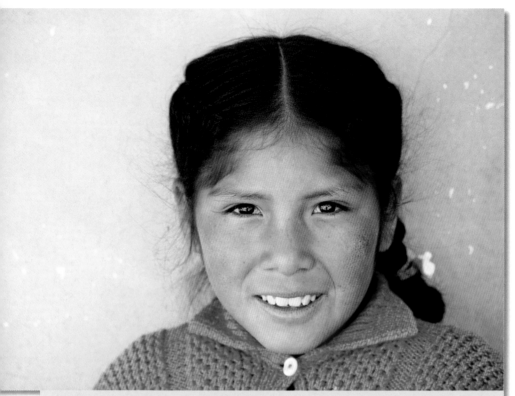

Soft, diffused light can transform your people shots. Harsh shadows, especially those from the midday sun, are unflattering on faces, but diffused light fills in the shadows and opens up the subject's face.

One thing that I think is a great help for making better photographs is in how you look at your subject when using your camera. If you are using the camera as a sighting device to "capture" a subject, the subject is now more important than the photograph, and you are really more likely to be getting a record shot rather than an artful photograph.

On the other hand, if you start seeing your subject and its relationship to the scene as a composition that creates a photograph, you are now seeing photographically. This is a very different mindset. You no longer look for subjects to photograph (though they are obviously still important), but for photographs to create with your camera.

This is something that has greatly improved with digital photography

compared to most film photography. The difference is the LCD review. You can look to see if you really have a photograph. Is that image on the LCD something you want to keep for the photograph or the subject? If just the subject, you can then decide if there is something you can do more photographically to create a better photo that you would be proud to hang on your wall.

In film, some photographers would take test images using Polaroid film that could be instantly developed. Then they could see what the subject and composition looked like as a photograph. But this was expensive and required special equipment that not everyone had.

The LCD review of digital cameras has made all photographers, from beginners to advanced users, better photographers. I see this all the time. Everyone can evaluate that little image to be sure they got what they wanted. If not, they retake the photo. At even a very basic level, that is working with the craft of photography to make a better image. If you make a habit of starting to look at the LCD to be sure you have a photo that you like, not just a record of the subject, you will be well on your way to making better photographs.

FOUR IMPORTANT LETTERS

I want to share something with you that I believe will help you throughout this book and will help you get better photos with digital photography. I use this in many of my workshops. I will tell everyone that I have four important letters, and that they might want to write these down.

I start with the letter "I". Simple letter. It doesn't stand for anything at this point. People madly write this down.

Then I add the letter "C". "C" could mean a lot of things, I suppose, but in this case, it doesn't add anything to "I", yet. And my group will write this down.

Being comfortable with your camera is very important. Familiarize yourself with the camera's main controls and functions. The more time you spend looking at the scene instead of figuring out your camera, the better your images will be.

Next is "A". "ICA" doesn't look like much, but then, I'm not done. And so the group writes this down.

The last letter is "N". Now as the group writes this down, they try to decipher this cryptic message. Some start to see it, others don't.

"ICAN" isn't an acronym.

I CAN. I can.

I can!

And yes, you can.

This is not some pop psychology. Henry Ford is said to have made this statement, "If you think you can or you think you can't, you are probably right." I can tell you from working with a lot of photographers over the years that an attitude of "I can" goes a long way

toward helping improve photography.

I have to tell you I have heard a lot of the opposite (or variations of it):

"I can't figure out my digital camera."

"I can't understand exposure."

"I can't figure out RAW."

"I can't take that kind of photo because I don't have the right gear."

"I can't photograph kids because they won't cooperate."

"I can't photograph great scenes of nature because I live in such a poor area for nature."

"I can't figure out Layers in Photoshop Software."

And so it goes.

I am suggesting to you that if similar ideas sneak into your thoughts while reading this book, keep in mind that this is a NO

"I Can't" Zone. You might not have figured something out, but that just means you don't have that skill yet. But you can do it.

This goes right back to George Eastman and from where Kodak started. He thought people could enjoy photography, and so began a whole business based on that idea. I think everyone can have fun with digital photography and master what they need. It might take a little time and a little practice.

And you can!

2 CHAPTER

Digital Components

Digital technology has changed rapidly throughout the past decade. Luckily, it has settled down considerably today. While manufacturers still constantly introduce new and improved models, digital photography equipment has reached a level of stability such that a book like this can now talk about it and the information is not outdated before the book even gets to the bookstores (that actually used to happen).

I can't predict what will happen in the future, and it is entirely possible that some amazing new technology will appear tomorrow that will throw us all a major curve ball and change everything, but that seems to be unlikely right now.

In this chapter, I want to give you a look at the major components of digital technology and their characteristics so you have a better idea of how you use them. Many of you with some experience could skip this chapter and your photos will be fine.

Yet, this chapter details digital cameras and how technology helps them do what they do. It can give you insight into better use of your camera. I'm certainly not going to give you a lesson in camera design and construction (that's not particularly useful for anyone other than camera designers and engineers), but there are several key elements of digital cameras that are worth discussing.

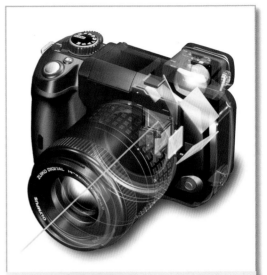

A digital SLR (D-SLR) camera's sensor reads the light coming through the lens. Since the sensor is only exposed to the light when the shutter is released, D-SLRs do not have live LCD screens.

The sensor: The sensor is the light sensitive part of your camera. It includes the megapixels you paid for in your camera, it has a specific size which can influence your lens size and things like noise, and it has a unique way of dealing with color. Sensors come in two basic types—CCD and CMOS. (See page 38 for further information.)

Camera as computer: All digital cameras have some amazing computer capabilities that come with their built-in processors.

Image formats: JPEG and RAW really aren't natural enemies, though a lot of people want to argue over which is the "right" one.

Digital image quality today meets and beats traditional film quality. In addition, camera manufacturers keep producing better cameras, and with that better sensor capabilities.

A screen with a view: The LCD panel lets you view images in ways that were never before possible.

Speed is good: How quickly the camera is ready for shooting, and how fast it acts while shooting, will affect your photography.

Noise: Digital cameras are very quiet, so we are not talking about audible noise. Digital noise is something entirely different, and can range from a non-issue that you never see, to a serious problem, to a creative possibility.

What they are: Pixels are the individual light-sensing photo sites on a sensor; megapixels is the number in millions.

What they do: They sense how much light is striking the sensor and create an electrical charge that is translated into an image.

Where they are found: Pixels are densely packed on the sensor at the back of a digital camera where the light falls from the lens.

How they vary: Pixels vary in number (listed as megapixels), size, and shape.

Everybody talks about megapixels. Get a group of photographers around the water cooler and megapixels always come up. A lot of information is discussed about this topic and some of it is actually right. Unfortunately, there is a lot of misinformation too, so I hope to clarify this important topic for you.

Megapixels refer to the number of pixels in the sensor, so the more the better, right? Not necessarily. There are many other issues involved here. Let's examine some key points about megapixels.

Megapixels deal with size: This is very basic. Of course the number of pixels refers to size, that's what a "number" is. Yet, understand this—if you have two cameras with the latest technology built into the sensors, and one has more megapixels than the other, the only thing you can safely say is that the higher mega-pixeled sensor can give you larger prints. If you are making 8 x 10-inch (A4) prints from both cameras, there is a good possibility that you will see no difference between them. You need a certain number of megapixels for a certain size print, and once you exceed that number, adding more gives no benefit.

Megapixels are not a simple measure of quality: Often you'll hear folks describe cameras in terms of megapixels as though it is the only thing that affects image quality. This is especially true with some salespeople at retail stores. Many don't quite understand

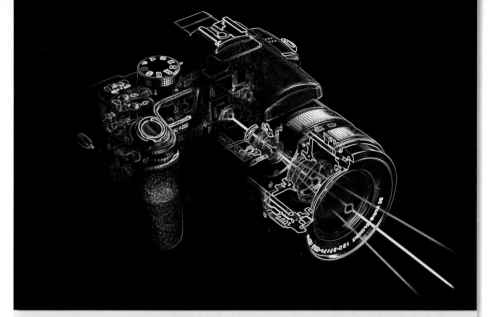

If you purchase a camera based on its megapixel count, then make sure you are using the camera to its fullest capabilities. Set your camera to its highest megapixel setting to ensure you are getting your money's worth.

what megapixels really are. The quality of an image is highly dependent on the camera's sensor design, lens quality, exposure, internal camera processing, and the photographer's ability. Megapixels mainly affects how large an image can be.

Use what you paid for: Should you set your camera to a lower megapixel setting if you don't need all the megapixels that come with it? Don't do that. Use the full megapixel setting. This will give you the highest quality image from your camera with the most flexibility in use. Cameras are optimized for their sensor, so if you are using something less than what the sensor is designed for, you are not using the camera to its fullest.

Size of the sensor matters: If you have two cameras with sensors of equal technology, then a camera with a small sensor and high megapixels will generally not match the quality of a camera with a larger sensor, but fewer megapixels. A larger sensor with fewer pixels means that the pixels (the actual sensing elements) can be much larger. A compact digital camera, for example, will have smaller, more densely packed pixels in its sensor compared to the

The more megapixels your camera has, the larger your photos can be. Consider how much storage space you will need for photos. Large photo files can quickly take up space on your computer hard drive. Removable storage devices such as CDs and DVDs are good storage options if you have limited computer space.

larger sensor of a digital SLR (D-SLR). Smaller pixels cannot react to light like larger pixels (smaller pixels have less surface area for the light to hit) and this results in more noise, less tonal range, and weaker colors than that from larger pixels.

Age of the technology matters: Now let's complicate things. Suppose you have a sensor with more and denser pixels that is a very recent design. Compare this to an older sensor with larger and fewer pixels. In this case, technology often catches up to deal with the limitations of physics. The sensor with more megapixels is often equal or even better in terms of color, tonality, and noise. This is because manufacturers are constantly creating better sensors and adding more advanced processing capabilities in the camera in order to get better color and less noise, for example.

More megapixels change your digital needs: With more megapixels, you need larger memory cards, more storage space on your

harddrive, more capability in your computer's processor, more internal processing power in stand-alone printers, and so on.

SENSOR SIZE

As you just learned, larger sensors often mean that pixels can be larger, offering more sensitivity and better color from your camera (among a number of things). But sensor size affects a lot more than this in a camera.

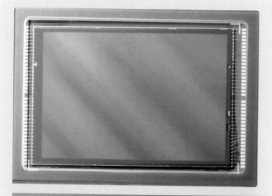

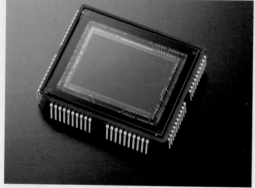

Sensors come in different sizes, both in terms of megapixels and physical dimensions. A physically larger sensor can allow for cleaner images with less noise.

Sensor size also affects the following:

The interpretation of focal length: The focal length of a lens changes how wide or narrow a view you can capture of a scene. But focal length alone doesn't tell you anything. What is a 50mm lens, for example? Without knowing the camera format it is designed for, you have no idea of what it can capture. A 50mm lens was a wide-angle lens for the traditional medium format type of camera, a "normal" (or standard) lens for 35mm and 35mm "full-frame" D-SLRs, a slight telephoto for the APS-C sensor size used in other D-SLRs, and a very big telephoto for a compact digital camera. The smaller the sensor, the more telephoto a lens acts (and the harder it is to get a wide-angle view).

The physical size of a lens: If you have two lenses of the same focal length but they are designed for use with different formats (such as an APS-C or full-frame sensor), then they will be physically different sizes. This is because a lens has to create an image circle large enough to cover the sensor size. A full-frame D-SLR must have a lens with full frame coverage, while a compact digital camera only needs coverage a fraction the size. Lenses have to be physically larger in order to create larger image circles, which is one reason why zoom lenses (even if they have similar focal lengths) can be physically smaller on a compact digital camera.

Camera size and design: A camera with a full-frame sensor (the size of 35mm film frame; approximately 1 x 1.5-inches (25.4 x 38.1 mm)) must, at the minimum, be large enough to enclose its sensor and circuitry, and be large enough to handle a lens of the size needed for the image circle to cover it. On the other hand, a pocket point-and-shoot digital camera may have a sensor that is only .5 inch (12.7 mm) across at its widest, which will mean the camera can be physically much, much smaller.

Photo proportions: Different image sensor sizes usually have different proportions. Manufacturers have not set a standard aspect ratio (the ratio of width and height). While full-frame (35mm film size) D-SLRs mostly use the standard 3:2 ratio of 35mm, the four-thirds format (used by Olympus and Panasonic) uses a 4:3 ratio. Smaller cameras use all sorts of proportions, from 3:2 and 4:3, to 16:9 and more. This all affects what your photo will look like when printed, or how it must be cropped to fit standard paper sizes.

Standard sizes: Though proportions can change in sensors, there are still a number of fairly standard sizes that you will see listed with cameras (see the chart to the right).

When lenses are designed for these formats, the image circle of the lens has to be just big enough to cover that size. Larger image circles typically require larger lenses. You can see there is a considerable difference in the size of the image circle needed to completely cover these different sensors.

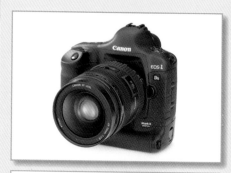

- **Full-frame D-SLR:** based on a 35mm film size, this sensor size is approximately 1 x 1.5 inches (25.4 x 38.1 mm)

- **APS-C:** based on the old APS film format, this sensor, smaller than 35mm, is also used in D-SLRs. It allows for smaller cameras and is 0.6 x 0.9 inches (15.2 x 22.8 mm)—this is an approximation, as there is slight variation in this size among manufacturers

- **Four-thirds:** this is a unique digital format developed specifically for D-SLRs, created by a consortium of manufacturers (though at the time of this writing, only Olympus and Panasonic are using it). It is slightly smaller than APS-C, 0.5 x 0.7 inches (12.7 x 17.7 mm), giving a proportion of 4:3 (for the name of the format)

- **Compact and point-and-shoot cameras:** typically these are one of three sizes (the measurement is the diagonal across the sensor) listed exactly as seen here—1/2.5 inches, 1/1.8 inches, and 2/3 inches

TYPES OF SENSORS

There are of two basic types of digital camera sensors—CCD and CMOS (with some variations on each). We could spend a whole chapter on them and you wouldn't be a better photographer. The results today are pretty similar. In fact, there is more difference in images from camera to camera due to internal processing than there is from sensor types.

CCD stands for charge-coupled device. This is a light-sensitive semiconductor chip. The CCD has the longest history of use with digital cameras and is still the most common when all digital cameras are considered.

CMOS stands for complimentary metal oxide semiconductor. CMOS chips are very common in computers. CMOS sensors oper-

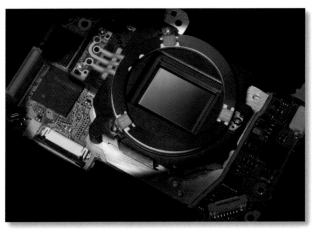

ate with lower voltage requirements than a CCD, which means you can use smaller batteries or the battery life is longer.

There are only a few manufacturers of camera sensors in the world, and Kodak is one of them. If you see the same megapixels in multiple cameras with similar design (e.g., two same-sized pocket cameras), check the sensor's physical size. If the sensors are the same size, then they are most likely made by the same chip manufacturer, regardless of the camera brand. This does not, however, mean that these two cameras will have identical results. Internal processing (explained below) will affect that.

COLOR AND THE SENSOR

A digital sensor creates color in an interesting way. Each pixel sees and captures color from a scene differently. (There was an attempt to create a sensor that saw color equally throughout its pixels—the Foveon chip—but it has yet to become a significant player in the sensor market.)

A sensor is made up of a pattern of pixels using three different filters: red, green, and blue. From this pattern, a color image can be built (there have been variations of red, green, and blue filters, but this is the predominant way colors are translated with a sensor). The pattern, called the Bayer pattern, uses two green, one red, and one blue in each group of four pixels, and is a design originally developed by Kodak (a world leader in sensor design, development, and manufacture).

Each sensing element sees the color of its filter, creating, in essence, a black-and-white image based on that color. Then either the camera or the computer (more on this shortly) creates a color photo by combining information from the red, green, and blue sensors. The resolution and detail captured by the sensor is based on the total number of pixels. The color information, though, is based on a fraction of the total pixels (1/4 each for red and blue, 1/2 for green) which are smartly interpolated to give a complete color image.

This does create a unique problem at times. When real-world objects have patterns with frequencies (meaning the size and texture of color detail) that are similar to the sensor pattern, you sometimes get new patterns in the photograph that did not exist in the real world. For example, a herringbone jacket at just the right distance and focal length will create colors and patterns in the image that are not really in the jacket. This is called a moiré pattern. You can usually get rid of it by moving closer to or farther from the subject.

What it is: Image processing done inside the camera.

What it does: Internal processing optimizes the image data as it comes from the sensor, translates it into appropriate formats, and even adjusts the look of an image file as it is saved to memory.

Where it's found: This is usually based in a proprietary computer chip somewhere inside the digital camera and includes both hardware and software components.

What it's called: Some manufacturers don't call this anything other than internal processing, but others have special names for it, such as Digic (Canon), TruePic (Olympus), Bionz (Sony), and so forth.

Inside your digital camera, some amazing things happen in order to create your finished image. Digital cameras have a lot of computing power built into them and they use it quite effectively, processing every single image file that comes from a digital camera. You may hear that a RAW file (more on that in a moment) comes directly from the sensor without processing, but that's a bit misleading.

At the minimum, every file has to go through something called the A/D (analog/digital) converter. This internal processor (usually its own computer chip) takes the electronic signal coming from the sensor, which is an analog signal, and converts it into the digital bits and bytes that create a digital image file. These processors use proprietary algorithms that camera companies are quite proud of, and rightly so. They result in images with less noise than might be expected from a smaller sensor with a lot of megapixels, they enhance color information coming from the sensor, they process tonal range information, and much more. In fact, this is why you can compare two cameras from different manufacturers that use the same sensor chip and find very different tonalities and colors in the images.

Some advanced cameras (particularly D-SLRs) have an added bit of processing before the A/D converter. This is called pre-conditioning of the analog signal, and is often used to get better color right away as the signal leaves the sensor.

Many advanced digital cameras now have internal processing to optimize your photos. This processing reduces noise and adjusts colors and tonal ranges, among other things, as an image is converted from the sensor into a digital file.

Digital cameras almost always have another processor besides the A/D converter that is used to process JPEG files and move image files quickly to the memory card. These processors also have proprietary algorithms that act like automated RAW file processing software. The manufacturers put a lot of work into this type of processor because it can make such a difference in the JPEG images. Processing the digital data from the A/D converter as it is converted into a JPEG file gives images better color and tonal range, and less noise. In addition, these chips are often used to

create black and white and other special effects in camera. Such internal processors have a big effect on what an image looks like coming out of one specific camera model as compared to another.

JPEG AND RAW

What they are: File formats your camera uses for image files.

What they do: Save the data captured by your camera so you can see and use the photo later, on or off the camera.

Where they are found: Settings for JPEG and RAW are usually found in a digital camera menu.

What are the differences: JPEG is a compressed file format (technically, it is not a true format, but a compression "scheme" or technique used

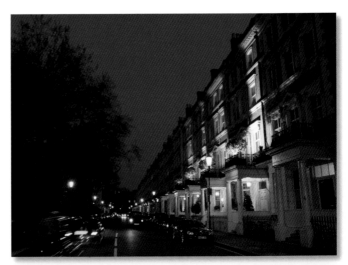

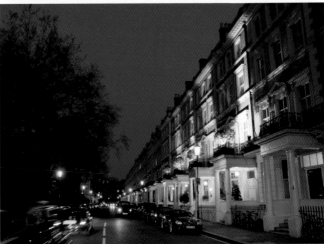

One big difference between JPEG and RAW image files is the ability, with RAW files, to alter the photograph with image processing software. This photo shows the subtle difference in this RAW image before image processing (above) and after processing (below).

JPEG and RAW image files can give equally good results, as long as the initial image does not need extensive processing with computer software to look great. RAW files offer far more flexibility for processing, but are also much bigger. Decide what workflow is best for your needs.

as a format in a digital camera) that smartly removes redundant data to make the file smaller for saving then reconstructs it later when it is opened. RAW is a file of unconstructed image data with minimal processing, and must be put into a special image converter to put it together as a photo.

You know the old saying, never discuss politics or religion with friends. The way photographers talk about JPEG and RAW (though they usually would put a versus in between), you'd think that the old saying should be amended to include JPEG and RAW. You'll hear an awful lot of advice, opinion, and even trash talk about them (especially JPEG).

All digital cameras include JPEG as the image format and will give you several choices for saving images. These choices mainly refer to the quality level of JPEG compression. When compressing files, it really does remove redundant data quite smartly in order

to make a smaller file. The problem, however, comes from the amount of compression. As compression increases, there is less data available in the image to give the best photo when the image is opened and reconstructed to its full, original size.

The more varied and unique the tones are in an image, the less it will compress in the JPEG file format because it has less redundant data. Photo © Bob Krist

JPEG files are based on a variable compression technology. You can change the amount of compression to make a file smaller, but always remember that this also removes more data from the file. Compression also changes as the saving algorithms examine the file; an image with a large area of the same color will compress much better (and with equal quality) compared to another scene with lots of small detail. The first has more "redundant" data (the color is the same over a large area), but the second has a lot more unique information. Consequently, JPEG images of equal quality will have slightly different file sizes. Use the highest quality JPEG settings unless you are really restricted with memory card space (then get a new, larger card!).

RAW files are proprietary image files that hold minimally processed data from the sensor and have a large pool of data for working on an image. They are sometimes slightly compressed, but never to the degree of JPEG files.

I'll give you one thing very straight. In spite of all the words bantered around about these image formats, both can give absolutely terrific digital images. You have seen photos published in magazines and books that came from both. In fact, the photos in this book came from both—can you tell the difference? Does it

Many digital cameras give you the option to make a JPEG and a RAW file with each photo you take. When you open these images in a browser, you will see two of each photo; one is the JPEG version, and one is the RAW version.

matter? Really, what is important, the photo or the technology it came from?

Choosing between JPEG and RAW as capture formats should not be about arbitrary image quality. RAW does not automatically give a better image than JPEG. In fact, if you shoot a quality JPEG image and a RAW image at the same time, and do minimal processing with each, there is a good possibility the JPEG image will look better. The reason for this is that camera manufacturers have worked hard to create internal camera processing of the JPEG file so that it looks great for the consumer. The RAW file has none of

that processing (and needs some for it to look its best).

Then what's the big deal about RAW? Flexibility and power. RAW gives more possibilities for the photographer when adjusting an image. You can always get a better photo from a RAW file if the image has exposure or white balance problems and if the photo needs strong adjustments to make it look right. If you really like to push an image in contrast and color, you may find that RAW will consistently give better results.

JPEG files are 8-bit image files, which is perfectly fine for making a quality photo, but just inside the limits for photo quality. If stressed, that file's processing requirements will push it outside its 8-bit limits, and it can show problems from that.

An 8-bit file has 256 tones available for each color channel (red, green, and blue; or RGB). RAW files are 16-bit files, though very few digital cameras can actually shoot at 16-bit. Most shoot at 12-bit which has over 4,000 tones per channel. If you don't need

all that information (and many pictures don't), you don't gain anything from the larger file. But when you do need it, that extra data can be very helpful. (By the way, these are expressed per color of RGB, so sometimes you will see numbers that are three times these—they simply reflect the total for all three colors.)

The internal processing of JPEG files has advanced dramatically since digital became ubiquitous. Camera manufacturers have worked hard to remove much of the hassle of optimizing images for the consumer. Photo © Robert Ganz

Think of it this way. You have a big dog that just fits into your compact station wagon. It fits fine, but you aren't going to get the dog to do any tricks in there—the car is the JPEG file, and the dog is your image. Now, put that dog into an SUV and it has lots of room to move around—it has more options, just like 12-bit and 16-bit files offer.

There are reasons for both formats, which is why they are choices for you on most advanced digital cameras. Simple point-and-shoot cameras only have JPEG files, but advanced digital cameras and D-SLRs have both. So how do you choose between them? Here are some ideas:

If you don't want to process each image in the computer after you shoot, then consider using JPEG for your photo file format. JPEG images are ready to go as soon as you shoot them—you can attach your camera to a printer and print it right out of the camera if you want to. RAW images require extra processing in the computer before you can print, email, or post them to a website.

RAW files are excellent for dealing with light and dark colors in the same image which can be a challenging exposure. They capture more information, giving exquisite detail to all tonal ranges and gradations. Photo © Bob Krist

JPEG is ubiquitous: You will never have a problem opening a JPEG file on any computer. RAW files, however, need processing before they can be universally seen, plus they are proprietary files for each camera manufacturer and camera model, so they need special software to use them.

RAW is a big format with lots of room to adjust: Most cameras shoot at 12-bit with 4,000 tones per color, significantly more than 8-bit, then record those 12-bits into a 16-bit file. Still, 4,000 is much more than we need in order to see a digital image as a photograph, but you get the idea that there is a lot of flex room in there for processing.

JPEG is fast: Since a JPEG file is a compressed file. Redundant data has been removed in order to make a smaller file. This is done extremely fast by the camera's internal processor in order to create a much smaller file than RAW. That can be handled very quickly by the camera, by the memory card, and eventually, by your computer.

RAW is very adaptable: If you have white balance issues, for example, you can correct them very easily in your RAW converter with no change in image quality. You can correct bad color in a JPEG file, but there will be image degradation from that processing.

JPEG is a processed RAW file: Camera manufacturers put a lot of research and development into their in-camera processing so that the camera will produce high quality JPEG files as needed.

RAW files deal with finely graded tones better than JPEG: When your scene has soft and gentle gradations of tones, JPEG can struggle with them as the images are processed, sometimes even leading to banding across the tones. Gradations have always been a challenge for digital because they are continuous and digital is not. Digital is ultimately based on a finite number of pieces of megapixels and memory. With more data to work with (as in RAW), gentle gradations can be processed more so than with JPEG.

JPEG is convenient: You can photograph scenes on a trip, for example, then walk into almost any photo processing lab and have prints made immediately from those images. You cannot do that with RAW.

JPEG gives small files that allow you to fit more images onto a memory card or hard drive.

JPEG also results in a simpler workflow in the computer (or even printing photos directly on a photo printer without going through a computer): RAW requires a more intensive workflow (though it can still be easy to use with the right programs).

RAW gives more details in dark and light areas: JPEG files have much less information from those parts of the image, so they cannot provide data that RAW can give.

There are other points to using both formats, but the point is, they both work. You can get great images from both. Many photographers shoot both in order to gain the benefits of both, and most D-SLRs let you shoot both at the same time.

What it is: LCD stands for liquid crystal display, and is a flat-panel visual display.

What it does: On a digital camera, LCD panels often come in two types: monochrome for information (like camera settings) and color as a monitor of actual photos.

Where it's found: LCDs on the top of the camera are typically called LCD panels and used for camera information. LCDs on the back of the camera are called LCD monitors, or just the camera LCD, and are used to display images and menu information.

The LCD monitor totally changed the experience of photography. It shows you instantly what the camera sees and/or what it has captured to the memory card. In the next chapter, you'll gain some ideas on how to really make the most of it. In this chapter, we will briefly cover an important part of digital technology, the live vs. review-only LCD.

The LCD that shows you exactly what the lens sees and acts like a viewfinder as you shoot is a live LCD. This means it is "live" as you compose and capture your photos—it is see-ing exactly what the camera's image sensor is seeing. All standard digital cameras that are not D-SLRs have this capability. If they have an optical viewfinder, you can turn the LCD off and use the optics for composing and framing up your shot, but you

Live LCDs show you what the camera is seeing in that same instant, so you know exactly what you are shooting.

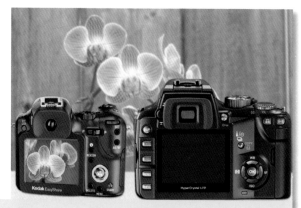

Whether your camera has a live or review-only LCD, it is an invaluable tool. Use the LCD to experiment with your photography. You have nothing to lose—just erase the images you do not like and try again.

can always return to the LCD as needed.

The advantage of a live LCD is that you see exactly what your lens sees, plus you see how exposure and white balance affect the image. In the past, a major disadvantage of this was that there were limitations in the speed of camera shooting and how it dealt with things like exposure and auto-focus. Those issues are largely gone now, though there typically is more of a delay in exposure from a point-and-shoot camera compared to a D-SLR, but this is not a sensor or live LCD issue.

D-SLRs, for the most part, do not have live LCDs. This is because an SLR, a single-lens-reflex camera, shoots through the same lens that its optical viewfinder sees the scene. This requires a mirror that bounces light into the optical viewfinder for focus and framing, which also blocks light to the sensor, so it can't be used for a live view on the LCD. Today, an optical viewfinder is brighter, clearer, and easier to see in all light than an electronic viewfinder (EVF) or LCD. That is likely to change in the future and will make photographers laugh who read this book then. But for now, this is an important consideration.

A few D-SLRs have been developed with a live LCD and still retain the use of the optical viewfinder (note—an EVF camera is not an SLR even though it acts similarly). These required some unique engineering, including using a separate sensor in the viewfinder area to power the LCD. It is very possible that more of these will be marketed in the future so we can all gain from the benefits of a live LCD and an optical viewfinder.

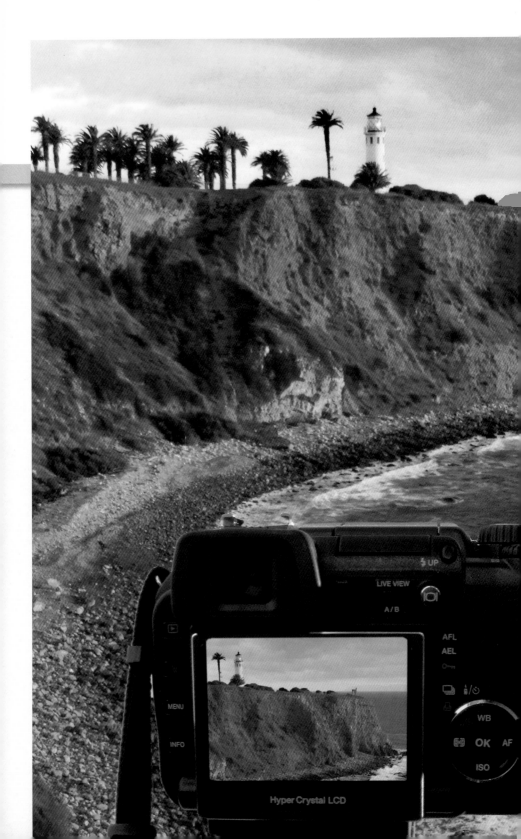

Camera Work

The cliché about photography is that the key thing you need is light. Now that is certainly true—you do need light in order to take a picture. But you also need ... a camera! Without a camera, you can't capture that light to create a photograph.

Digital cameras today do some amazing things. The average digital camera has the power of a roomful of computers just 30 years ago, and now that power fits in the palm of your hand. Cameras come in all shapes and sizes, from small enough to fit in a shirt pocket, to large enough to anchor a small boat (not that you should).

They also come with a whole range of capabilities. All those possibilities can be a little intimidating, and to let you in on a secret, I don't know many photographers, amateur or pro, who know and use every little function on any camera beyond the point-and-shoot. In this chapter, we'll look at the diverse choices you have in buying a camera and go over some key camera techniques that will help you get the most out of any camera.

THE PERFECT CAMERA

A common question that I often get is, "What camera should I get?" That's a loaded question because it implies there is such a thing as the perfect camera that will fit everyone's needs.

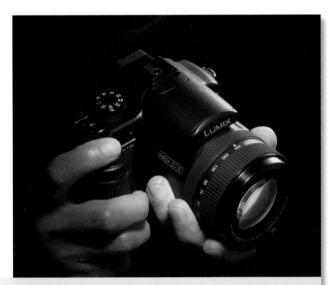

No matter what kind of camera you own, or what kind you want to own, make sure that the camera works for you. If it is too small for your hands, or the controls are hard to get used to, you probably will not use the camera as often as you would a camera that fits you perfectly.

Well, there isn't. There are many different camera models in your local camera store because, frankly, there are many different people buying them for different reasons. What makes a camera perfect for me is not necessarily a perfect camera for you anymore than the car I drive is the best car for you or anyone else. But you can find a great camera that meets your needs and helps you take wonderful, satisfying photos.

CAMERA TYPES

The camera industry doesn't have a consistent way of categorizing cameras. For example, a large group of cameras are called "point-and-shoots," yet the design, appearance, and capabilities of those cameras vary too much to really lump them into one group. To be

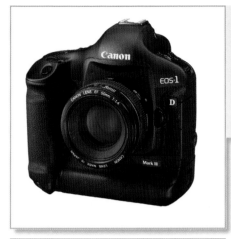

Digital SLRs (D-SLRs) have interchangeable lenses, accessory flash units, and offer the most manual control of all cameras. Some D-SLRs are geared toward professionals and some are geared toward the advanced amateur.

fair, one reason why categorizing cameras is difficult is that the features are so very different, making it possible for some cameras to fit more than one category.

I will give you a set of camera types to help you understand the camera choices available. This can, help make some sense of the variety of cameras, and help you determine what a particular camera can or cannot do for you. The chart on page 59 lists a series of camera types and some key features. In addition, here is a quick overview of each:

Digital SLR (D-SLR) – Pro: This is the top of the line of a camera manufacturer's models. It does not arbitrarily offer the best photos (this is dependent on a number of things, including lens used), but it does offer the most rugged and sealed construction designed for the demands of daily shooting in field conditions by an on-the-go photojournalist. All D-SLRs accept interchangeable lenses, offering a great range of focal lengths. Plus they increase the possibilities for macro shooting. Pro D-SLRs are big, heavy cameras with many capabilities.

D-SLR – Mid-range: Mid-range cameras offer many of the features of the "pro" D-SLRs and are smaller. They have rugged construction, but are not sealed as well against water and dust. They are very popular with traveling pros because of their size. They take

most of the accessories that their pro siblings do. Again, all D-SLRs accept interchangeable lenses.

D-SLR – Entry level: Today's entry-level cameras are totally unlike the stripped down models of film days. These are often quite sophisticated cameras with many features. They are a lighter-use design for experienced amateurs, and they often include automated features that higher end cameras do not, such as more program modes for exposure. Some of these cameras are exceptionally small for a D-SLR, and for that reason, are often used by pros when they need to travel very light. As in the first two D-SLR categories, this group is designed for interchangeable lenses.

Advanced compact digital camera – high zoom range: This is a unique category of camera that did not exist in film days. These cameras are smaller than any D-SLR, yet they share most, if not all, of the same autofocus and exposure controls of entry level and mid-range models. Their lenses, however, are a fixed zoom, typically with zoom ranges of 10-12x, and are definitely long enough for sports and wildlife. Generally, they use an electronic viewfinder (EVF) along with the back LCD for live viewing. They have no true optical viewfinder, which allows this design to be more compact.

Advanced compact digital camera – small zoom range: This group is very similar in capabilities to the previous group except that the lens here is smaller,

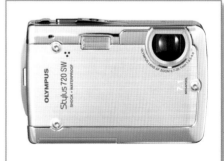

Advanced compact zoom cameras give you a variety of focal lengths without needing to carry multiple lenses.

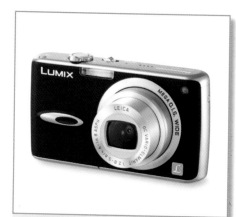

Compact digital cameras make travelling extremely easy. They are very portable and take good quality photos.

usually a 3-4x zoom. Because the lens is smaller, the camera is also more compact. These cameras typically have an optical viewfinder with the back LCD for viewing or no viewfinder at all (other than the LCD). They often have the capability of accepting accessory lenses that screw on in front of the built-in lens to add additional focal length or close-up capabilities.

Advanced compact digital camera – rotating LCD: Here is a unique variation on the advanced compact digital camera category. The LCD moves out from the body and either rotates or tilts. This allows you to see the LCD at different angles, allowing you to easily shoot overhead or down low, plus it makes macro shooting easier. This is a great advantage, by the way, for bifocal wearers, because the screen is easier to see without tilting your head back.

Pocket digital camera – full-featured: These are truly small cameras, and some seem to offer impossible features in their tiny size. Such cameras can go with you anywhere, yet they include most of the top-grade exposure and focus features of D-SLRs. Many pros tuck one of these into their camera bag so they have a little camera to shoot with for fun, but also when shooting in situations where a larger camera is not appropriate. One *National Geographic* photographer I know uses such a camera to photograph in locations in an unobtrusive, almost invisible way (people don't think he is "serious") that allows him to take shots that a larger camera would not.

Pocket digital camera – point-and-shoot: Similar to full-featured pocket cameras, these are completely automatic and you have no control over camera adjustments; hence the term point-and-shoot.

These are really the only true point-and-shoot digital cameras, though folks will often call non-SLR cameras point-and-shoots, even though they are not.

Entry-level point-and-shoot digital cameras: These cameras tend to come in a variety of shapes and sizes (though all are small), and are very basic cameras with limited features and strictly point-and-shoot operation.

Cell phone digital cameras: It is hard to say what impact these cameras will have in the future. Right now, they have very limited use for anyone serious about photography. Their capabilities and lenses are pretty marginal compared to standard cameras. There are a few with more megapixels, but this is largely a marketing ploy, as the lens quality and the limited space for camera controls means you really can't make good use of those megapixels.

Point-and-shoot cameras are a great way to take snapshots without the cost of more expensive, advanced equipment.

DIGITAL ZOOM

You'll hear mention of a digital zoom feature in non-SLR digital cameras (though even a few D-SLRs have the same thing; it is just called what it is—a crop mode—rather than the marketing-oriented "digital zoom"). This has nothing to do with a lens or a true optical zoom that actually magnifies the subject before the light hits the sensor. It is an in-camera digital effect.

With a digital zoom, part of the image is cropped in-camera and enlarged to fill the pixel size of the sensor; in some cases, the camera simply gives a smaller, cropped image file. This results in

Camera Type	Size	AF & Exposure Capabilities	Interchangeable Lenses	File Formats	Flash Capabilities	Durability	Recommended Uses
Digital SLR–Pro	Very large	Very high	Yes	RAW and JPEG	Accessory flash but no built-in flash	Best in the industry	Pro photography; photojournalism; nature; sports; portraits; flexible macro
Digital SLR–Mid-range	Large (Moderate for D-SLR)	High to very high	Yes	RAW and JPEG	Accessory flash & often w/built-in flash	Very high	Pro photography; photojournalism; nature; sports; family; travel; portraits; flexible macro
Digital SLR–Entry level	Moderate (Compact for D-SLR)	High	Yes	RAW and JPEG	Accessory flash & built-in flash	High	Nature; limited sports; family; travel; portraits; flexible macro
Advanced compact digital camera—high zoom range	Moderately compact	High	Add-on accessory lenses	JPEG & often RAW	Accessory flash & built-in flash	High	Nature; sports; family; travel; portraits; macro
Advanced compact digital camera—small zoom range	Compact	High	Add-on accessory lenses	JPEG & often RAW	Accessory flash & built-in flash	High	Nature (not wildlife); family; travel; limited portraits; macro
Advanced compact digital camera—rotating LCD	Compact	High	Add-on accessory lenses	JPEG & often RAW	Accessory flash & built-in flash	High	Nature (not wildlife); family; travel; close-ups and unique angles; limited portraits; macro
Pocket digital camera—full-featured	Pocket-sized	Good	No	JPEG	Built-in unit only, typically low powered	Good to High	Nature (not wildlife); family; pocket camera for the photo enthusiast; travel; limited portraits; macro
Pocket digital camera—point-and-shoot	Pocket-sized	Limited	No	JPEG	Built-in unit only, typically low powered	Good	Family photography; snapshots; limited travel; macro
Entry level point-and-shoot digital cameras	Small to compact	Limited	No	JPEG	Built-in unit only, very low powered	Okay to Good	Family photography; snapshots; limited travel
Cell-phone digital cameras	Pocket-sized	Very limited	No	JPEG	Built-in unit, very low powered, or none	Okay to Good	Snapshots; limited travel

an enlargement of the image area provided by the lens at the maximum telephoto focal length of the zoom, so it only shows what the lens has already produced at that focal length. It cannot show you any more detail than the maximum telephoto setting of the lens.

With high-megapixel cameras, you often have more than enough pixels for the size images you need to print, so a moderate digital zoom that is simply cropping into those megapixels may give you an acceptable image that looks like you used more of a telephoto setting than your lens is capable of. Try it out and see what quality you get. If it works for you, then go for it.

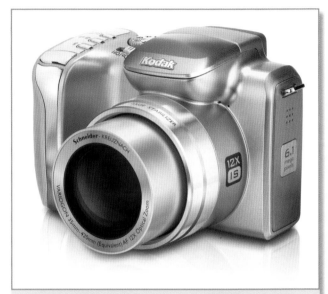

Digital zoom cameras often crop the image in the camera to make it look larger in the image area. This is good if you do not mind the slight loss in quality and have no need for extremely high quality images.

MEMORY CARDS

What they are: Removable data storage for digital cameras.

What they do: Memory cards store digital image files.

Where are they found: You can purchase memory cards from any retailer that sells digital cameras or accessories.

What types are available: Memory cards come in several different types, the most common being CompactFlash cards (for larger

cameras), SD cards (for small cameras), and xD-Picture cards (the smallest of cards found in a select group of cameras).

Memory cards continually increase in capacity and speed, yet do this while prices drop for gigabytes (GB) per dollar. Memory cards are important; they allow you to take many pictures at a time, far more than you could ever get from a roll of film. They affect camera design, but they don't offer photographic features independent of cameras, so they should never affect a choice of a camera.

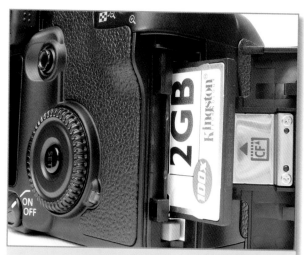

Memory cards have a number of key features that can be helpful to understand so that you can better choose and use them:

Capacity affects how many photos a card can hold. The more gigabytes, the more photos a card can store. This is going to vary, though, depending on the megapixels of the camera, the quality setting, and if you shoot JPEG, RAW, or both. A 1 GB card will hold over 600 JPEG images (sized at 1.5 megabytes (MB) each) from a 6-megapixel camera, and will hold 110 RAW files (at 9 MB each) from the same camera (numbers will vary from camera to camera). With a 10-megapixel camera, a 1 GB card will hold 250 JPEG files (4MB each), and 53 RAW files (19 MB each). In the last chapter, you see that JPEG is a variable compression format. This means it can have different file sizes, so these are approximate numbers—a specific number is not predictable.

No matter what kind of digital camera you have, you need a good memory card. Your memory card size determines how many photos you can take before changing cards.

Large memory cards can handle large image files, such as RAW files. If you know you will shoot RAW files, then it is a worthy investment to purchase several larger memory cards (2GB and larger). Do not let a perfect photo opportunity pass by because you do not have enough memory card space.

Memory cards are relatively cheap now. Buy the maximum of what you think you need to be sure you have enough capacity in one or more cards so you do not run out of space.

Memory card speed does not affect camera speed. How fast a camera can shoot is totally dependent on that camera's internal file handling capabilities built by the manufacturer. Memory card speed affects how fast image files are removed from the camera buffer (place of storage where the camera first puts image files), and it only affects that removal when the camera is designed to handle that speed. Card speed will also affect, to a degree, how fast images download to the computer.

As a whole, though there are exceptions, memory cards are very durable—most are solid pieces of plastic with the electronics imbedded in them. CompactFlash cards are extremely tough and you cannot hurt them by dropping them or getting them wet. SD and xD-Picture cards are also very durable, though they are smaller and less substantial, so they can be cracked or deformed more easily (though still not without some effort). One thing that can be a problem is a Microdrive, a memory card sized like a Compact-Flash card, but with a tiny hard drive inside. They are low priced for the memory involved, but are easily damaged if dropped or subjected directly to water.

WORKING WITH YOUR CAMERA

How you use your camera is as important, if not more important, than the actual camera itself. People have said to me that you must have certain types of cameras for real quality images. Yet, I have had photos from camera that had sensors as small as 3 megapixels published as two-page spread and the image looked great. I had a magazine cover from a 4-megapixel compact that looked as good as images coming from film and higher megapixel D-SLRs.

The point is the camera is not as important as how you use it. You gain a great deal of flexibility from a high-megapixel D-SLR, which can help you get the photographs you want, but such a camera is also perfectly capable of creating high-megapixel boring, dull photos and even poor quality shots.

No matter what the camera, good photos start with the appropriate technique for the subject and style of photography. The rest of this chapter will give you the core information you need to help you truly shoot like a pro. These are the basic techniques that pros use for quality images, and can be applied to any camera.

LCD USE

The LCD on your camera is a huge resource. Consistently, I hear from long-time photographers that the LCD was one thing that helped make digital such an invigorating new part of their photography. Before we look at specifics on LCD use, here are some ideas on setting up your LCD for optimum use:

1. Set the review time: All D-SLRs, as well as many compact digital cameras, let you set the review time. This is how long the image stays on the LCD screen after you take a shot. I recommend you use 8-10 seconds if the camera allows this. This keeps the image up long enough to quickly evaluate it after shooting. If the image is up longer than needed, or you don't want to review it right away, push your shutter button lightly and it will go away. If you are shooting in a sensitive area and don't want the light from the screen to appear, you can usually set the review time to 0.

2. Turn off auto-rotate: Your LCD is horizontal and only displays the photo at its maximum size as a horizontal image. If a vertical photo is made to fit vertically into that space (which is what auto-rotate does), the long side is now shortened to fit the short height of the horizontal LCD, and you lose your ability to see smaller details. Many cameras now offer a modification of the auto-rotate function that is helpful—the images have information put into their metadata to make the computer turn them vertical, but they display to maximum size in horizontal orientation on the camera's LCD.

3. Know the difference between review and playback: Review is when the camera automatically puts up the image you just shot on the LCD; playback is when you press the "play" or "review" button and you can go through all images on the memory card. Cameras vary as to what you can do in each function. Some cameras let you erase an image in both, and some only in playback, for example. Review will only stay on for a brief time, while

playback will stay on as long as you have set the camera to stay on (also a menu choice).

Now, on to the really fun stuff, the actual use of the LCD for better photos. Here are some ideas to try:

Instant photo: The LCD panel has become akin to a Polaroid™ or instant photo. You can see the results of your effort immediately. You know if you got the picture or not, which means that everyone, from beginner to advanced pro, can improve photos instantly. You don't have to "hope for the best" when traveling and you only have a short time at a great location; you can check and make sure you got the shots you want while you are still at that location.

Exposure and color: While it is true that a digital camera's LCD is not completely accurate when it comes to seeing exposure and color in a photograph, it certainly is helpful in those areas. You can learn to interpret your LCD—e.g., does it usually show images too bright or too dark? Shoot and compare what you see on your computer screen.

New angles and compositions: The LCD can encourage you to try new angles and compositions when photographing your subject. When you see the image in review or playback, you can instantly see if you need a better angle to the subject (e.g., move a little to the left and get rid of a distracting part of the background) or if you could improve on the composition (e.g., I wonder what would happen if I got closer and put the subject lower in the frame?).

Experimenting: Experimenting is related to new angles and compositions. You can try all sorts of new ideas when photographing a subject, from changing exposures, to blurred effects from slower shutter speeds, to different effects from white balance choices. Wonder what would happen if you attached the camera to a tripod and held it high overhead after pressing the self-timer? Go for it. There is no cost to experimenting (you can always erase photos you don't want), plus you can instantly playback any and all images of a group so you can learn and revise the shot.

Reviewing your shooting for technique and camera problems:

Seeing the photo right away lets you check your technique, and occasionally, see if the camera is having problems. Is your shutter speed fast enough to stop the action? Check and see. Do you really need a tripod? Take a shot and enlarge it to see if the details are sharp. Are you getting the right action shots at a soccer game or are you too slow? Even sports pros will do exactly that to be sure their technique is up to speed when conditions are challenging.

A new angle on a familiar situation can make for a great photograph. Use your LCD to try new angles and compositions when you are shooting. Photo © Bob Krist

HOLDING THE CAMERA

How you hold your digital camera makes a big difference in sharpness. My father once bought a new pocket camera before he went on a trip and took a lot of pictures as he and my mom visited the location. When he got home and showed me the pictures, they all looked slightly out of focus. It seemed like he had gotten a bad camera, and the old adage of "try out your gear before the trip," seemed especially appropriate.

Then we noticed a very sharp photo that stood out in stark contrast to the others. It was as if a different camera had been used, but in fact, it came from the same camera. The give-away was a photograph of my mom and dad sitting on a bench. They had a friend take the picture with my dad's camera. It turned out that my dad was holding the small camera poorly, so that when he

squeezed the shutter, the lightweight camera moved slightly, causing the image to blur.

I know you have seen this: someone hops out of a car at a beautiful setting, holding up their digital camera with one hand, the camera waving precariously away from their body as they line up the scene in the LCD; then they punch the shutter and run back into the car. That almost guarantees a less-than-sharp photo; sharpness they paid for in that camera's lens and sensor.

It is easy to get into the habit of holding a camera right so that you can capture the best image possible from the conditions. This will vary a little from holding a large D-SLR to holding a small, pocket camera, but some of the basics are the same for both.

Here's how to hold and shoot with an SLR type camera (instructions for left and right hands are true whether you are left or right handed—the camera is designed to be held one way for best sharpness):

1. Grab the right side of the camera with your right hand, thumb at the back, and index finger over the shutter, the rest of your fingers curled around the right front of the camera (many cameras have some sort of grip on this side just for this purpose).

2. Turn your left hand palm up and place the camera in your palm. Curl your thumb around the left side of the lens and the rest of your fingers around the right side (the size of the lens will affect how you actually do this—do whatever seems most comfortable). With longer lenses, move your left hand out to balance the whole lens in your palm.

3. For vertical shots, simply rotate the camera in the palm of your hand. Some photographers like their right hand at the top because it keeps fingers of both hands clear of each other. Others like to move the right hand to the bottom, even though the fingers get a bit jumbled, because the arm is lower and can be kept more stable.

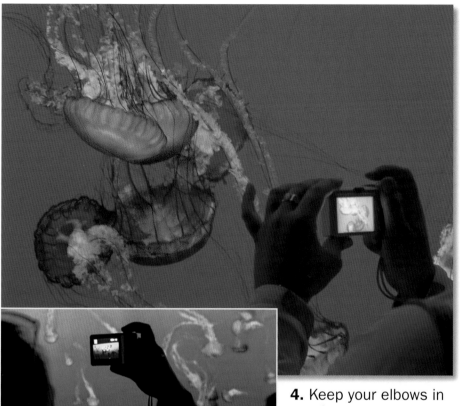

Holding your camera correctly is vital to producing quality images on a consistent basis. Make sure you support the bottom and push on the shutter button with just enough force to trigger it. The large image shows the correct way to hold your camera, and the small image shows the incorrect way.

4. Keep your elbows in close to your sides. It is not unusual to see people looking like birds landing on a perch with their flapping elbows as they try to take a picture. You can imagine what some of those photos look like.

5. Squeeze the camera shutter down gently. Never punch or jab it; that will move the camera. It helps to push the shutter down halfway to get the focus and exposure set, and then a simple, firm movement of the finger sets off the shutter without much effort.

6. Never hold your breath. Try just holding your breath and you will

see that you will start to shake. Breathe quietly, though if you want the optimum technique, take a breath, then breathe out as you release the shutter (this is an Olympic sharpshooter technique).

Now let's vary this slightly for a compact digital camera when you are using it with the LCD as a viewfinder (when you use an optical viewfinder up to your face, most of what you do with a D-SLR also applies):

1. Grab the right side of the camera with your right hand, though now if the camera is small, put the thumb at the bottom of the camera. Place your index finger over the shutter button, the rest of the fingers curled into the fist, then the side of the middle finger placed against the front of the camera (this will depend on the size of the camera and if it has a grip or not).

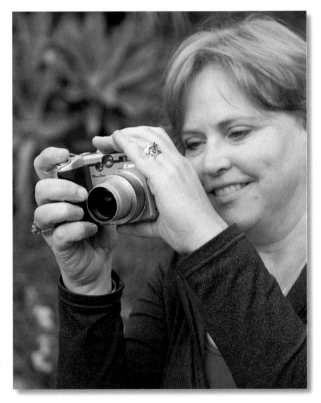

2. Grab the left side of the camera with your left hand.

3. For vertical shots, simply rotate the camera in your hands. Watch out for the location of the flash. Even if you aren't using it, get in a habit of keeping it over the lens. If it is below the lens while the camera is held vertically, you will get unflattering and unnatural shadows.

Your handholding technique can make or break a photo, especially in conditions that require slower shutter speeds to make a correct exposure, such as nighttime or indoors.
Photo © Bob Krist

4. Keep your elbows in close to your sides, and move them forward until you can easily see the LCD. Cameras with rotating or tilting LCDs can be held comfortably below your eye-level. Once again, it is common to see people flapping their elbows as they try to take a picture, which is really unstable with a camera held out from your face.

5. Squeeze the shutter button down gently. It doesn't take much to accidentally move a little pocket camera that has no mass moving during exposure. Never punch or jab at the shutter button. It is a really good technique with these cameras to push the shutter down halfway to set the focus and exposure, then trigger the shutter with a little more of a push.

6. Again, never hold your breath.

FOCUSING

Cameras do most of the work when focusing with their autofocus (AF) mechanisms. Autofocus works well, considering that the camera has to figure out what to focus on, set the right focus with the lens, and take the picture, all within a fraction of a second.

Autofocus works mainly by looking for contrast in a scene. A sharp object has more contrast than something out of focus. This

is called passive AF and works as long as there is enough light and contrast in the scene. It will have trouble when the light is dim or the subject and its surroundings have very similar brightness and contrast. It can also have trouble with too much contrast, such as a bright light that confuses the system.

Some cameras add an active AF system for dealing with low light conditions. These activate a light from the camera or an accessory flash to help the camera determine the distance to the subject.

Advanced cameras, particularly D-SLRs, add another element to the focusing: focus tracking, allowing the camera to follow focus on a moving subject.

Cameras vary in how many points they use for autofocusing. These are the specific spots in the image seen by the camera and used for focusing. More is better since it means more areas for the camera to find something to focus on. Lower-priced cameras may have 1-3 AF points that are automatically selected depending on what is closest to the camera in the subject. As camera prices go up, so do the number of AF points, up to numbers as high as 45 (though most D-SLRs are in the 9-15 range).

Regardless of how many AF points are available on your camera, you can do the following to get the most from your camera's AF system:

Single-shot and continuous AF: If your camera has this feature, you can choose between either single-shot or continuous AF. Single-shot AF means the camera finds focus one shot at a time and will not take a picture if focus is not found. This ensures something in the frame is sharp and allows you to lock focus by pressing the shutter halfway (some cameras give you the option to set other buttons to control the focus lock). This is the setting to use most of the time, but it does make shooting action difficult. Continuous AF means the camera is constantly focusing, regardless of what the shutter is doing, allowing the camera to shoot

Good focus is essential in keeping your viewer's attention. To eliminate focusing problems, experiment and become familiar with your camera's focusing system. Photo © Robert Ganz

continuously whether the subject is sharp or not in any given shot. This is the action setting that lets you hold the shutter down and shoot at the camera's fastest speeds. It is not so good for single-shot images, as it can keep changing focus as you shoot. A few cameras have an additional "auto" setting that automatically switches between these modes, but in most cases, you are better off choosing a specific AF setting that best matches your shooting needs.

Move the camera: Don't simply accept that where the camera focuses is correct. Many cameras have viewfinders that show the AF point being used; pay attention to that and move the camera

Good focus is important in this image and is what makes it work. Single-shot autofocus works well in situations where you know exactly where you want your focus plane to be. Photo © Bob Krist

until that AF point is on the part of the subject that needs critical sharpness. With cameras that don't show this information in the viewfinder, move the camera so it is centered on the key part of the subject, lock focus, and move the camera to reframe your composition where it is not centered.

Caution: Moving the camera to lock focus and recomposing can give you problems with sharpness with certain cameras or subjects (this has to do with changing distances, angles to the AF sensor and so on). In these cases, you may have to focus manually or choose a side focus point near the subject.

Change the AF point: Many advanced digital cameras, including most D-SLRs, allow you to select a specific AF point for the camera to use. This can be a very helpful tool to allow you to keep autofocus accurate when you are using strong compositions with key elements well to the side. This is critical with action

photography. For example, a baseball photographer might change to a left side AF point as he watches for a steal to second, knowing the second baseman or shortstop will be at the left of the frame as the runner comes in from the right.

Look for contrast: If your camera is having trouble focusing, look for contrast in the scene. Even in very dark situations, you can often find a bit of contrast for the camera to lock in on. If the whole scene is low in contrast, look for any kind of edge that shows a distinct difference and line up your AF on that.

Avoid contrast problems: Be aware—backlight from the sun, strong patterns (such as Venetian blinds), and other sharp contrasts can throw off an AF system. Try pointing the camera in a slightly different direction to lock focus, or use manual focus.

Continuous autofocus is good for fast moving subjects, such as athletes. It allows the camera to quickly change focus and not lock on one plane.

Low light and slow lenses: If you shoot with a slow zoom lens (a lens with a maximum aperture of f/4 or slower) in dim light, you may find your camera constantly searching for focus. This is just putting the camera to the limits of its capabilities. Again, look for something with a bit of contrast that the camera can work with.

Use manual focus: There are times when you just need to shut off the AF and go manual with focusing. A lot of small digital cameras do not allow for manual focusing, so many photographers assume

Different light sources will create different color casts in a scene. White balance helps you correct for that, but it can be a subjective choice as to what is best. These three images show the same scene with different white balance settings.

they all don't. That's not true. Many allow manual focus, and all D-SLRs do. Manual focus can be used when AF just is not working. It is also very helpful for close-up work, for situations where you really need focus on one specific part of the subject, for depth-of-field issues when you need focus from near to far, and for any other photographic challenge that requires focus to remain on one point as you make several exposures.

WHITE BALANCE

What it is: White balance is a setting on a digital camera that affects the overall color of an image.

What it does: White balance is something a camera does to make neutral colors (such as white) appear to their truest in a particular light (meaning that the setting around the subject affects how we perceive neutral), without a color cast from that light.

Where it is found: Pushing a dedicated white balance button and using a dial can control white balance settings. On some cameras, it is set through the menu.

What types can be found: White balance settings come in three types: automatic, preset, and custom. Automatic means the camera makes the adjustments, preprogrammed white balance requires you choose a setting appropriate to the scene, and manual lets you customize the camera to a very specific color of light. Most digital cameras let you choose among several white balance settings.

White balance is an amazing bit of digital technology. There are still some lights that can't be balanced completely (sodium vapor is a good example of that), but mostly, digital cameras' white balance controls achieve consistently excellent color. Here are some ideas on how you can best use this technology:

Try something other than auto: Auto white balance (AWB—the default setting of digital cameras) has made huge advances and gives great results, especially in tricky and changing light conditions. However, it can also give you dull, uninspired colors because it will often remove color casts you don't want removed (such as the warm tones of a sunset) or just make a wrong "guess" as to what is the right color of a scene. In addition, auto white balance can give you quite inconsistent color when you are taking multiple shots where the light does not change but you change the angle, composition, or focal length from shot to shot. What happens then is that the camera "sees" different aspects

Depending on what you are looking for in your final photo, white balance can be a subjective creative tool. The top image shows a slightly warm version, the middle image is closest to neutral white, and the bottom image has a cool color cast.

of the same scene, yet does not "know" that this is not a different scene altogether, so it recomputes the white balance settings for each shot.

Caution: Many photographers shooting RAW say they don't have to worry about this because they can easily change white balance in the conversion from RAW. While that is true, blindly using auto white balance causes some distinct workflow problems in RAW. First, if the camera has inconsistently changed white balance, you now have more work to do to match multiple shots from the same scene (this can be a real pain when dealing with people and skin tones). Second, if you chose a preprogrammed setting, for example, you lock in your white balance to a known color palette; if you shoot AWB, sure you can change the white balance, but to what? How does that change relate to what was really

seen at your shooting location? Are you sure you remember?

Using preprogrammed settings I: Choosing a preprogrammed setting to match the conditions. This is fairly simple, just match the setting to the conditions you are shooting: sun to a sunlit scene, shade to a shady subject, light bulb (incandescent or tungsten) to an indoor situation, and so forth. Your choices will be influenced by what you can choose with a particular camera. This does a great job in cleaning up colors. I have found, for example, that many AWB settings do not do that well with incandescent lights, but when I use the incandescent preset, the image looks great.

Using preprogrammed settings II: Choosing a preprogrammed setting for a specific effect. You can use a setting that is not exactly matched to the scene in order to make that scene look warmer or cooler. For example, many photographers find that the best looking sunrises or sunsets come from the cloudy or shady settings. Many cameras give a nice added warmth to a scene, even in sunlight, if they are always left on the cloudy or flash setting when shooting outdoors. For really creative effects, you can try totally unmatched preprogrammed settings. Try the indoor tungsten light setting outdoors for a very blue, cool effect. You can also use the daylight setting indoors to give the scene a very warm look.

Manual white balance: This is a very under-used choice for white balance and can be very helpful in getting truly neutral tones in an image. With this option, you tell the camera to make a specific tone neutral. Using your manual white balance depends on your specific camera model (camera manufacturers have not created a standard procedure), so be sure to read your camera manual. In general, the manual option works like this: put something neutral in front of your camera in the light you are shooting under (the neutral object can be white paper, a gray card, white fabric, or even specially made white-balance cards); tell the camera to make this neutral. You can even warm a scene quite nicely by white balancing on a pale blue piece of paper (a paint sample from the hardware store works well for this).

Sensor dust can be very frustrating, and is mainly a problem for digital SLR (D-SLR) users since the sensor is open to the air every time a lens is changed. Many cameras have built-in dust removal features, and you can also take your camera to a certified repair center for a professional cleaning.

DUST CHALLENGES

Dust is a problem for digital cameras. On a sensor it creates unwanted spots, which are very noticeable on the image in light areas such as sky. Most non-D-SLR cameras have fewer problems with sensor dust because you cannot remove their lenses. Still, in dusty, windy conditions, dust can get on their sensors, too, as these cameras are not completely sealed against such conditions. The only way to get dust off of these sensors is to send the camera in for repair or cleaning.

D-SLRs have an additional challenge—interchangeable lenses. Every time you take a lens off a camera and put on a new one, you increase the possibilities of dust getting onto the sensor. (Technically the dust is on a protective piece of glass in front of the sensor, not the sensor itself.)

A number of cameras now have built-in dust removal capabilities. These cameras employ sonic vibrations to knock dust from the sensor, anti-static coatings on the glass over the sensor, and vibrating sensors to shake the dust off. All of these options help decrease dust problems.

What if you don't have one of these cameras? What can you do about dust? Frankly, even if you do have a camera with dust removal capabilities, you are going to keep your dust problems to a minimum if you follow some of these steps. Here's how to keep dust spots from appearing in your photos:

Changing lenses: Be careful about how you change your lenses. First, turn off the camera. This shuts off power to the sensor and lessens any possibility of a static charge that might attract dust. Also, change lenses quickly. Keep the time a lens is off the camera to a real minimum. Have the new lens ready before you take the camera lens off so the new lens can go on the camera immediately. Be very careful about changing lenses in dusty or windy conditions (you may be better off putting on a zoom lens in the car and leaving it on).

Keep your camera and lenses clean: Use a blower or a soft brush to brush off the outside of your camera and lenses. Use a slightly damp (not wet) cotton cloth to clean off the outer surfaces if you have been in dusty conditions.

Clean your camera bag: If conditions are dusty or dirty, or if you have been using a bag steadily over a period of time, get out the vacuum cleaner and thoroughly clean out that bag. If a bag gets beat up and really dirty, get a new bag.

Caution: If you are unsure about cleaning your D-SLR's sensor, do not take the risk. Take it to an authorized dealer for cleaning. It is better to pay someone to clean your sensor than it is to buy a new camera.

Clean a D-SLR's sensor I: This is something you have to be very careful of. You want to be sure you do not damage anything on or

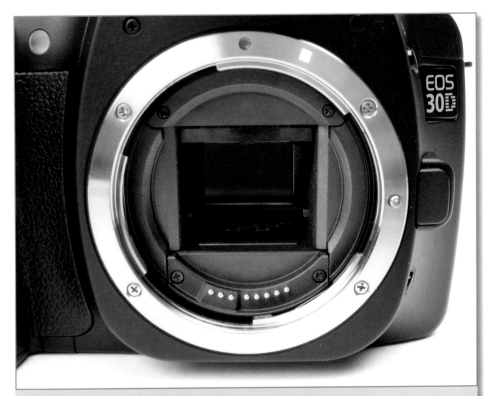

D-SLR users have the most to contend with when it comes to sensor dust. You can clean the camera yourself, carefully following the instructions in the camera manual, or you can take it to a professional. Remember, the sensor is the most important and delicate part of your camera, so be careful not to damage it.

around your sensor. Check to be sure it is needed, first, by this simple test: point your camera at blank sky and take a photograph of it with one stop over-exposure of the sky. Now look at that shot carefully—enlarge it, move it around in the LCD. Do you see any soft-edged black dots? Those are dust spots. If you don't see any, you don't have to clean your sensor (though it doesn't hurt to blow out the mirror area once in a while as described below).

Clean a D-SLR's sensor II: Follow the directions in your camera manual very carefully (and be sure your battery is fully powered). In general, take the lens off the camera (in a windless area, such as a room or a car), with the camera pointed down so the lens opening faces down (this minimizes the risk of dust falling into

the opening, and gravity may help remove existing debris). Set the camera to its sensor cleaning mode (usually in a set-up menu), blow out the inside of the camera with a strong bulb blower, turn the camera off, and put the lens back on. You can buy strong bulb blowers from a camera store or you can use a small plastic syringe. Be sure you don't touch anything inside the camera with the tip of the blower.

Caution: Never use compressed air; the propellants used can come out and damage a sensor.

4 CHAPTER

Exposure

Exposure was once a very real challenge for photographers. A hundred years ago, during the time of the first Kodak cameras, exposures were limited to bright sun without any other options. Fifty years ago, the average photographer might feel lucky if only 30% of their images were poorly exposed. The percentage of good shots would be higher for daytime, sun-behind-the-photographer light (which is where that old cliché of keeping the sun behind you came from), and much lower if the light was low or the camera looked toward the sun.

Today's cameras with their built-in exposure systems give good exposures most of the time, plus they offer options for dealing with exposure for different subjects. In this chapter, you'll explore what exposure is all about, how to ensure you get the best exposures, and how to make decisions about choosing f/stop and shutter speed.

Digital cameras now come with extremely sophisticated exposure systems, making it easy to use a preset exposure mode, or to set your own exposure on cameras with manual exposure capabilities. Photo © Robert Ganz

WHAT IS GOOD EXPOSURE?

Good exposure does many things:

◆ **Gives you the right image tonalities.** This means that the brightness of your photo shows off your subject in its best light (literally). It does not require a lot of work in the computer to look good (though you may want to enhance it there). Colors are appropriately bright; important colors and tones do not look muddy or washed out.

◆ **Strikes a balance between highlights and shadows.** Sometimes you will get good detail in both highlights (bright areas) and shadows (dark areas) of a photograph when the overall contrast of the scene fits the capabilities of your camera's sensor. In that case, a good balance means bright highlights and dark shadows

without either looking unnatural. In other conditions, the range of brightness in the scene may be greater than what your camera can handle. In that case, a good exposure avoids too many washed out highlights if highlights are critical to the subject; or it avoids dark, solid shadows if detail there is important.

◆ **Keeps noise to a minimum.** Underexposure always makes noise a problem. Noise is seen when dark areas are brightened. It was there all the time, but a properly exposed photo keeps dark areas dark, so noise stays hidden. When light areas are dark from underexposure and have to be lightened, then noise is often revealed.

WHAT AN EXPOSURE METER REALLY DOES

Okay, quick question (and a bit of a trick question): what does an exposure meter do? It is designed to measure the light coming from a scene and give you an exposure, a combination of shutter speed and aperture that lets in a precise amount of light through the lens in order to create some sort of image from your sensor. Note, though, I did not say it gives you a "good" exposure. The complete exposure system in your camera is designed to give you what it perceives as a good exposure, but that is still based on what the meter is actually doing.

What an exposure meter does is give an exposure to make whatever it sees appear as a middle gray tone (and color). A bright white sand dune will theoretically have the same gray value as a pile of coal, yet gray is not appropriate to either. This is where meters run into trouble—scenes that are mostly light or mostly dark. When the subject and its surroundings have mostly middle tones, there is never a problem.

An exposure meter cannot tell the difference between a scene in bright light from a bright white subject in dimmer light, yet both require different exposures. It also can't tell the difference

between a pile of coal in bright light from a twilight scene, which also require different exposures.

Camera manufacturers now design metering systems in cameras to try to compensate for this and make exposures more consistent. There is quite a variation among these systems from low-priced to high-priced cameras, plus there are definitely different design philosophies among the various camera manufacturers as to how to do this.

Later in this chapter, you will learn how to work with your camera and the built-in metering system to compensate for how it meters. Most of the ideas also work with hand-held meters, which are rarely used now but still have value for certain types of photography, such as studio work and precision landscape photography.

Bright whites can often fool the light meter in a camera. Be sure to check your LCD and verify you captured the exposure you want.

For now, keep in mind that light meters want to make bright scenes darker, so to compensate, you usually need to add exposure. Meters also want to make dark scenes brighter, giving them overexposure, so to compensate, you usually need to reduce exposure. A quick and easy way of doing that is with the +/- compensation feature of most digital cameras and then by checking the results in the LCD.

Lights at night can be a challenging exposure reading. Most light meters want to make a dark scene like this brighter. Use your exposure compensation feature to bracket your readings to ensure you have a good exposure.

TTL METERING

What it is: Through-the-lens (TTL) metering that reads a scene to give exposure information to the camera.

What it does: TTL measures the light coming from the scene as focused by the camera lens. This allows it to see what the sensor sees and nothing else.

Where it is found: This meter is usually based on a special sensor made specifically for exposure metering, and through some optical tricks by the camera designers, takes some light from the lens path in order to measure light coming from the scene.

What types are there: Most digital cameras use some variation of

TTL metering (except for some of the very basic, entry-level cameras). They vary from a single meter sensor to multiple sensors measuring many parts of the scene as imaged by the lens (these sensing points can reach over 1000 in some cameras).

TTL metering really changed the face of photography when it was first introduced in the 1960s. For the first time, the camera meter could measure exactly what the lens saw, which meant it could more accurately measure the light coming from the subject. The problem, at first, was that it saw the whole image area, and rarely was the light and brightness equal. A bright sky, even a small area of sky, could overpower the whole reading and create a less than perfect exposure for the subject.

METERING SYSTEMS

Camera manufacturers began adding multiple meter sensors to the image area in an effort to produce better exposures. One of the earliest types of multiple sensor metering systems, called center-weighted metering, is still available on many cameras today. This takes readings from across the scene but favors the central area for the composite exposure reading.

Some cameras also included partial or spot metering, also available in digital cameras today. These are isolated meters usually in the center of the image area. Partial metering typically measures a circle equal to a little under 10% of the scene, and spot meters read from just a few percentage points. Spot and partial meters are used to isolate readings to a very specific part of the scene or subject. In the past they required sophisticated interpretation of a scene by the photographer in order to use them effectively.

Manufacturers pressed on to develop new exposure systems that could give better exposures without requiring advanced metering education on the part of the photographer. Small computer chips that fit inside a camera started a new way of dealing with exposure.

This allowed for varied sensors placed across the image area and their readings were interpreted based on a number of factors. The camera could evaluate and compare readings, throw out small areas that were too bright or too dark, and find a much better exposure. This was not an average of readings across the scene, but an interpretation.

Today's multi-pattern meters have many

This series of images is an example of exposure bracketing. Some cameras allow you to set this automatically, so that each time you take a picture, the camera takes three exposures: the "correct" exposure, one stop overexposed, and one stop underexposed. You can also use the exposure compensation feature if you don't want to take three images each time you press the shutter release button.

sensors and, literally, the power of a small computer inside the camera to evaluate readings. Metering points now have extra credence if they match where the camera is focusing. Plus, they compare readings with databases of how scenes read with certain types of light so that an exposure can be created for the conditions. The computational power inside a modern digital camera is really quite remarkable and gives excellent automatic exposures with even low-priced point-and-shoot cameras.

Metering systems, along with the rest of digital camera technology, are advancing quickly. They read complicated lighting situations, expose for small areas, and use sophisticated processing tools to evaluate results.
Photo © Bob Krist

EXPOSURE CONTROLS

Exposure meters and their accompanying systems choose the correct shutter speed and f/stop to use in order to allow the right amount of light to strike the sensor, the right amount being what the sensor needs in order to create an image at a given ISO setting. A sensor has a given range of light that makes it work and our goal as photographers is to ensure that the light arriving at the sensor is within that range. The metering system will try to give that correct amount, but there are many combinations of shutter speed and aperture that can achieve the correct exposure.

Choice of a shutter speed/aperture combination can be totally automatic by the camera, or you can choose it directly or indirectly and still use the highly evolved, automated metering system in the camera. This choice strongly influences what your final image looks like, either indirectly by your choice of metering mode, or directly by your selection of shutter speed, f/stop, or both. Before we look at exposure system options, we need to look at ISO, shutter speed, and f/stop and how you might choose and use them.

ISO SETTINGS

What it is: A standard way of setting the sensitivity of a camera to light.

What it does: ISO settings adjust a camera so that high settings (such as ISO 800) make the camera more sensitive to light and low settings (ISO 100) make the camera less sensitive to light.

Where it's found: ISO settings are changed through a combination of a button and a dial on a digital SLR (D-SLR) or through a menu setting on other digital cameras.

An ISO setting on a camera provides the meter with a standard way of evaluating light based on a selected sensitivity to light. In the days of film, the ISO changed from film to film and reflected a measured sensitivity of film to light. With a digital camera, you select an ISO in the camera.

Technically, a digital camera's ISO setting does not actually change the sensitivity of the sensor, which is why it is an ISO setting rather than a true ISO number. Digital cameras adjust the "sensitivity" of the sensor circuits to settings that are compared to film of the same ISO speed by amplifying the sensor signal that creates the image.

One challenge with ISO settings is that higher settings will increase the appearance of noise. Different camera models respond

differently to how much noise is visible, however. Small-sensor cameras, especially the little pocket cameras, can be very sensitive to ISO change and you will notice noise quickly as ISO settings are increased. In D-SLRs with large sensors, you can often get very clean images with minimal to no noise at any standard ISO setting and low noise at high ISOs.

Regardless of the camera, however, low ISO settings consistently give the least amount of noise and the best color. Traditionally, film would increase in grain and decrease in sharpness with increased ISO. This is not entirely true with the digital cameras because their images are extremely clean at low and moderate ISO settings. Some increase in noise will be noticed at the higher ISO settings, but today's cameras offer excellent results at high settings, better than what you used to expect from film. This opens digital photography to new possibilities for using slow lenses (lenses with smaller maximum lens openings, which are usually physically smaller as well), shooting in low light, and shooting in natural light.

Low ISO settings show the best image quality, but even at high ISO settings, today's digital cameras show surprisingly little noise. This makes it possible to shoot in low light situations and use smaller lenses.

What it is: Shutter speed is the length of time the shutter is opened in order to let light in and strike the sensor.

What it does: Shutter speeds control the quantity of light hitting the sensor by changing how much time the light is allowed to strike the shutter. This can vary from tiny fractions of a second (e.g., 1/4000) to several seconds (e.g., 15 seconds).

Fast shutter speeds are necessary for stopping action. The quicker the movement, the faster your shutter speed needs to be to make a crisp, clean image.

Where it's found: The shutter is the device that opens and closes to create a shutter speed; this is usually either interlocking blades inside a lens that open and close (typical of most pocket digital cameras) or two curtains in front of the sensor that open and close separately (common to D-SLRs). A few cameras also include the ability to turn the sensor on and off to control the timing, but this is not a typical shutter. Shutter speed settings are usually chosen directly from a dial or buttons on the camera or using a menu on the LCD.

Shutter speeds influence time and how the camera sees time. Fast shutter speeds freeze time and let us see things that we cannot see with the naked eye. Slow speeds blend and blur action also showing us things we cannot see with the unaided eye, in this case, flow and movement patterns. Fast shutter speeds stop the movement of a subject (making it look crisp and sharp), plus they will stop any camera movement or shake during exposure (which dull an image and make it look fuzzy and "out-of-focus") to give you maximum sharpness from a lens.

Slow shutter speeds demand bracing or stabilizing the camera, otherwise blurry images result (a camera cannot be handheld). Slow shutter speeds allow small f/stops, increasing depth of field (greater sharpness in depth), but that increased sharpness is masked if the camera is not held absolutely still during the exposure. The ideal camera support for this is a tripod, though monopods, beanpods, and other stabilizing devices and techniques help. Moderate shutter speeds are in-between in all aspects. They often benefit from camera support, and proper camera holding (as described in the last chapter) is absolutely critical.

CHOOSING SHUTTER SPEEDS

The shutter speed you ultimately choose (or the exposure mode you choose that indirectly allows you to choose shutter speed) is affected by what you need to happen in your photograph. If you are handholding a camera, your shutter speeds will be limited to faster speeds that limit camera movement effects. If you need to portray action in a certain way, from perfectly arrested speed to soft blurs of movement, you must choose a shutter speed that controls that. The chart below will help you make these choices.

The speed of your subject affects the shutter speed needed to capture it. The angle of the camera to a moving subject also affects shutter speed; the same subject moving from right to left

Movement Speed	Shutter Speed	Use
(these are arbitrary groupings)		
Fast	1/1000 and faster	For high-speed action; fastest speeds stop very rapid action; camera shake during exposure is rarely a problem except for very big telephoto lenses; use these speeds to allow the use of a wide f/stop for special depth-of-field effects
	1/200-1/800	For moderate-speed action (high-speed action often blurs even if the rest of the photo is sharp); camera shake is rarely a problem with standard and wide-angle focal lengths (though it is an issue with strong telephoto focal lengths)
Moderate	1/50-1/160	Not action shutter speeds (unless the action is moderate to slow) as action will usually blur; camera shake now becomes a concern so good handholding technique is critical; telephoto focal lengths are rarely sharp when handheld at these speeds (camera movement is magnified by such lenses); these shutter speeds are often chosen to balance certain f/stop needs
Slow	1/40 and slower	Not for stopping action, but as shutter speeds slow, blur action becomes more interesting (this is strongly affected by the speed of the subject); very important shutter speeds for low light and small f/stops; few people can consistently handhold any of these shutter speeds and keep an image sharp (none can at slower speeds)

across the image area compared to moving toward or away from the camera will require different shutter speeds. The cross movement changes position faster than the to and from movement, therefore requiring a faster shutter speed to stop movement.

THE IMPORTANCE OF A TRIPOD

Maximum sharpness comes from using any camera/lens combination on a tripod. Period. If you aren't using a tripod, you either never shoot in conditions demanding slower shutter speeds or you are living with images that are not as sharp as they could be. I can guarantee that an inexpensive lens shot on a tripod will consistently beat the most expensive, highest rated lens that is never shot on a tripod. If you want to get the most from your equipment, at some point, you will need a tripod.

Shooting directly into the sun usually requires low ISO settings, small apertures, and fast shutter speeds in order to make a good exposure.

Choose a tripod by setting it up at the store, locking down the legs, and leaning on it. It should not bend or sway significantly; any movement more than a few millimeters will give you a less than stable tripod, which will not give you sharp images. Both metal and carbon-fiber tripods are excellent options. The advantage of metal is lower price; the advantage of carbon fiber is less weight.

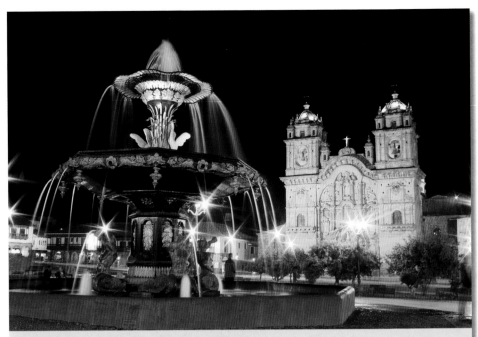

A tripod is almost necessary for a night shot like the one above. Long shutter speeds combined with small apertures make for stunning images such as this, but only if the image's sharpness is not compromised.

A tripod also needs a sturdy head to go with it. Pan-and-tilt heads have many levers to lock and unlock, compared to a ballhead that has a single main knob or lever, but the pan-and-tilt has two advantages: lower price for equal stability and easier to set a camera into position without the camera and lens taking off on its own.

The ballhead is much more convenient for setting camera position, but since the lock tightens and loosens all dimensional movement, there is more potential for sudden change in unexpected directions. Smaller ballheads are not very useful for stabilizing a heavier camera such as a D-SLR. You can get very lightweight, yet large enough, ballheads. Buy ballheads with a quick release, and then get extra release plates for all the tripod sockets on your cameras and lenses. Quick releases make tripods so much easier to use.

Compact portable tripods are also a good option, especially if you are traveling and cannot spare the cargo space for a heavy-duty

tripod. Many manufacturers have their own versions, but the main features are common to most. Compact tripods usually extendable and retractable legs for easy portability, they are very lightweight, and can be used with any camera that has a tripod mount. Compact tripods are also available in metal or carbon fiber, or other less expensive materials. Take your camera with you when choosing a tripod—you can test it on site with your own gear to make sure it will work for your specific needs.

APERTURES, F/STOPS, AND LENS OPENINGS

What it is: Apertures, f/stops, and lens openings all refer to the same thing—a variable opening inside the lens that affects the quantity of light hitting the sensor.

What it does: An aperture changes in diameter to let in more light (wider opening) or less light (narrow opening) through the lens (this is also called an iris diaphragm since there is a multi-leaved diaphragm that opens and closes like the iris of an eye).

Where it's found: The actual lens opening is inside the lens (with a few rare exceptions where the openings are changed at a lens surface); f/stops are typically set from a dial on top of the camera or through buttons using a menu on the LCD (older cameras had f/stop settings on the lenses themselves, and a few "retro" digital cameras have included such controls as well).

The aperture of a lens has a direct relationship to the shutter speed. If an aperture lets in more light, the shutter speed must be faster to ensure a correct exposure by limiting the time light hits the sensor. If an aperture is chosen that limits light to the sensor, the shutter speed must be slower to allow a longer time for the light to come through. So aperture obviously influences what shutter speed can be used. If you need a certain shutter speed to stop action or to create an interesting blur, then you must use the aperture that creates the right overall exposure. In

automatic exposure systems, this relationship is set automatically for you, but it is important to know that it is happening so you don't get surprised with an unexpected shutter speed or aperture.

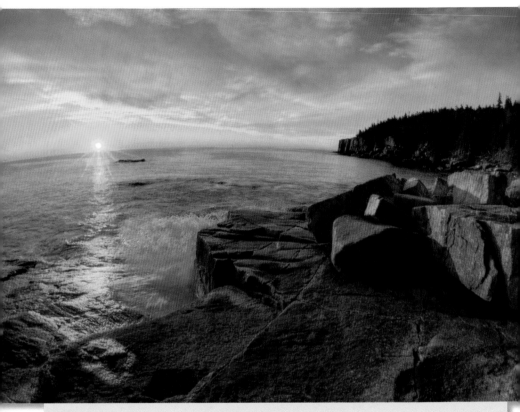

A small aperture for greater depth of field requires slower shutter speeds to make an accurate exposure. This landscape is sharp from front to back, showing that the photographer used a small aperture. Photo © Ferrell McCollough

Aperture also affects depth of field or the amount of acceptable sharpness from front to back in a scene. A narrow (or small) aperture creates large depth of field, while a wide (or large) aperture reduces it. Both are creative controls in photography. A large depth of field is very important for showing detail in a landscape, from the flowers in the foreground to the mountains in back, but can make an image confusing if you are showing a birthday girl blowing out candles in front of all her friends. In the latter

situation, you often want much less depth of field so that the friends' faces are not as sharp as the birthday girl, giving clear importance to the real subject of the shot.

The following chart will give you an idea of how apertures affect your photography. Keep in mind that apertures (f/stops) are relative—it helps to compare them to each other. A single f/stop is only smaller or larger than another when there is another to compare it to. A whole f/stop change either doubles or halves the light coming through the lens—if the aperture is larger the light is doubled, if smaller the light is halved.The largest or widest f/stop of a lens is also called the maximum f/stop and is the f/stop listed with the focal length of a lens: 105mm, f/2.8. You will see two numbers on some zooms: 18-45mm, f/3.5-5.6. This means the

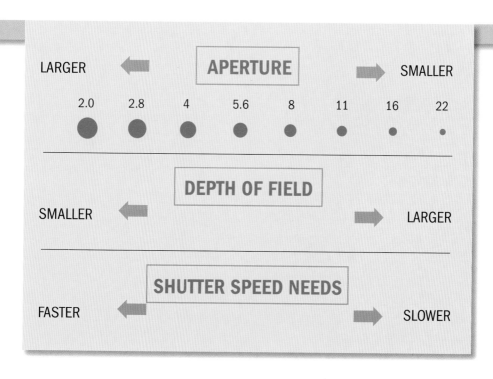

lens has a variable aperture that changes with the focal length, i.e., 18mm has f/3.5 and 45mm has f/5.6 in this example. The smallest f/stop for a lens is also called its minimum aperture.

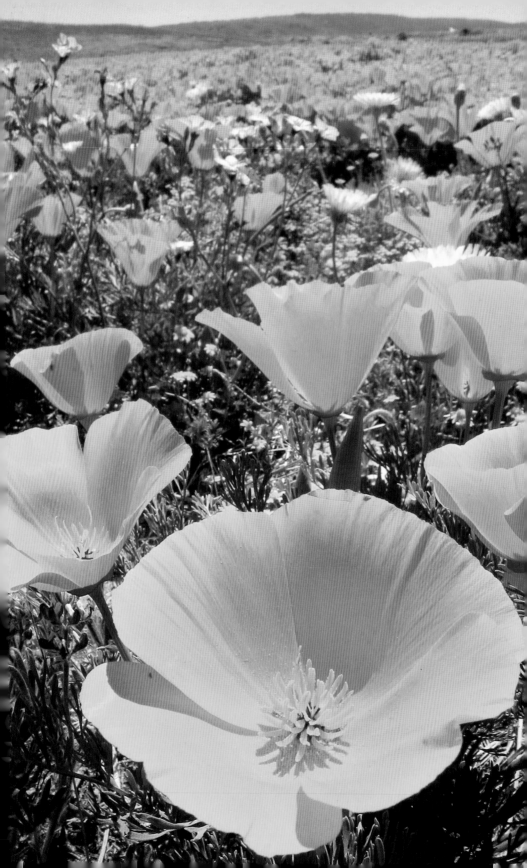

Technical note: f/stops can seem confusing because smaller f/stops have larger numbers, but you can memorize what they do in terms of depth of field and shutter speed. You don't have to know the industrial formula behind them. However, f/stops are technically reciprocals based on a relationship of focal length and lens opening size, so in reality, f/22 is really 1/22, but the reciprocal is never used.

THE RELATIONSHIP BETWEEN SHUTTER SPEED AND F/STOP FOR EXPOSURE

As f/stops and shutter speeds change, they need to balance each other so that the overall exposure stays the same. In other words, if a shutter speed is changed to decrease the time light can hit the sensor, the f/stop has to change, too, in order to increase the amount of light coming through the lens in a precise amount to compensate for the shutter change.

Generally, we talk about changes of f/stop and shutter speed as steps, with a full step equal to a full f/stop, either doubling or halving the exposure. Full f/stops are seen in the chart on page 103, while shutter speeds can be compared by their speed, for example, 1/125 to 1/250 halves the exposure, while 1/125 to 1/60 doubles it (cameras will sometimes show shutter speed without the reciprocal, so 125 is actually 1/125).

Examples: If you change the shutter speed from 1/250 at f/8 to 1/500, then the aperture would have to be f/5.6 (the shutter

Many digital cameras have autoexposure modes that automatically choose the f/stop and shutter speed for the subject you are photographing. The portrait mode chooses large f/stops to limit the depth of field, while the landscape mode chooses small f/stops to increase the depth of field.

This photograph shows a small depth of field that focuses the viewer's eye toward the subject. Small depth of field is a good way to create a contrast in an image, especially one like this where the colors of the background and the subject are so similar. Photo © Jack Reznicki

speed halved the light, so a compensating doubling of the light is needed with the f/stop). If you change the aperture of f/11 at 1/60 to f/5.6, then the shutter speed would have to be 1/250 (the aperture change increased exposure by a factor of 4, so the shutter speed has to compensate with 1/4 the speed).

This is done automatically with autoexposure (discussed next), but once again, it is important to know this is happening so you don't get surprised with an inappropriate shutter speed or the wrong depth of field (from the f/stop change). If you shoot in manual exposure, you need to do these compensations yourself. Most digital cameras allow you to change both aperture and shutter speed in fractions of a full step (typically 1/3 or 1/2 steps).

AUTOEXPOSURE (AE)

What it is: Exposure systems that calculate and set shutter speed and/or f/stop for a camera automatically.

What it does: These systems examine multiple points across an image area; compare them to each other, the metering distance, and to a database of exposure information; then tell the camera what values to set shutter speed and f/stops.

Where it is found: AE systems are dependent on metering sensors somewhere in the light path from the lens (in most cameras) that send the information to computer chips inside the camera body to process the data. AE systems are usually set from dials on top or the back of the camera, though some compact cameras do all settings through menus on the LCD.

What types of AE are there: All advanced digital cameras have at least three types of autoexposure: program, aperture priority, and shutter priority. In addition, many digital cameras include special program modes for specific types of photography, such as macro, portraits, night, and sports.

Here's an overview of AE modes and how you might use them (shutter speed and aperture or f/stop choices will be covered later in the chapter):

PROGRAM (P)

In this type of autoexposure, the camera chooses the shutter speed and aperture (f/stop) for you. It often has two variations, a basic or full-auto program that cannot be adjusted and a shiftable program mode. In the shiftable mode, the shutter speed and/or aperture combination can be "shifted" for a single exposure (or sequence) so that you can exert some control over shutter speed for action or f/stop for depth of field while maintaining equivalent exposure. Program mode is for those situations where you need

to shoot quickly and get a good mix of shutter speeds and apertures. Full-auto program also usually means you can't change things at all on the camera (such as white balance), so it is of less use to the photo enthusiast. It is perfect, however, when you are having someone else (a non-photographer) take pictures and don't want to worry about them using the wrong settings.

APERTURE PRIORITY (A OR AV)

In this mode, you select the aperture (f/stop) and the camera chooses the appropriate shutter speed to give you the right exposure. Most cameras can select that shutter speed in very precise steps to match the aperture for the right exposure. Aperture priority can be used to select an f/stop for high depth of field (small aperture), selective focus (the widest aperture a camera has for very shallow depth of field), or anything in between. It also guarantees you are using the fastest shutter speed possible for a given condition; this happens when you select the widest aperture of the lens, which then allows in the maximum amount of light and requires the fastest possible shutter speed to compensate for that f/stop. As the light changes, the camera will keep choosing the fastest shutter speed. "A" refers to Aperture, while "Av" stands for Aperture Value.

SHUTTER PRIORITY (S OR TV)

In this mode, you choose the shutter speed and the camera selects the appropriate f/stop for the exposure. You would use this mode to select a fast shutter speed for action, a slow shutter speed for blur, or a shutter speed that would guarantee you would have no problem with camera movement during exposure (such as 1/125 sec. for standard focal lengths). "S" refers to Shutter speed, while "Tv" stands for Time Value.

In aperture priority mode, you choose the appropriate f/stop and the camera will choose the correct shutter speed.

PROGRAM MODES

Many so-called "consumer" digital cameras, which include both D-SLRs and compact digital cameras, have a series of program modes that are designed to simplify exposure choices for specific subjects (often other functions are affected as well, such as ISO settings, white balance, drive settings, and focus—your camera manual gives specifics for your particular model). These program modes make certain exposure choices easier to apply, but they usually do not allow much flexibility to tweak them for specific situations.

Portrait mode: Usually this one chooses a wider aperture to limit depth of field and keep the subject sharp while letting the background go out-of-focus. Some cameras will also select a telephoto zoom setting and/or a warmer white balance setting.

Close-up mode: The camera will usually select a wider f/stop for faster shutter speeds to ensure good sharpness with a handheld camera as well as for less depth of field so you set a sharp subject off against a softer background.

Landscape mode: The camera favors small f/stops for more depth of field (often important for scenic shots), plus the camera will often choose a more saturated color setting.

Sports mode: The camera chooses fast shutter speeds to stop action, including using higher ISO settings to allow faster speeds.

Night flash mode: This mode combines a flash exposure on the subject, and then combines that with an overall exposure to balance the background, bringing in its detail.

The portrait mode aims to create an effect similar to the one shown here. The subject is sharp and the background is out-of-focus. Many digital cameras have exposure modes that will do this automatically.
Photo © Bob Krist

MANUAL EXPOSURE

The manual exposure (M) option is often used by long-time photographers who are used to working in manual without AE. I would suggest, though, that every photographer at least try the automatic settings on his or her camera at times to see what they can do.

You will often find that they give accurate exposures faster than going through manual.

Manual exposure is helpful in tricky situations. In this exposure mode, you set both the shutter speed and aperture yourself at anything you would like. You can use some of the exposure metering systems of the camera (though you usually can't use a multi-point evaluative type of metering system in manual). You then use an exposure scale usually somewhere in the viewfinder or on an LCD panel. Correct exposure will usually be at the mid-point of the scale (though cameras use different sorts of ways of showing this and it isn't always a scale).

You can see how much the exposure settings vary from what the meter says is right for the scene by observing the scale. This allows you to add or subtract exposure as appropriate to compensate for bright or dark subjects (especially when using partial metering). Many cameras will show up to two f/stops over or under the mid-point.

A number of complex metering conditions might require you to use the manual mode: panoramic shooting (you need a consistent exposure across the multiple shots taken, and the only way to ensure that is with manual); lighting conditions that change rapidly around a subject that itself has consistent light (a theatrical stage, for example); close-up photography where the subject is in one light but slight movement of the camera dramatically changes the light behind it; and any conditions where you need a consistent exposure through varied lighting conditions.

THE MAGIC OF THE HISTOGRAM

What it is: A visual indicator of exposure as seen in brightness values of pixels.

What it does: A histogram plots the number of pixels per brightness value, starting with black on the left and ending with white

on the right; it can help you evaluate an exposure for its effects on dark and light areas.

Where it's found: Not all cameras have histograms; those that do display it on the back LCD of the camera in certain display modes. Camera manufacturers haven't made finding the feature consistent, so check your camera's manual to see how to turn it on. In D-SLRs, it is only displayed on review when looking at already shot photos; in other digital cameras that have one, it may appear only in the LCD review mode, but some cameras can display it over a live image.

How it differs: Most histograms are luminance or brightness histograms, which are the easiest to read and interpret for most photographers (and what will be covered here). Some cameras offer color or RGB histograms; these show brightness values for each color channel and are used to interpret how a camera is capturing a scene in terms of color (used by commercial and advertising photographers).

I believe the histogram is a truly great innovation for digital cameras. Sure, it sometimes looks a little intimidating; it was never part of film photography and it certainly doesn't look very creative. It is a graph based on mathematics, but to use it you don't have to know anything about math. You can read it without understanding more than the basics of how it works. You don't need to use a histogram for every image, but if you check it for critical photos when the light is tricky, it gives you important information about an image's exposure.

The histogram is a chart that looks like a hill, mountain range, or multiple hills. Some histograms are solid graphs, while some just show a line where the top of the graph is—both are identical in use with different displays. To read exposure, begin by looking at the left and right parts of the chart. The left shows the darkest parts of the scene and the right displays the highlights. The entire width of the graph represents the total range of tones that your sensor is capable of capturing. Anything beyond the left edge is

Notice the histograms for these two photos. When an exposure covers the full range of tones, it is spread across the entire chart area (left). The image below is overexposed; notice that the left side of the histogram drops off, while the right side spikes up.

pure black, outside of the range of the sensor, so nothing is recorded in those shadows. Anything beyond the right edge is pure white, and again, outside of the range of the sensor.

A good exposure will have a full range of tones from left to right appropriate to the scene, yet there's no "right" shape to the histogram. That will change depending on the light and tonalities in every unique scene. The key, though, is to be sure no important exposure information is clipped at the right or left (visible if graph

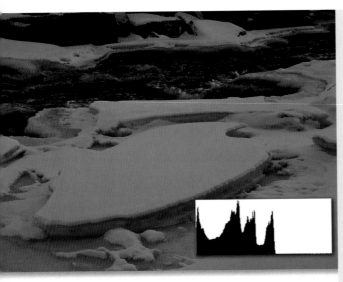

A histogram for an underexposed image will have most of its data on the left side, shown here. Scenes that are dominantly white, such as snowscenes, can fool the light meter. The exposure system wants to make a bright scene darker. In the image on page 115, the histogram shows gentle slopes on each side of the graph. This shows that the image has a complete tonal range, and is well-exposed.

is abruptly cut off). A cutoff or clipped histogram means details weren't captured at all.

That ideal isn't always possible, however. Some scenes simply have too great a contrast range for your sensor, which will result in clipping at either the left or right (or both) because your camera can't do anything else. You may have to decide what's most important for your scene—highlights or shadows—and be sure the histogram isn't clipped at that end. Bright, specular highlights from reflections of glaring lights probably should be pure white, for example. Or the darkness of a deep shadow might look just fine as black.

Underexposure will show up with little or no data on the right side of the chart, while the rest of the data is skewed to the left. Often, the hill at the left is cut off sharply at the far left edge and there is a large gap in the graph at the right side. This illustrates two major problems: less detail and color in the shadows (even if it is adjusted in the computer) and noise. Underexposed, dark areas often pick up annoying and distracting noise. The correction is fairly easy: add exposure.

Overexposure demonstrates the opposite. You'll find little or no data on the left side of the chart compared with the right, including

a gap there, plus the right side is often cut off sharply. That cutoff is a real concern, since those areas of exposure beyond that level are washed out and appear blank in the photograph. The correction: subtract exposure.

A low-contrast scene shows something entirely different. Typically, it will have a histogram with an entire hill of data well within the left and right borders. Gaps are seen at the left or right side or even both. This is a challenging histogram because often it needs

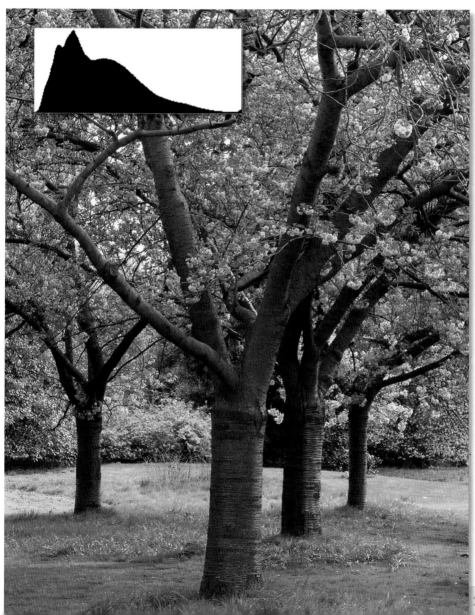

to be stretched in your image-processing program. That stretching can cause problems with tonalities banding because not enough data may be present to support all the tones. This is a good situation for a RAW capture, since it allows stretching the tones without damage to the image.

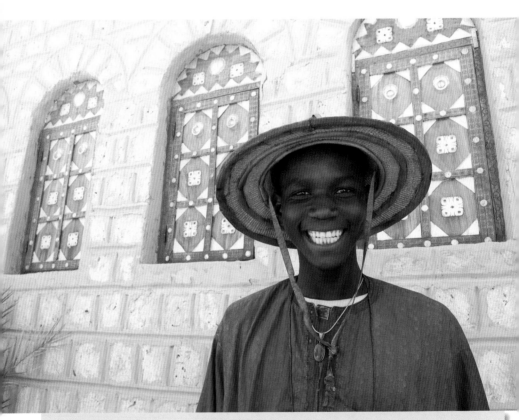

This image is exposed well for light, dark, and medium tones. If you aren't sure whether you have captured the full gamut of tones in an image, you can check the histogram. Photo © Bob Krist

Overall, you want your photo to display a histogram that slopes down as close as possible to the most important brightness values of your photograph. If the highlights are critical, then the slope must end at or before the right side. If the shadows are essential, then the slope must favor the left side. This is critical in getting an image with proper data into your computer.

There are no absolute rules for using a histogram. Every scene is different. You'll need to interpret the histogram as it relates to the scene in front of you and what you believe is a good way of seeing the scene. It's worth experimenting, since there's no cost to taking extra shots in digital. Try different exposures and see what they look like on the histogram to learn how this function reads various scenes.

FIXING EXPOSURES

While autoexposure (AE) systems work very well and give excellent exposures, you will find that certain situations give poor exposures. The histogram helps you see this. To fix such exposures, use some sort of exposure compensation. One solution is to use manual exposure and try several different exposures (called bracketing), then pick the best one later.

But nearly all cameras offer exposure compensation. Paired with the ability to review the histogram and image in the LCD Monitor, you can quickly get good exposures without using manual. Compensation is applied to the exposure through a dial, buttons, or menu, usually showing up as some sort of +/- control. Increase or subtract exposure in increments of 1/3 or 1/2 stops up to whatever the camera's range allows. You usually see the exact exposure compensation on the scale at the bottom of the viewfinder and/or on the LCD panel.

It is important to remember that once you set your exposure compensation control, it stays set with most cameras even if you shut off the camera. Make it a habit to check your exposure setting when you turn on your camera to be sure the compensation is not inadvertently set for a scene that doesn't need it. With experience, you will find that you use exposure compensation routinely with certain subjects. Remember, the meter wants to increase

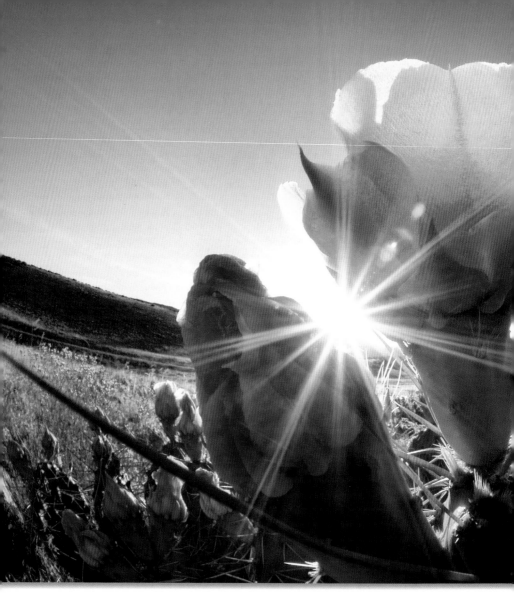

exposure on dark subjects and decrease exposure on light subjects to make them closer to middle gray. For this reason exposure compensation may be necessary by giving less exposure for dark subjects and more for bright subjects.

The LCD monitor comes in handy when experimenting with exposure compensation. Take a test shot and check the photo (and, if available, its histogram). If it looks good, go with it. If the scene is too bright, subtract exposure; if it's too dark, add it. Again, remember that if you want to return to making exposures without using compensation, you must move the setting back to zero.

Use your LCD review feature often if you are unsure of how your image will be exposed. The exposure compensation feature on some digital cameras is extremely helpful in fine-tuning your image results.

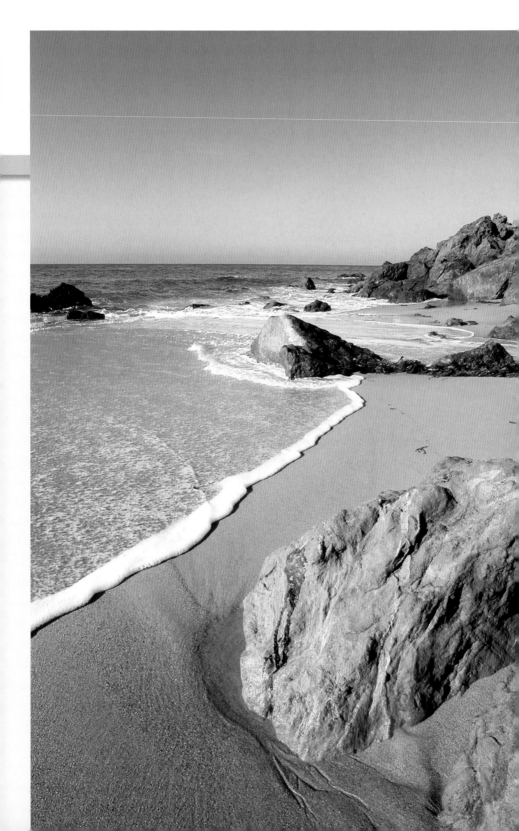

5 CHAPTER

Daylight Photography

Daytime photography has traditionally been the easiest way to get quality images. In fact, for George Eastman's early Kodak cameras, daylight was the only way to get quality images. Today's digital cameras give many more options for very high-quality images at any time of day, in any kind of light.

Daylight can offer us stunning light and color, but it can also create harsh and ugly shadow conditions. Daylight can make a face glow or it can cast unflattering shadows. It can bring a landscape to life or make it look dead and lifeless. By understanding a bit about daylight, you will become aware of its affects so that you can better use daylight in your photography.

Light is a very strong part of a photograph, yet when taking pictures, many photographers see only the subject. It is easy to be overly influenced by what the subject is compared to what the subject looks like in the light. Light has a huge effect on how a subject looks in a photograph.

Daylight photography is one of the most common types of photography, but there are several variations on what daylight consists of. The light can be sharp or diffused, warm or cold, among other differences.

One thing that quickly lifts the level of your photographs comes when you see the light, literally. This chapter will help you see light in a variety of ways. As you look at the photos and read the ideas in the text, start separating yourself from the subject. Sure, the subject is important, and you should always be concerned

about it, but in order for the subject to look its best, you must see what the light is doing to the subject.

Light can compete with the subject if you are not careful. It can distort, hide, and change a subject's appearance in ways that do not help your photo. It is much easier to see your subject in real life. The human eye automatically adjusts to any type of condition without our awareness. You or the subject may move, changing visual references, colors, and dimensions. Our eyes accept and adjust to these changes, but the camera does not. Because we can see the subject well does not mean the camera can, too. Light has a big impact on this. Photographers must learn to read the light as the camera does.

Though light can cause problems in a photo with your subject, light can also complement and support the subject. It can enhance, brighten, enrich, dramatize, and affect the subject's appearance in very positive ways. But the only way you can gain the positive effects and avoid the negative effects is to see the light and what it is doing to your scene and subject. You can never go back to just having "enough" light—that's for the photographers of George Eastman's time!

DAYLIGHT

What it is: Daylight is any light that originates from the sun and occurs naturally during the day.

What it does: Daylight is the primary and most popular light for photography because it illuminates subjects and their environments in ways that meet our expectations for light.

Where it is found: Daylight comes directly from the sun, diffused through clouds, reflected from the sky, reflected from bright surfaces (such as a wall), and so on.

What types are there: Daylight can be harsh or gentle, warm or cold, flat or directional. It has many variations.

Now let's look at some daytime light conditions and what they can do for your photography.

BRIGHT SUN ON A CLEAR DAY

Bright sun on a clear day is a high-contrast light and creates sharp shadows and highlights.

When the sun is shining and the air is crisp and clear, you find some of the most brilliant and clean light possible. It is also creates the most contrast.

This light is specular light, and crisp day sunlight is about the most direct there is. It comes from a very small light source (the sun is actually quite big, but it is so far away that it is a very small, bright light in the sky). This light precisely places highlights and shadows on the subject. Even a slight change in camera position dramatically affects relationships of light and dark areas, which means you need to select your camera position carefully.

Specular sunlight creates very sharp shadows, sometimes making them quite

interesting subjects for a photograph all by themselves. This edge between light and shade is dramatic and contrasty, and results in extreme exposure challenges. It is often not possible to expose for the sun properly and get any real detail in the shadows. The shadows quickly obscure and hide visual information (which can be a good thing if there is something in the background behind your subject that needs hiding).

A subject's outlines can be totally obscured by a bright sunlight. This happens when highlights, the brightest parts of the photo, strongly favor one part of the subject, while deep shadows envelop another part, literally splitting the subject in two.

Bright, clear sun is good for action photography since you can use fast shutter speeds and still have enough light to expose the photo properly.

On the other hand, that interplay between light and shade can make for most interesting photos. In these conditions, sometimes the shadows are so strong that they make interesting subject matter all by themselves. Or you may find that the drama of this light can be captured to make a dramatic image, too. Bold colors are featured and highlighted by bright sunlight. Subtle colors can be obscured.

The key to working in bright sunlight is watch those highlights and shadows and be aware of where they are in your frame. You must be sure the important parts of your subject are in the highlights and you expose for them. Exposing for the shadows can get you

into trouble with washed-out, ugly bright spots in the photo. You can also play with dramatic light that uses washed out areas as important graphics in the photo, not problems that happened because of not-so-perfect exposure. Photography should never be so cut-and-dried that some "rule" keeps you from creating interesting photos.

In bright sunlight, you must scan the brightest areas and base your composition on them. Often, you cannot use a composition based simply on the subject and its surroundings because the light does not always complement it.

Great subjects for bright sun:

◆ **Landscapes** (early or late in the day)

◆ **Beach and snow scenes** (the lively contrast of light and shade makes these scenes come to life, plus the shadows show nicely on sand and snow)

◆ **Architecture** (light and shadow define planes and textures in a building)

◆ **Travel photography** (light and shadow define and enliven big subjects such as historic buildings, town squares, and so on)

Challenging subjects for bright sun (challenging subjects mean that you have to be especially careful how you photograph subjects in this light and you may find that these subjects are not worth the effort in this light):

◆ **Portraits, flowers, and wildlife** (the light is harsh and unforgiving)

OPEN SHADE

Open shade is the condition of light you find in shade that is open to the sky on a sunny day—that's where it gets its name because when you are in this shade, you can see the sky, making it "open"

Open shade is much softer than bright clear sun, and has gentle highlights and shadows. Open shade can be found on most bright, clear days, so if the direct sunlight is too much, look for a shady alternative.

to that sky (as compared to shade under a tree, for example). This is a radically different light than bright sunlight. It is a very important light because it is always available on a sunny day. If you don't like the specular sunlight, often you can find a big chunk of open shade that will give you entirely different results.

Open shade light is sky light. It comes from an expanse of sky as compared to a point of light from the sun. When you are in open shade conditions, some of the sky is blocked and this affects how large an area of light is affecting the subject. As the size of the light increases, it has less direction and gives a softer quality to the highlights and shadows. This makes highlights and edges of a subject quite soft and beautiful. Anything that is shiny or reflective gains more of a shape in this light because it will reflect the large light source (the sky) over its whole surface rather than just a spot of light from the sun.

Open shade is a flattering light for people photography.

In open shade, you find that shadows are far less distinct, though exactly what the shadows look like depend on how large the open sky is that is creating that light. Shadow edges become less distinct as the sky area gets larger, and as that sky decreases in size, shadows become more prominent. Regardless, all shadows have soft, blended edges in this light.

This makes this light very flattering for people as it softens shadows and highlights on their faces (plus they won't squint from the sunlight). It actually works quite well with any subject that has subtle tones and colors that are easily obscured by strong light and shadow effects. Bold colors can actually be toned down with this light (which may or may not be good—that depends on your subject).

Another important characteristic of open shade is its color. When there are few or no clouds in the sky, this light is very blue. This makes a digital camera's white balance setting important. Auto white balance often misses the best color in these conditions. Use Shade or Cloudy preprogrammed settings to warm up the subject and remove the blue. Our eyes compensate for the blue

light so we don't really see it—a camera does. As clouds increase in the sky, they reflect light from the sun into the shade, warming it up and making blue removal less important.

Sunrise and sunset make an interesting variant of this light. While the sun directly produces very warm light at this time, the sky above open shade is often very blue, giving the shadow light an even stronger blue cast. If you want to remove that, you may need to use a manual white balance setting. An interesting way to work this light is to photograph a scene with both the open shade light and the direct sunset light, creating a strong cold and warm color contrast. Clouds, reflective white buildings, or cliffs often reflect a warm light into the shadows.

Good subjects for open shade:

◆ **Portraits** (really excellent—also look for some direction to the light when the sky is blocked in certain directions)

◆ **Groups** (of people, objects—this light makes it much easier to see all elements more easily in the photo)

◆ **Flowers** (watch out for too much blue, though)

◆ **E-bay photos** (the open quality of this light shows off details of products so potential buyers can better see them)

◆ **Waterfalls** (they can get quite harsh in bright sunlight—open shade evens out their tonalities better)

Challenging subjects for open shade:

◆ **Architecture** (not enough contrast to readily define building elements)

◆ **Sand and snow scenes** (the light is so open and enveloping that it is hard to see distinct picture elements)

◆ **Landscapes** (in open shade elements will lose texture and dimension)

HAZY SUN

Add some light clouds in the sky and the sun gets hazy. This spreads out the light and changes how it affects a scene. The sun becomes less direct and becomes diffused. In addition, the clouds themselves reflect light from other parts of the sky into and around the scene. This light can vary from a very slight haze (such as a hazy summer day that just barely spreads the light from the sun) to a cloud that almost obscures the sun (you can still see the sun, but now the light is really diffused and spread out around it).

A hazy sun definitely affects the highlight/shadow relationship. There is still a distinct shadow, but it is softer than in bright light. You will often hear diffused light called "soft light." In large part, this is because shadows do not have the hard edge of bright sunlight. The more diffused the light, the greater the haziness in front of the sun, the softer shadow edges become. This has a huge effect on how your subject and scene appear in a photograph.

Additionally, the contrast between highlights and shadows lessens, softening the overall look of the photo—another reason the light is often called "soft." This greatly affects the impact of an image. Bright sunlight is dramatic. Hazy sunlight is much less so, having a gentler effect on your subject.

Still, hazy sunlight is a directional light. It might not be as strong as bright sunlight, but the relationship of dark and bright

Hazy sun light is softer and more diffused, and therefore has less contrast.

parts of a scene are strongly tied to the position of the sun. Camera position is still important, though you may find you have to make a more drastic position change to really affect the photo.

Many of the good and bad things that come from bright sunlight apply to hazy sun, but now the light is mellowed a bit. Shadows are rarely a great subject on their own now, and a subject's shape is easier to see and understand because the highlight/shadow edges are not as strong. Colors are affected depending on the degree of the haziness. Less haze and bold colors are strong. More haze and bold colors are toned down, while more subtle colors show better.

Still pay strong attention to where the highlights are in relation to important parts of your subject. Those areas dominate an image and grab a viewer's attention no matter what your subject is. Expose for important highlights so that they are not washed out. Washed out highlights really hurt an image taken in this light.

The more haze you have in a situation, the more subtly colors appear. This can be very effective with a moody shot, such as the one above.

Good subjects for hazy sun:

◆ **Travel** (there is enough dimension to the light to give texture and form to subjects, yet is not so harsh as to obscure important colors or details; also, this is a more forgiving light when you are traveling and don't have a lot of options as to when you can photograph)

◆ **Wildlife** (the softer light helps fur and colors show better, yet the directional quality of the light gives form and texture)

◆ **Sunrise and sunset scenes** (haze often intensifies the colors)

◆ **Colorful outdoor events** (like fairs—this light opens up shadows so colors and textures appear more vivid and clear, yet you still have a direction to the light for more dimension to an image)

Challenging subjects for hazy sun:

◆ **Portraits** (the light can still be harsh and unforgiving, though the softer the light, the better this becomes)

◆ **Landscapes** (landscapes start to lose their "pop" and life when shadow and highlights lose their contrast, plus skies look dull)

◆ **Architecture** (buildings often need a strong and bold directional light to make forms and textures stand out)

CLOUDY BRIGHT LIGHT

When clouds fill the sky and totally obscure the sun's position, but are still bright and light, you have cloudy bright conditions. The sky might be a little brighter in the direction of the sun, but you cannot see any sign of the sun itself.

This is a very diffused light. The light becomes, in a sense, the entire sky itself, resulting in a more or less direction-less light (except from above). No matter where you go in relation to the subject, the light and shadow stay pretty much the same.

Actually, it might be better just to say the lighter and darker areas rather than light and shadow, since shadows pretty much disappear except on the underside of subjects. The few shadows that do appear have such soft edges that it is hard to see where the shadow begins and the highlight ends. It is gentle rounding of tonalities from light to dark.

This is a very low contrast light because the shadows are being filled with the light coming from everywhere. Don't be fooled, though, into thinking that cloudy bright will always give low contrast. That happens when your subject is illuminated by a very large expanse of sky. If a tall building or a cliff blocks the sky in some direction, then the light becomes more directional and gains contrast.

This light is a bit bluish and unattractive for some subjects. Use the Cloudy or Shade white balance presets on your digital

Diffused light highlights soft tones, gentle contours, and muted colors, such as in the above image. Photo © Robert Ganz

camera. I usually find auto white balance does not give the best color in these conditions.

This is a challenging light for digital cameras. Because it is generally soft and low in contrast, it frequently does not use the full capabilities of a sensor. No matter how you expose the subject, you may find it difficult to get a pure black or pure white. This can make digital images with less snap and color. On many digital SLRs (D-SLRs), you can adjust the camera's response to such conditions by changing its contrast and saturation settings (these affect JPEG photos and give instructions for RAW photos processed in the camera manufacturer's RAW software)—this is usually in the shooting menu on the camera (check your manual for specifics).

Otherwise, you will find some basic adjustments in the blacks and whites are needed in the computer in order to get the most out of your shot. This will be covered later in Chapter 13.

Cloudy bright is a very enveloping, soft light that features gentle contours and colors. It is not a light for drama and high energy. It actually tones down scenes that have those characteristics. Watch what happens when a cloud obscures the sun on an otherwise bright sunny day—that cloud now changes the scene to cloudy bright, lit by the cloud and sky. Cloudy bright is a light that opens up an image, revealing subtle colors and tonalities that are not seen otherwise. That also opens up textures, resulting in pattern details of a subject showing up as texture disappears.

Good subjects for cloudy bright conditions:

◆ **Portraits** (the soft shadow edges and spread-out highlights are very flattering)

◆ **Highly detailed scenes** (the details show up better when strong light is not obscuring them with contrasty light and shade)

◆ **Markets filled with competing colors and textures** (cloudy bright will tone them down)

◆ **Fall color scenes** (this allows the rich variety of colors to really start to glow instead of fighting light and shade contrast)

◆ **Scenes inside a forest** (forests are extremely difficult to photograph with bright sun; the spots of light are strong and the shadows are dark; waiting for a cloud to obscure the sun makes a big difference in what you can capture of the scene)

Challenging subjects for cloudy bright:

◆ **Architecture** (you lose definition and texture)

◆ **Strong forms in a landscape** (the forms disappear and blend into the rest of the scene because of the lack of a strong directional light)

◆ **Anything that has important textures** (textures need strong directional light)

HEAVY OVERCAST

As clouds collect and intensify, light levels drop and cloudy bright goes to cloudy dark. This can be a difficult light to use. It tends to look very heavy and gloomy, plus with brightness going down, exposures require higher ISO settings, slow shutter speeds, and/or wider lens openings.

Many pros avoid this light altogether because it really can dampen the life in a subject (and of course, if the clouds get too saturated in moisture, they will literally dampen the photography with a bit of rain). It is a very heavy light that is unflattering to most subjects (except when you want to show off a storm and its light, of course). The light has very little dimension or form to it, except for darkness under the subject, which tends to just add to the heaviness of the light.

Several things can help when you are photographing in these conditions. First, avoid auto white balance. I find it rarely gives the best colors in this type of light. You especially need to add some warmth to the photo, as the camera tends to see cooler and grayer tones than our eye. Add that warmth with a Cloudy or Shade white balance setting. Or try a pro's trick of using custom white balance and white balancing on a pale blue card (a blue paint sample card from the paint store works great)—the camera removes that blue and warms up the scene.

Second, if the subject is fairly close, try turning on your flash. The flash will often brighten and enliven a heavy overcast scene, bringing out colors that just don't register well otherwise. Even a built-in flash in a simple point-and-shoot digital camera often helps, but only if the subject is close enough. With more advanced cameras, try adding more or less light from the flash (by adjusting the flash compensation) for more creative control.

Third, check your camera manual to see if you can adjust things like contrast and color in the camera (as also noted in the section on cloudy bright light). You can often create custom parameters or shooting styles specifically for very cloudy conditions that will give the scene added energy.

Rain can add an interesting element to a cloudy day scene. This is the time many photographers put their cameras away, yet that rain can bring some special qualities to the photograph that will enliven a scene. Mostly it adds some sparkle and dimension to

highlights, plus larger wet areas reflect light. This is one reason why you'll see night scenes in Hollywood movies looking like it just rained—the crew wets down the streets for good reflections and highlights.

Good subjects for heavy overcast:

Unfortunately, not many except for rainy day images. It can be an interesting condition to use flash with so you can make a subject stand out from a darker background.

Challenging subjects for heavy overcast:

Most!

LIGHT DIRECTION

You probably noticed that light direction plays a part in all of the daylight conditions described so far in this chapter. Direction is an important quality of light and a very useful tool for getting great photographs. It is not, as you've seen, a key part of all lighting conditions, though it can often be modified with a little attention to the surroundings of your subject.

On a bright sunlit day, light has a very strong direction. It comes from a specific point and creates highlights and shadows that go in definite directions. Strong directional light helps create form and texture in a photo. Consider this—a photo is a two-dimensional object trying to show off a three dimensional world. Directional light will help create the illusion of three dimensions in that two-dimensional photo.

Light can come from all directions around a subject: front, side, top, back, and bottom. When we look at how light affects a subject, we refer to a light direction in reference to the subject, i.e., front light hits the front of the subject as we see it from our

This image of the Jefferson Memorial in Washington, D.C. uses a heavily overcast day to create drama and contrast in the photo. It was made with several exposures, and the photographer used HDR imaging software to create the final picture. Photo © Ferrell McCollough

camera position; backlight hits the back of the subject.

Light direction is always important, even when the direction is weak on cloudy day. Specular sunlight gives drama and strong direction. Diffused light weakens the direction of the light, but it still affects how you photograph a subject. You may look, for example, for any direction at all, such as when you bring a portrait subject into the shade next to a tree so that the tree blocks light from one side, which then results in a directional light from the other side. Or you may find that the sky is a little brighter in one direction, giving some dimension to a backlight.

Learning light direction and its effects on a subject really requires

you to take a lot of photographs in many different light conditions, including light that is less than flattering to a subject, just so you can see the effects of the light in a photograph. Edward Steichen, a famous photographer in the mid-1900s, was said to have

Light direction and placement are important aspects to consider when you are shooting with daylight photography. Pay attention to the shadows and the quality of the light to make the most of your shooting time.

photographed the same subject, a white egg and white saucer, over 1,000 times just so he would better understand light. I am going to give you a "cheat sheet" to help you better identify and use the direction of light. This is a simplified way of looking at light, to be sure, but it does point out how it changes as the direction varies on the subject. There are six major effects of light due to directional effects and the chart compares them. It is important to understand that there is no such thing as an

arbitrary good or bad light—it can only be good or bad in relation to a specific subject and your needs for a photograph.

Here are the effects of light as seen in the chart below:

Direction: This refers to how the light strikes the subject as you see that subject from the camera position.

Shadows: Shadows have a key role in how light direction affects a subject. Where they fall affects what is seen and emphasized in the photo.

Form: Light affects the form and shape of an object. This refers to how light affects the three-dimensional qualities of a subject and scene. For form and three dimensions to appear, you need a difference in brightness from one side of the form to another.

Texture: Texture appears when light hits the raised parts of a surface and shadow appears in the low parts.

Color: Color is strongly affected by the quality of the light (bright sun gives brighter colors than dark clouds), but it is also affected by light direction because color is different in the bright areas compared to the shadows.

Pattern: Color and tonal patterns in a subject need to be illuminated by light in order to be seen. They are easily obscured by strong directional light that features form or texture over this sort of detail.

Separation: Some light directions help separate a subject from other elements in a scene or the background. To create separation, you need highlights on the subject to contrast with shadows elsewhere.

Depth: Depth in a photo comes from the appearance of change from foreground to background. Light direction affects depth by creating planes of light and dark, separation, or even atmosphere in the air itself.

LIGHT DIRECTION AND ITS EFFECTS

Direction	Shadows	Form	Texture
Front	Shadows fall behind subject and have minimal effect	Flat light; not a light if you want 3D forms, but can be used to obscure strong forms	Removes texture (no shadow and highlight contrasts)
Side	Shadows fall to the side of the subject and have a very strong effect.	Form is very strong because the light and shadow effects are so strong.	Texture is at its highest, especially with a low, skimming side light.
Back	Shadows fall in front of the subject, toward the camera and have a very strong effect.	Form can be flat if the subject is in silhouette or strongly dimensional if the light is high enough to provide light and shadow on the subject.	None if the subject is in silhouette or high if the light is skimming the subject from behind.
3/4 Front	Shadows fall to the side and behind the subject. Important, but not dominate.	Form starts to appear because of light and dark, yet shadows don't dominate.	Texture starts to appear but is rarely strong.
3/4 Back	Shadows fall to the side and in front of the subject.	Form starts to appear because of light and dark, yet shadows dominate.	Texture can be strong in small areas of the photo.
Top	Shadows fall below subject and in depressions in subject.	Form appears and can be very strong.	Texture is high; can be almost as high as side light.
Bottom (rare outside)	Shadows fall above subject (Halloween lighting)	Form appears and can be very strong, but it can also be confusing because the light and shadows are not where we expect them to be	Texture is high, like top and side light, but can also be confusing because of where the light and shadows are.

Color	Pattern	Separation	Depth
Colors of a subject are emphasized and clearly seen throughout the image. All colors look very solid.	Tonal patterns are strongly seen because they are not obscured by shadow or texture	Poor subject separation; image is flattened out in appearance as objects can blend with each other.	Depth effects are much reduced, with no effect from separation or atmosphere.
Color can be obscured. Strong shadows and textures make many colors harder to see.	Pattern is usually obscured except in small areas of light. Shadows and textures have stronger effects.	Separation can occur when a highlight on the subject is seen against a shadow behind it.	Depth can be strong or weak. It depends on the light and dark effects from front to back in the image.
Translucent colors glow and come alive. Solid colors can be dull and obscured by shadow or bright highlights.	Pattern is usually obscured.	High separation when light hits the edges of objects (rim light) or is high enough to create bright areas against shadows behind.	Depth can be enhanced with this light—it can strongly separate objects, plus increase the feeling of atmosphere because backlight can light up the air.
Because much of the subject is in light, strong, solid colors show up well.	Pattern also shows up well.	Separation is minimal, so background must be watched carefully.	Depth is minimal.
Translucent colors can be strong, other colors tend to be obscured.	Pattern tends to be obscured.	Separation can be high.	Depth is emphasized.
Colors tend to be minimized and obscured.	Pattern tends to be obscured.	Separation can be high because of highlights on top of objects.	Depth can be emphasized or flattened depending on if the light is more back or front.
Colors tend to be minimized and obscured.	Pattern tends to be obscured.	Separation is usually low because the highlights and shadows are in the wrong places to separate a subject well.	Depth is usually deemphasized because the light is not a normal light.

One big challenge for all photographers is dealing with contrast. This can be a real problem on bright, sunny days, yet it can occur on cloudy days with the right conditions. The problem is that the digital camera has trouble dealing with high contrast tonalities in a scene and might make any high contrast scene look worse in the picture than what you saw in real life. This can turn pretty scenes ugly, attractive people into hollow-eyed ogres, and make eyes disappear with kids wearing hats.

So what can you do? If you are aware that contrast can cause problems and notice it happening with your subject, that's an important start. It means you are seeing the light and its effects on a scene.

Here are five easy solutions to dealing with contrast that anyone can apply:

1. Use a flash. You will often notice news photographers using flash at all times when action is breaking around them. This technique ensures that they capture important details from shadows (brightened by the flash) to bright areas. That results in images that can be seen and understood because no shadows obscure important parts. You can do the same by turning on your flash—most digital cameras come with a built-in flash of some sort (or at least the capability of adding a flash).

Every camera with a flash that I have seen includes the ability to turn the flash on or off, including forcing it on at all times (a technique sometimes called Fill Flash). Most cameras balance the flash with the bright sunlight so that adding light to the shadows reduces contrast and doesn't overpower the sunlight. You can check your LCD to ensure the balance is right. If it is not, many cameras allow you to reduce the flash output by adjusting the flash exposure compensation.

It amazes me to see so many people using standard point-and-shoot cameras to take pictures of friends and family in bright, contrasty light, yet they never take the very easy step of turning on that flash. The result is that they get harsh people photos with dark eyes and shaded faces from cap brims. Check your camera's manual to see how to turn your flash on to brighten shadows.

2. Wait for a cloud. Does that seem too simple? As you read about it in this book, it may appear to be an obvious solution if there are clouds in the sky, yet I can tell you from experience working with many photographers in workshops and classes that this is not always so obvious when that subject is in front of you. It can be worth checking the sky, noting the clouds and their movement, to see if you can wait for one to block the sun and create a more diffused sky light.

3. Block the light. Blocking harsh light yourself (when you can't wait for a cloud or there are none) gives you the equivalent of open shade on your subject at any time. I have used all sorts of things to block the sun, ranging from my body (when shooting a

macro subject), to a standing companion casting shade, to a large piece of cardboard. Blocking the light is very effective for close-ups and portraits. Photographers who do a lot of outdoor portrait work often use a black board (sometimes called a flag, though it can simply be a piece of black-painted Fome-Cor®) to block the light. The advantage of this is that no light is reflected from the black board, making the side of the subject that faces it darker, which then gives some dimension to the light, yet without the harshness of the original light.

4. Use a reflector. A reflector is a simple way to add light into dark shadows. Almost anything that is white or neutrally reflective is usable—all you need is a way of bouncing sunlight off of the reflector into the shadows. You can buy portable, fold-up reflectors that work great and can be folded up for convenience, though you can also use a piece of white Fome-Cor® from the art store or a light-toned, folding windshield shade used to keep cars cool in the sun.

Reflectors work great with close subjects. Flowers and other close-ups are perfect examples. People photos can often use the help of a reflector though you may find a problem when the reflected light is so bright that it makes people squint or look away. The answer to that is to have your subject look down and away from the bright light until you are ready to take the picture. Then you ask them to look into the camera and you take the picture immediately before the bright reflector makes them squint or sneeze.

5. Diffuse the light. You can, in effect, create your own "hazy cloud" between the subject and the sun by using a diffuser. Diffusers are neutral-colored and translucent, and spread the light out across their surface. How much they spread the light depends on the material used. As the light is more diffused, the contrasts in the light become less pronounced and shadows less obvious. You can buy convenient, folding diffusers, just like reflectors, or you can try things like translucent cloth, a white shower curtain, or even tracing paper.

Use a reflector or flash to fill in dark areas of your image or to highlight the subject, as seen in the above photo. The ambient background is well-exposed, and the bit of fill light on the subject draws the viewer right in to the image. Photo © Bob Krist

6. Shoot backlight.

When you shoot toward the light, you can get very harsh highlights, however, the rest of the subject blocks the light and is seen in open shade. You can move so that the harsh highlights are small and in unimportant parts of the subject, and emphasize the open shade part of the light for less contrast. The important things are that you watch where the highlights are, keep them small, and expose for the shadow.

7. Look for another picture.

When the light is really bad, you are better off finding a new photo than struggling with light that will never really help or flatter your subject. Harsh, high-contrast light that strikes a subject wrong can be obscuring, distracting, and downright ugly. See that light, recognize it, and then look for a new composition.

The time of day has a lot to do with the color, the direction, and the quality of the light.

Daylight Photography

TIME OF DAY

The time of day that you photograph has some big effects on light and how the light affects the subject. As you observe the light on your subject, you will quickly notice how light changes throughout the day, creating very different looks on the same subject. In fact, an excellent exercise for photographers is to try photographing the same subject throughout a sunny day, from sunrise to sunset, and even before and after the sun is in the sky.

The time of day affects several important elements of light:

1. Color: This is one of the most obvious effects from time of day. Sunlight early in the morning tends to be yellowish (though it can be orange, or more rarely, red), while shadow light is very blue. As the sun rises higher in the sky, it appears more neutral to the eye and the camera. By mid-day, the light can start to look a little bluish because of the way it interacts with the air and the sky. It gets more neutral by mid-afternoon, then warms up as the sun gets close to the horizon. Late sun tends to be orange or red (much warmer than morning light), though it can be simply yellowish.

2. Direction and dimension: Light is far more directional early and late in the day than in the middle of the day. You need shadows for dimension. This is one reason why most landscape and travel photographers take the majority of their photos early and late in the day. It gives them more options to capture light that works with the subject.

3. Crispness: Light tends to be at its crispest and sharpest first thing in the morning. During the night, haze usually declines greatly because of a number of atmospheric effects. Consequently, early light is not diffused, so shadows and highlights have crisp, sharp edges. During the day, dust, water, pollution, and other things get into the air, diffusing and spreading it out, so that

light at the end of a day is often quite softer. Now in areas along coasts where there is a lot of fog, of course, this might not apply, as fog is most prevalent in the morning.

LIGHT AND WHITE BALANCE

We covered the key points of white balance in Chapter 3, and you have noted that white balance is important with different lighting conditions. White balance has a great effect on what light looks like in your photo. Sunlight and all the variations of daylight have a wide range of sometimes subtle, yet important colors. This color affects what your day-lit subject looks like in many ways and is important to the final look of a photograph.

This is why it is so important to set your white balance control to something specific, either using presets or custom white balance, rather than using auto white balance. Auto white balance too often removes the key color casts of natural light, plus it can be inconsistent.

This is especially important as you photograph early or late in the day. At those times, the light from the sun is very warm and shadow light is very cool in color. Those color casts from the light give life and vitality to a photograph, and to retain them you need to shoot with a preset white balance—daylight is fine, but cloudy or shade will often intensify the warm colors in ways that are closer to the results photographers used to expect from film.

White balance is an important control to be aware of, especially when you are shooting early or late in the day when the light has a distinct color cast.

6 CHAPTER

Existing Light Photography

Digital photography has greatly expanded the possibilities for good images in almost any kind of light. In George Eastman's day, the average photographer was pretty much limited to sunlight with the early Kodak cameras as noted in Chapter 5. As time passed, great photographers pushed the envelope for capturing images indoors with the existing light of the scene.

Color mucked this up, though. In black and white, it didn't matter what color the light was—indoors or in any other non-daylight condition—any color cast created by the light was translated into gray tones.

But color film sees the color of light in very restricted ways compared to our eyes. If the film is not balanced for a particular light in the scene, the colors look bad. Sickly greens appear under fluorescents, and orange casts under incandescents. You could use a specific film balanced for certain lights that could help and you could use filters, but overall, getting good images in non-daylight conditions is challenging. Many pros decided they wouldn't deal with it at all, so they said forget existing light and they used flash. The light wasn't necessarily true to the scene, but at least the colors looked good. And then came digital technology, and with it, the ability to deal with almost any lighting situation directly from your camera or with image processing software; no need to change film types or filters. Now you can take your digital camera anywhere and usually never worry about what colors the light might create in your images.

EXISTING LIGHT

What it is: Existing light is the light that "exists" naturally when you take your photo; it is also called ambient, available, or natural light. While daylight technically fits this definition, it is usually considered separately (as we have done in this book).

What it does: Existing light provides very real lighting conditions for subjects and their environments.

Where it is found: Existing light comes from any light source that can brighten a scene, from a light bulb to a candle.

What types are there: Existing light comes in nearly infinite variations; the most common include incandescent lights, fluorescents, mercury vapor, candles, flash lights, and so on.

DIGITAL CHANGES EXISTING LIGHT PHOTOGRAPHY

Digital really changed all of this. Existing light is now more useful and workable for every photographer. Unnatural flash is not a necessity, and new possibilities are available for sensitive photography of what a scene really looked like.

Three major elements of digital photography enable better images in existing light:

1. White balance: This is a huge benefit of digital when shooting under varied light conditions. Whether shooting with auto white balance or presets, you can move from conditions with varied light, such as daylight to fluorescents to incandescents, and get neutral colors in each photo without color casts. That just didn't happen with most film. (High-speed color print films of the late 1990s and after came close by allowing easy neutral printing by labs, though they didn't always achieve it, plus you then only had a few film speed options.)

Notice the different color casts made by the different lights in the above image. The exterior lights are white, the entry way on the building is green, and the light coming from the windows is slightly yellow. These are all existing light sources.

2. ISO change on the go: With a digital camera, you can change your ISO setting with every shot if you want to. You don't have to change film to get a faster or slower speed. You can even shoot the same scene with different ISO speeds for effect.

3. LCD review: With night photos, especially, you often had no idea what the photo would look like when shot on film until you got the images back from the processor. Longer exposures were a problem because of something called reciprocity failure (meaning the film changed sensitivity with exposures over one second). Now digital cameras allow you to instantly see what the photo looks like and make adjustments.

Existing light is often synonymous with low light. This is the light indoors at home, in an office, arena, high school gym, at night on the street, in a manufacturing plant, a restaurant, and so on. This light can be interesting, but will often put up challenges for the photographer.

Here are some things that you need to recognize about low light challenges:

◆ **Sharpness:** This is a very big problem. As light decreases, changing exposure needs usually require slower shutter speeds. This makes images less than sharp or even blurred from camera movement that occurs while handholding a camera.

◆ **Noise:** Noise is still a challenge at low light levels because low light requires higher ISO settings. High ISO speeds increase noise with digital, just as they result in increased grain with film. Camera noise is one area that manufacturers have been working on a lot, so noise is much lower than it used to be. Digital image noise is, as a whole, much less than the grain that shows up from high-speed film. Digital SLRs (D-SLRs) especially today, have low noise levels at all slow and moderate ISO speeds (up to 800 or so, depending on the camera) and keep it minimal at higher speeds. Small digital cameras, such as advanced compacts and point-and-shoots, used to have problems with ISO speeds above 100. The latest cameras have greatly reduced this problem, bringing noise to acceptable levels at higher ISO settings.

◆ **Contrast:** Low light is often very contrasty light. The reason is that there is little overall light (other than in business settings with fluorescents), so each light in a scene will be bright, but areas around it often dark.

◆ **Light quality:** Low light levels give a very different look to the light and a scene than brighter lights do. This can add

Because sharpness is a common problem in most low light situations, you should consider using a tripod to minimize camera movement and maximize sharpness and image quality. Photo © Bob Krist

atmosphere to an image, or it can make a scene unattractive. As a photographer, be aware of this possibility and look for ways to work with the light that you have. Do not force a subject or scene into a composition that will not work with the light.

◆ **Light color:** Low light often means that the light has varied colors. It is common for these conditions to have multiple light sources, each a little different in color, meaning that even if you set white balance carefully, some will be neutral, some not. This can actually be an interesting element of existing light, but it can also be distracting if you don't account for it in your images.

ISO SETTINGS

You will find a whole section about this in Chapter 4. Here, we'll quickly look at some ideas that you can use for choosing an ISO setting can affect your photography in low light and other existing light conditions:

1. You can use any ISO for any light: There is a misconception that only high ISO settings can be used for low light conditions. While they offer certain benefits, you don't have to use them. You can put a camera on a tripod or another support and shoot at very slow shutter speeds with a low ISO setting.

2. Use low ISO settings for highest quality: Low ISO settings limit your noise challenges and give the best color, too (though

there is a trade-off with noise as exposure times increase). You get your highest image quality with the lower ISO settings, though in most D-SLRs, you may find only small differences in the low and moderate settings.

3. Choose high ISO settings for speed: Light levels may drop, but that doesn't mean everything quits moving. High ISO settings mean you can use faster shutter speeds. If you shoot indoor sports, for example, you may need to really push your camera's ISO capabilities, going to the very highest settings, in order to gain action-stopping shutter speeds. In cases like those, some noise is better than blurry images.

4. Select high ISO settings for handholding in low light: Faster shutter speeds mean you can handhold a camera with the assurance that you are not getting blurs due to camera movement. As stated above, noise and a sharp photo are more pleasing than a soft image due to such blurring.

Photo © Jack Reznicki

5. Use high ISO settings for moderate and low-light street photography: Street photography is a genre of photography where one walks through a city or town looking for interesting photos. This is an important way of photographing at events like fairs. You need to be able to quickly bring a camera to your eye and take a picture with reasonable f/stops and moderate to faster shutter speeds in order to capture quickly changing scenes. High ISOs are good for these scenarios.

LENS SPEED

With the proliferation and popularity of ever-smaller zoom lenses (and zooms with large ranges), attention has been diverted from a very important lens characteristic that greatly affects photography in low light—lens speed. Lens speed refers to the maximum f/stop of a lens, the widest aperture, the lens opening that lets in the most amount of light. This is the number that is always given with a lens, such as 100mm f/2.8, 24mm f/3.5, 18-200mm f/4-6.3, and so forth.

The smaller the number associated with the lens, the larger the maximum f/stop and the more light that gets through the lens (if this is still confusing, look at how an f/stop is written, such as f/4, and remember that it is actually based on a fraction, so f/2 or 1/2 is larger than f/8 or 1/8). More light means you gain the possibility of shooting with faster shutter speeds and lower ISO settings. Even in very low light levels, you can combine a higher ISO setting with a fast lens and use shutter speeds that you can handhold.

Many zoom lenses are relatively slow, meaning they don't allow in as much light at their maximum f/stops. This is especially true of compact lenses. To be kept small, they cannot have a large f/stop. Plus, compact zooms are usually variable f/stop lenses, meaning that they don't have one maximum f/stop. A lens might be marked as an f/4-6.3 lens. This is not its f/stop range—it

Digital technology has made low-light situations more accessible for today's photographers. High ISO settings, fast shutter speeds, and powerful flash units all contribute to creating better quality low light photographs.

means that the f/stop changes as the lens is zoomed, reducing in its light-delivering capability at the telephoto end of the zoom.

What constitutes a fast lens depends on the focal length of the lens. It is very difficult, for example, to make big telephotos or very wide-angles as fast as more moderate focal lengths. For moderate focal lengths, f/2.8 is generally considered the start of faster lenses. Speeds like f/2 or f/1.4 are really fast lenses that let in a lot of light (and they are also large and expensive lenses, too). Lenses that start at apertures such as f/3.5, f/4, or f/5.6 are considered slow, letting in progressively less light. For long telephotos like 400mm, f/4 is considered a fast lens. Anything with f/stops larger than f/4 on superwide angles is a fast lens.

This is extremely significant. If you walked through a carnival at night looking for interesting photographs in the bright light, you may find it very difficult to use an 18-55mm f/3.5-5.6 zoom

A wide-angle lens or wide-angle setting on a zoom lens minimizes camera move-ment when handholding a camera, allowing slower shutter speeds to be used.

compared to a 50mm f/2 lens. That f/2 lens is three whole f/stops faster than the zoom at that focal length. The zoom might mean you can shoot at 1/15 second even at a high ISO, yet in the same conditions, the f/2 lens would allow a shutter speed of 1/125—a huge difference that would definitely make the differ-ence between a sharp and unsharp handheld photo. This is one reason why many photojournalists regularly use fast lenses.

One way you can get the fastest shutter speed with any lens in low light conditions is to always use aperture priority exposure mode (as described in Chapter 4). You then set your camera to use the maximum aperture possible with your lens and let the camera choose the appropriate shutter speed. Since it is always dealing with the greatest amount of light possible coming through the lens, the camera's exposure system can pick the fastest shut-ter speed possible for the conditions.

HANDHOLDING TECHNIQUES

How you hold your camera is discussed in detail in Chapter 3. You can get away with casual handholding camera techniques in bright sun—shutter speeds can easily be set high. But in existing light conditions where the light is low, your handholding technique is critical. If you plan on shooting subjects in low light, go back and review that section and practice the techniques. You can improve your handholding capabilities with practice.

There is another hint to dealing with low light that was mentioned, but not specifically spelled out—the use of focal length for more sharpness in low light conditions. Here's what that's about:

◆ Telephoto lenses (and zooms) magnify the subject, but they also magnify camera movement. This is also true for a camera locked to a tripod when the wind is strong.

Bracing against something stable helps to minimize camera movement in low lighting.

◆ Telephoto lenses need faster shutter speeds than wide-angle lenses to gain equal sharpness of a scene. A common rule of thumb is to use a shutter speed of 1/focal length as the slowest shutter speed for handholding. So a 200mm lens might need 1/200 sec., while an 18mm lens might be fine with 1/20. (Many photographers consider these barely satisfactory and will use them as a maximum speed only when absolutely needed; also, these are based on the traditional 35mm film size, so smaller digital sensors may require faster shutter speeds.)

◆ So when you have to shoot at slow shutter speeds in low light without a tripod, try a wide-angle lens or the wide-angle setting of a zoom.

WHITE BALANCE

White balance was discussed at length in Chapter 3; however, it is so helpful in existing light conditions that it is worth discussing a bit here, too. The color of light changes dramatically with the different light sources that make up existing light conditions— sometimes you want to remove that color and make neutral tones neutral, but sometimes you want to keep some of that color because it makes images livelier in certain lights.

Here are some things to try:

White balance is important for most situations, but even more so when you are indoors with artificial lighting. Most artificial lighting, such as fluorescent and tungsten, has a color cast that will show up in your images unless you use the white balance feature.

White balance to the main light source: Many existing light situations will present you with several different light sources on your subject. There might be fluorescents plus window light, or incandescent plus mercury vapor. The color of these lights

are different enough that you are not able to use a single white balance setting that covers them all (you can shoot several white balance settings, or shoot RAW and select white balances there, and combine images with different white balance corrections in Photoshop software). In general, you will usually find the best results from setting a white balance to match the most important light on your subject.

Try auto white balance: Existing light can have a big range of colors that doesn't exactly match the choices of white balance preprogrammed settings. This is one place that auto white balance really helps to get a setting closer to what is in the scene. One problem, though, is consistency. All those lights can make the camera keep changing its white balance in different views of the same scene.

Use custom white balance: Since existing light has a large range of non-standard colors, manual white balance can help lock in a white balance for it. On most cameras, the manual white balance setting has a larger range of color temperature correction than auto white balance, too.

Try an unmatched preprogrammed setting: Sometimes it is worth shooting with a setting that locks in the white balance at a point that does not match the existing light's natural color. The most common use of this is to try the Daylight setting at night to warm up the scene. City scenes in particular may be technically "correct" with the Tungsten setting, but often that makes them look rather cold. Daylight warms up the scene. Look at your LCD review to see if you like the effect.

Bracket your white balance settings: If you aren't sure, try several white balance settings. There are no white balance police out looking for photographers who can't precisely match white balance settings with the light. So try a few settings on the same scene since there is no cost to taking the pictures. Some cameras have a white balance bracketing function that will do this for you automatically.

OUTDOORS AT NIGHT

I've talked about a few situations when you might deal with existing light outdoors at night, such as street scenes. There are many opportunities for you to experiment with your digital camera in all sorts of nighttime situations. The digital camera, with its variable ISO and white balance settings, plus LCD review, makes such photography not only possible, but also fun and productive for any photographer.

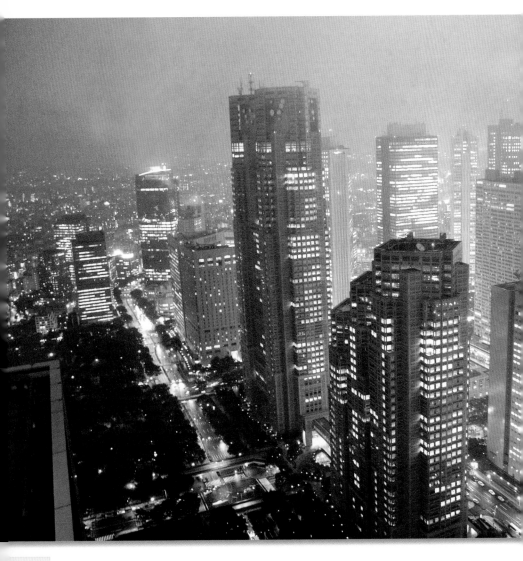

Everything discussed so far in this chapter applies to any night-time outdoor subject, from handholding your camera to choosing ISO settings. But there are some specific night shots that you might find fun and rewarding that are commonly available. Here are some ideas:

Night cityscapes: When the sun goes down and lights go on in the city, there are some amazing possibilities. The hardest part is finding the right overlook to the city. You may find that a little daytime scouting will pay off quite nicely, plus you can check with people living in the city for their recommendations. Sometimes

you can find a neat angle from a postcard and ask if anyone knows where it was taken from.

Start shooting cityscapes as the sun sets. There is a very magic time that occurs as the sky still has color and the city lights appear. You can never predict when the perfect time will be as the lights change, so start shooting as soon as the sun has set.

Cloudy days can be dull for a city during the day, but perfect at night. The clouds reflect back some of the city's light, giving some tonality in the sky to show off shapes of the buildings.

In general, you will find a tripod and a telepho-to work best for this type of shot. Try different white balance settings, though the Daylight preset usually works best as the sky color re-mains after a sunset, plus Daylight will often give nice warmth to the city.

Night moonscapes: A full moon gives very bright light, and can illuminate a landscape. Exposure is tricky, so you may have to experi-ment a bit. Working with large surface areas, such as big expanses of rock, water, or snow,

can be especially effective. You can try both the Day-
light and Tungsten light white balance. Even shot on a
tripod, you may find you need high ISO settings in order
to get shutter speeds of 15-30 seconds at fast to
moderate f/stops. If your camera does not have such
settings, try the Bulb (B) setting described in the
fireworks section next.

Fireworks: Fireworks are always dramatic subjects.
Position is everything. You need to have a clear view
of the sky where the fireworks are. You will be using
long exposures, so it is best to be close enough that
you don't need a long telephoto lens. A tripod is
essential for the best images.

Fireworks often start before the sky is fully black.
Black skies usually work best to set off the colors,
but you can use the early explosions to set up your camera for
the best composition and exposure (you will be exposing for
the fireworks which do not change in brightness). Fireworks are
enjoyed for their change over a brief period. We like to see the
streamers and sparkles.

The camera can only record this over a period of time, too. Try set-
ting your camera to Manual exposure at f/5.6 and 3-4 seconds,
white balance at Daylight, and ISO at 100. This is only a starting
point—every fireworks display is different, but this should get you
close. If the bursts are too dark, set the ISO higher; if too light,
set the f/stop to f/8. The time the shutter is open affects what
the moving streamers of light look like. Release the shutter as
the fireworks rocket attains its height, just before it explodes (you
can play with this timing for different effects).

If your camera does not have shutter speeds of 3-4 seconds, see
if it has a Bulb (B) setting. This setting keeps the shutter open as
long as you keep the shutter button pressed (an electronic cable
release helps, if your camera accepts one). You can also use this
setting for multiple "blooms" of fireworks; keep the shutter button

Photo © Joe Farace

pressed so the shutter stays open, then cover the lens with your hand between blasts, uncovering the lens as a firework explodes.

Lightning: Lightning makes for stunning photos, but it is challenging to capture. First thing, be sure you are in a safe location that is not a target for the lightning—never set up under a tree, for example. Set up your camera on a tripod and point it toward the lightning. Try setting the camera to f/5.6 at ISO 100 (this is very hard to predict exactly, so try some shots and modify the settings accordingly), white balance for Daylight and the shutter at B or Bulb. Open the shutter and wait for lightning—you can even leave it open for several lightning strikes. This only works at night, though, because leaving the shutter open during the day will overexpose your image.

If you get really serious about lightning photography, you might look up a product called the Lightning Trigger. This attaches to cameras with remote or electronic cable releases and triggers the camera at any lightning strike it senses. This way, you don't need to leave the shutter open and can even shoot during the day.

7 CHAPTER

Flash Photography

In the history of photography, the idea of flash has been around for quite a while, even if its use was spotty. You've probably seen movies showing life in the late 1800s when the photographer used flash powder. This really was used. A trough of highly flammable powder literally exploded with a lot of light (and smoke!) to make a photograph in dark conditions. This was a rather dangerous lighting technique (plus the smoke made more than one shot difficult indoors), so it was not part of George Eastman's Kodak camera.

Today, most flash occurs electronically with carefully controlled light that bursts from the unit for a precisely timed exposure. Flash gives photographers light that can brighten dark scenes, fill in shadows, stop action, create the direction and quality of light, and control the color of light on a subject. It comes in as small a unit as a built-in flash on a pocket point-and-shoot digital camera, and as large as powerful studio lights used by commercial photographers.

ELECTRONIC FLASH— HOW IT WORKS

What it is: Electronic flash is a light source controlled by the photographer based on a small flash tube that puts out a very fast burst of consistent light.

What it does: Electronic flash lights up subjects and scenes in a consistent and controllable way.

Where it is found: It can be built into a camera, a small and highly portable accessory flash that fits into a camera's flash shoe, and a large, powerful unit used in studios.

What types are there: Built-in, accessory, studio, and high-speed specialized units.

Electronic flash comes as an accessory unit, built in on the camera, or specialized units.

While it is possible to use old style flash bulbs (a single-use sort of flash), and even flash powder if you were really ambitious, there is little need for either. Today's electronic flashes hold a great deal of power in very small packages with extremely versatile controls.

Whether built into a camera, an accessory unit that plugs into the hot shoe of the camera, or a large studio flash assembly, electronic flash all works basically the same way. It helps to know how it works in order to better understand how to control it. Here are some things that happen with an electronic flash.

1. Camera triggers the flash: This is very important, obviously, because the flash must be triggered when needed and not at some random time (which is what happened with flash powder). You need some way, therefore, of connecting the camera and flash

so the camera can trigger it. That's pretty simple with an internal flash—the manufacturer simply connects the components internally. For accessory flash, the camera has a hot shoe, a slot that both holds the flash and has electrical contacts for communication between camera and flash. Studio flash generally use some sort of cord that connects to a special plug on the camera for their connection. In both cases of flash units separate from the camera, it is also possible to connect them with some sort of wireless capability, ranging from light pulses to radio waves.

2. Flash goes off in time with shutter: When the flash is triggered, it must be timed properly with the shutter of the camera. The flash must be "synced" so that it gives its burst of light when the shutter

There are many ways to use your flash, for both technical or creative effect. The cactus in the above image is lit by a flash unit and the camera's exposure is set to show the background sunset.

is fully open. If not, no exposure appears from the sensor.

3. Electronic flash works by power to tube: Each flash unit can have its components simplified into four major functions: input power, stored power, flash tube, and flash controls. Whether from battery or a plug in the wall, a flash has to get power. This is then stored and intensified in high-capacity capacitors (which is what the flash is doing when it is recycling). The flash controls adjust when and how this built-up charge of energy is released to the flash tube. When the flash tube gets this burst of energy, it releases it in the form of a burst of light.

4. Extremely fast: The actual blast of light coming from an electronic flash happens very, very fast. Even the slowest accessory flash that fits directly on a camera has speeds generally faster than 1/1000 sec and can be as fast as 1/10,000 sec. This is much faster than most shutter speeds, and always faster than the speed that a camera can "sync" with a standard flash. Because of that, shutter speed, in general, has no effect on the amount of light coming from an electronic flash.

FLASH SYNC—WHAT IS IT AND WHY IS IT SO IMPORTANT TO KNOW?

What it is: Flash sync is the timing that matches the flash burst to the open shutter.

What it does: Flash sync ensures that the flash goes off when the shutter is open to allow light to reach the sensor.

Where it is found: This is built into electronic timing controls in the camera.

What types are there: X sync is the one used for electronic flash; FP sync is for flash bulbs (not so common today); and high-speed sync is a specialized mode, described later.

The basics of flash sync are easy to understand. The flash has to go off when the shutter is open or no picture can be taken—they have to be synced together as described above.

But flash sync is actually more involved than that. There are actually five things you need to know about flash sync:

1. Sync speed: The sync speed of a camera is the fastest shutter speed the camera can use and still sync the flash burst with the complete opening of the shutter (it is always far longer than the burst speed of the flash, but there is a good reason for that as you'll see below). You can always shoot any slower shutter speed and have perfect flash sync, but you cannot shoot faster unless you have a camera and flash combination that allows high-speed sync.

2. Focal plane shutters: All digital SLR (D-SLR) cameras have a focal plane shutter, which causes some flash sync challenges. A focal plane shutter uses two shutter panels or "curtains" in front of the sensor to create a shutter speed. The first curtain moves to allow light through to the lens, and the second curtain comes right behind to cut it off at the selected speed. A flash must go off when both curtains are fully open. As shutter speeds shorten with such a shutter, the second curtain will start to close before the

first is fully open. The result is a slit that moves across the image area. The flash never has a fully open area to use, so it cannot sync with that shutter speed.

3. Leaf shutters: Most compact and point-and-shoot digital cameras use a different shutter. Their shutter is built into the lens and is made of small, overlapping pieces of metal, the "leaf" part of the lens. These quickly pull back to create an opening through the lens for the light, and close again to time the shutter speed. They are not as fast as focal plane shutters. They can, however, have higher sync speeds because there are not two curtains chasing each other across a sensor.

4. High-speed sync: About ten years ago, camera manufacturers started introducing a new feature with their focal-plane shutter cameras and flash: high-speed sync. This meant cameras could sync with flash even though the shutter curtains never allowed the full sensor to be open to flash at higher than sync speeds. What manufacturers learned to do was create a flash that would pulse with

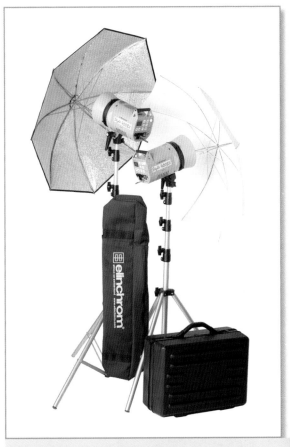

Flash units like these are commonly found in studios. Some professional flash units have wireless capabilities, giving studio photographers more flexibility in their light placement and less movement restrictions.

light over the time that the camera shutter opened and closed, therefore creating the appearance of continuous light across the image area. This proved to be useful for adding light into shadows in bright scenes, for example, but flash power is not as strong as when used with standard flash.

5. Rear vs. front curtain sync (also first vs. second curtain sync): This is a popular technique that merges blurred and sharp images together with focal plane shutters. There is a lot of misinformation about it, however. You hear photographers talking about these as if front curtain sync were totally different in effect than rear curtain sync, even to the point of implying the blur/sharp effect can only be done with rear curtain flash. In reality, both flash sync types are perfectly capable of capturing flash sharpness and blending it with movement. This is explained in detail later in the chapter, but all you need to do this is a slow shutter speed for the ambient or existing light to create a blur, then the flash for the sharp image overlayed on the blur. (Many point-and-shoot cameras have a night portrait mode that achieves a similar effect.)

The difference between these sync types is that front or first curtain sync triggers the flash as soon as it is fully open (the flash is very fast, so stops most action), then the shutter stays open to allow an exposure from the existing light that allows blurred action AFTER the flash. In rear or second curtain sync, the flash is triggered just before the second curtain closes to complete the exposure. This means that the shutter is open to allow blurred action BEFORE the flash. The result is that the blur/sharp relationship can change.

AUTO FLASH EXPOSURE—HOW IT WORKS

What it is: Auto flash exposure controls light to the sensor automatically for proper exposure.

What it does: Cameras control how much light comes from a

flash based on how the light is reflected back from the subject (mostly, though the flash can control itself, too). It is controlled either automatically by the camera (i.e., it sets the f/stop for the correct exposure and the right sync speed), or the photographer selects the f/stop and sync speed for more precise control.

Where it is found: This is built into the electronics of a camera.

What types are there: Different manufacturers have proprietary systems for achieving good exposures in many conditions.

Auto flash exposure is so good today that many photographers use nothing else. Studio photographers don't have such capabilities with their big strobes, but for everyone using small accessory flash and built-in units, auto flash exposure is a tremendous help in getting consistently good flash images. This is no amateur-only technology, either. Photojournalists and other location photographers use automatic flash regularly. Travel pros depend on it.

Flash exposures were once very difficult and required flash meters, Polaroid tests, and a lot of trial and error. With auto flash exposure, you can get excellent exposures right out of the box. You will get consistent exposures if you understand a little about how flash exposure systems work.

Auto flash works like this:

1. The camera triggers the flash (properly syncing it to the shutter).

2. Immediately, the flash on a digital camera sends out a "preflash." This allows the camera to see the light from the flash coming through the lens and get a reading on how much light is needed for the subject. Most advanced cameras also take into account the focusing distance of the lens for more precise exposure settings (flash changes in intensity with distance so elements of a scene at different distances will have different brightness levels).

3. The shutter opens and the flash is set off with the right amount of light.

Flash can be subtle or strong. When you are using your flash, think about your final product. Do you need bright light to remove deep shadows, or do you want a softer look? Flash is easily controlled.

4. The amount of light from the flash is based on the duration of the flash. The burst of light from the flash is cut off when the right amount of light has left the unit. This can mean extremely short flash durations at close distances.

5. The shutter closes.

Auto flash exposures are controlled in two ways:

1. Flash exposures are controlled through the camera, as explained above. The camera meter controls most built-in and accessory flash exposures as the light comes through the lens.

2. Flash exposures are controlled at the flash. Some very basic point-and-shoots use a flash sensor on the camera, and many accessory flashes also permit exposure control with the flash itself.

Built-in flash units are a good tool for filling in harsh shadows, but the light they produce can be one dimensional and flat. They are adequate for subjects that are within a few feet, but they are not as powerful as accessory flash units, and the further the built-in flash is from the subject, the more the light drops off.

In this case, the flash reads the light bouncing back from the subject and cuts itself off when enough light has been emitted for the subject.

In all cases, flash exposure is based on the light the flash sensor sees bouncing back from the subject. Because of that, you can have exposure challenges with white or bright subjects (they bounce back more light than the system expects, so it gives them too little light, resulting in underexposure), and when subjects stand alone with little around them to bounce light back (the system then sees something darker than expected, so it gives the subject too much light, resulting in overexposure).

The great thing about digital is that you can see exactly what is happening with exposure when you check the LCD review. It is like having your own little Polaroid test, but without the time or mess. The flash or the camera will have flash exposure compensation capabilities, so you can increase the amount of light from the flash to correct underexposure or decrease it for overexposure.

One other thing to know is how the flash deals with its extra power. "What extra power?" you might wonder. A flash must be charged

enough to put out its maximum power when used. However, if you are photographing something up close, for example, you don't need all that power and the flash cuts off before its whole charge is used. Years ago, that power was just dumped. Now it is shunted back into the flash, resulting in shorter (and sometimes instant) recycle time when it is ready to shoot again.

For this portrait, two flash units were used, one from the camera to light the face, and one behind the subject to separate him from the background. There are many ways to light portraits; this is a classic example.

A guide number (GN) is a measure of power from a flash unit. Theoretically, two units with the same guide number will give the same amount of light on a subject. I have to qualify this a little bit because there are no universal standards for determining guide numbers. You may find that two flash units with the same guide numbers, but from different manufacturers, give different amounts of light.

Studio photography is predominantly flash photography. There are lights for the background, lights for the subject, and sometimes even lights for the back of the subject.

The guide number (GN) is based on the relationship between f/stop and distance of flash to subject. (Remember that flash is so fast that only the f/stop, not shutter speed, controls exposure, not including the duration of the flash itself.) Any given GN is actually the result of a formula of f/stop x distance at a specific ISO setting (the sensitivity of the camera also affects its sensitivity to the light from a flash). If the GN is based on feet (it will be very different if based on meters), then the distance used is 10 feet. That, combined with an ISO, gives a specific f/stop for the distance.

You can calculate an f/stop to use for the camera and flash if you know the distance of the flash from the subject (camera to

subject when the flash and camera distances are the same). If you had a GN of 110 and your flash was five feet from the subject, the f/stop needed would be f/22.

But, you really don't have to do all that. The flash metering system in your camera will help you. Looking at guide numbers of flash units, however, gives you an indication of their power. This can help you decide what you are getting when you buy a flash. More power means you can photograph with flash at greater distances, plus you can more easily use flash accessories, such as a large diffuser.

A built-in flash might have a guide number of 40 (in feet for ISO 100), while a compact, accessory flash might have a guide number of 110 (also in feet for ISO 100). It looks like the built-in flash is a little less than half the power of the accessory flash, but looks are deceiving. That built-in flash has 1/8th the power of the accessory flash. You may remember that f/stops double or half exposure with each change in a full f/stop, such as f/4 to f/5.6. Now keep in mind that a GN is also based on f/stops. So going from 40 to 110 is like going from f/4 to f/11, a change of three f/stops, or a change of 2 x 2 x 2 or 8. The low-powered unit is 1/8th the power of the high-powered unit, and the bigger accessory flash has 8 times the power of the built-in.

Guide numbers are one thing to consider when purchasing an accessory flash unit. The guide number tells you how powerful a flash unit is.

A built-in flash always offers one great advantage over any other flash; you always have it with you and your camera. On the other hand, it has two big disadvantages: it is always fairly low powered, and it must be used from the camera position. You can use built-in flash to good effect if you remember that this is not a powerful unit.

Here are some possibilities:

1. Fill flash: You can always turn on your flash when the light is harsh and you are seeing dark shadows on your subject. Almost every single point-and-shoot camera has this capability (the Flash On setting), yet you rarely see people turn on the flash during the day. That shot of the kids at Disneyland would definitely improve with a little fill flash. Pros use it for a little kick of light into the eyes of an outdoor portrait, too. Fill flash is further explained a little later in the chapter.

2. Added light on rainy or dark cloudy days: Heavy clouds can really dull a scene and its colors. Turning on the flash can brighten things nicely, especially when photographing people.

3. Controlled light in low light levels: With your built-in flash, you always have controlled, dependable light, no matter what the existing light conditions are.

4. Party light: At parties and other events, photographs must capture the people and the activities there. Yet, existing light is often dim and variable. While you might be able to shoot with the ambient light, the photos might be inconsistent. A built-in flash gives you direct light from the camera that fills in all the shadows and gives you consistent images that feature the people at the event. It is a bit harsh for standard people photos, but that harshness has a lively feel to it for events.

Sometimes flash is the only light available, such as this girl catching a grunion by the ocean at night. The flash was on a cord and held off-camera to give nice directional light.

There are three main limitations of on-camera flash:

◆ **Low power:** You won't get a lot of distance from these flashes and sometimes they have trouble overpowering bright existing light. You can get more distance from them by using higher ISO settings.

◆ **Position is locked on camera:** This means the light can only come from that one position, direct front light on the subject. This may also cause red-eye because the flash is close to the lens and cannot be moved away from it (more on red-eye later in the chapter).

◆ **Light can be harsh:** Flash is a small, specular light source that can be harsh on many subjects. You can try diffusing it with a small diffuser that fits over the flash to help with close subjects (though it won't do much, other than reduce light for more distant subjects) or you can drape it with a white, translucent cloth for a similar effect.

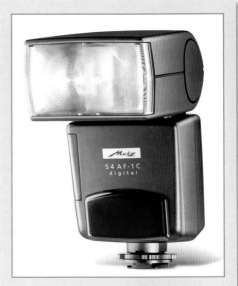

DEDICATED ACCESSORY FLASH

Almost all accessory flashes (the small flash units that attach to the camera's hot shoe) are dedicated units. I would not recommend any other kind. A dedicated flash unit is one that communicates with the camera for best exposure and so it is "dedicated" to that particular camera type. (In general, that means it will work with any camera of a particular brand, though that

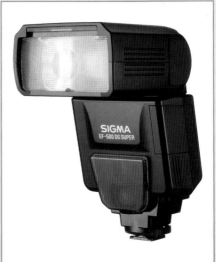

Depending on what kind of flash you need, you have several available options in terms of accessory units.

is not 100% true, so you need to confirm that any dedicated flash will, indeed, work properly with your camera.)

Accessory flash gives you a big boost over built-in units with these advantages:

◆ **More choices:** Most flash manufacturers (including camera manufacturers) have a variety of units ranging from close-up flash units (such as ring flash or twin flash that mount close to the lens), to pocket units, to large, highly versatile flashes.

◆ **More power:** The smallest of accessory flash are, in general, at least as powerful as a built-in flash, but you can find other units many times the power of the built-in unit; this allows stronger fill flash on bright days, greater distance with the light, and bounce flash capabilities (explained below).

◆ **More flexibility:** Accessory flash offers many different controls to allow for a variety of types of flash photography. In addition, most accessory units allow bounce flash and can use accessories such as diffusers, reflectors, colored filters, and more.

◆ **Flash width zooms:** While a few built-in flashes offer limited zoom capabilities, most advanced electronic flash units change the width of the flash beam to better match the lens used. This allows the flash to be more efficient with its use of the light.

◆ **Position can be changed:** You can use accessory flash on and off the camera for many more lighting options.

All of these things are possible with complete automatic control of exposure. Modern dedicated flashes work with cameras to use information from the camera as well as the flash, such as focus distance, exposure evaluation over many points in the scene, color quality of the flash, and more.

MANUAL FLASH

Most accessory flash units can be shot manually, and all studio-type flashes are manual. This means is that the flash output is dialed up or down to a specific amount, but then it always puts out that amount. You have to control the exposure by setting the f/stop of your camera appropriately. You determine that exposure

with a flash meter, distance charts, tests, or just trial and error. Trial and error was difficult with film, but with digital you can try almost anything, look at the LCD review, then make adjustments until the exposure is right.

Manual flash is not for everyone because exposures are more difficult to deal with unless you are in a standard situation (such as a studio). However, it does have its advantages:

◆ **Constant output of light:** You can ensure, for example, that you are getting all the power possible from your flash unit.

◆ **Faster flash duration:** When you dial a flash down, its speed gets shorter. With many handheld accessory units, this is fast enough to stop high-speed action, such as a hummingbird's wings.

◆ **More power:** All manual, studio-type lights are very powerful. (While I call them studio-type, they can be used in the field for their power, but this often requires assistants and a separate power source).

SHUTTER SPEED AND FLASH

As we've discussed, the flash burst is so fast that the shutter speed of the camera has no effect on the flash light exposure (this is mostly true even for high-speed sync flash). The lens aperture is the only thing that controls this exposure.

However, shutter speed does affect the exposure of the ambient (existing) light that is usually present when you use flash. You can use any shutter speed you want with flash as long as it is the sync speed or slower. This allows you to control how bright the ambient light is in the photograph, compared to the light from the flash, as ambient light exposure is controlled by the combination of shutter speed and f/stop.

Flash is an important tool for most types of photography. It stops action, adds light for better exposure, and can set the subject apart for contrast in your composition.

It is probably easier to understand if I give you an example. Suppose you photograph a person at night in front of a brightly lit building. Let's say you are shooting at f/11 for the flash and using a sync speed of 1/250 sec. Most likely, the person will look fine (from the flash) but the building will be very dark. Next, you photograph the same situation with a shutter speed of 1/15 sec. Now the building is more naturally captured from the ambient light exposure of 1/15 sec. at f/11, plus the person still looks fine because only the light from the flash is exposing him or her to give the proper exposure at f/11.

This used to be extremely complicated before dedicated flash. Now, most cameras let you do this automatically, though you have to check your manual to see what controls are involved. Some cameras give the correct ambient light and flash exposure combination when set to aperture-priority exposure mode, but others will not. Check your manual or go to your local camera store to learn how to set your camera to balance ambient light and flash.

If you really can't figure it out, there is still an answer with a digital camera: use the manual exposure mode. Set a reasonable f/stop (for depth of field, perhaps) and the camera automatically communicates with a dedicated flash to give the right flash exposure for that f/stop. Then, set a shutter speed (sync speed or slower) that gives the right amount of exposure for the existing light. Take a picture and check your LCD review. If the ambient light is too dark, add light by choosing a longer shutter speed. If it is too light, reduce its effect by selecting a faster shutter speed.

This is a very valuable flash technique. It lets you fill in shadows created by harsh light (including sunlight if your flash is strong enough), light a subject in dark conditions yet allow the surroundings to show in the photo, and balance the light on a subject with the existing light behind it.

You can also use this technique creatively:

◆ **Make your background lighter or darker and keep the subject lit normally.** You do this by changing the shutter speed.

◆ **Create interesting sharpness and blur effects.** The flash makes a moving object sharp, yet a slow shutter speed will allow it to blur. This is a very unpredictable effect, so you need to try it and check your LCD review to see what shutter speed might be best. You can even handhold the camera (including deliberately moving it during exposure) to get a difference between flash and ambient light sharpness.

◆ **Experiment with front and rear curtain sync (if you have a D-SLR).** When you shoot with slow shutter speeds for the sharp flash and blurred ambient light effect, the blurs will look different depending on which sync you choose.

RED-EYE CHALLENGES

What it is: Glowing red eyes of people when photographed with flash.

What it does: Makes people look like they have demon eyes. It is not particularly attractive.

Where it is found: This comes from flash photos under two conditions—the light is low and the flash is close to the axis of the lens.

What causes it: The low ambient light makes the pupils of people's eyes dilate, then a flash near the camera lens sends light into the eyes which reflects off the back of the eyes. Since the

pupils are wide, that red reflection gives the red-eye effect.

What types are there: Many animals have this effect, but while people get red-eye, dogs for example, usually have green-eye.

So how do you avoid red-eye? If you shoot only existing light and in bright light conditions, you will never see it. However, you can avoid red-eye with flash, too.

A red-eye reduction feature is common to most digital cameras with built-in flash. With this feature, the camera does something to cause the subject's pupils to contract slightly. Most

Flash does not have to be obvious in your images. It is just another tool, and the more you use and understand its capabilities, the more comfortable you will be experimenting with its effects.

commonly, this is an extra flash (or burst of little flashes), though some cameras actually turn on a light. This does work, and is probably the best approach for events like parties.

It does have some serious shortcomings, however. The most problematic is the extra flash before the actual exposure. This can cause subjects to blink or squint when the real exposure happens. It can cause subjects to change their attitude toward the camera, often resulting in stiffer images when the flash really goes off. Finally, many subjects think you have taken the picture and start to turn away from the camera.

Other options include turning on more lights in the room (not always possible); have the subject to look at a bright light for a moment then have them to look at the camera; using an accessory flash (that puts the light away from the lens axis); and bouncing the flash from the ceiling (not always possible with low-powered built-in flash). The one nice thing about dealing with this challenge when you are shooting with a digital camera is that you can see immediately if you are having problems with red-eye and take steps to fix it. Your final option is to fix it later on the computer. Many programs like Kodak EasyShare and Picasa software have a red-eye removal tool. It is simple to use and works very well.

Move Your Subject Away from the Wall

On-camera flash is harsh to begin with, but when you put your subject near a wall, it looks much worse because of the ugly shadow that usually appears behind the subject. This is hard-edged and distinct and detracts from most subjects. By moving the subject away from a wall, the light reflecting off the wall is reduced, which also minimizes the shadow and its edge.

OFF-CAMERA FLASH

One very simple and effective way of improving your flash images is to get a dedicated flash cord for your accessory flash. This allows you to attach the camera to the flash, yet hold it away from the camera, and immediately gives some dimension and shape to the light, avoiding issues such as red-eye. The flash

Moving your subject away from a wall not only removes distracting shadows, but it gives contrast so that your subject stands out.

cord keeps the auto flash exposure working normally.

The best way to hold the off-camera flash is in your left hand because your right hand is needed to trip the shutter button. Extend your arm out and up to get some space between flash and camera, then point the flash at your subject. This immediately gives a dimensional light with more attractive shadows. You can use an old photojournalist's technique to help you aim the flash. Hold the flash between your thumb and fingers, then rotate your hand so you can put your pointing finger on top of the flash. Point that finger in the same direction as the flash produces its light, then when you hold the flash up for exposure, point your finger at the subject. You should then be pointing the flash correctly.

Off-camera flash still provides good light, and it creates different shadows that add dimension and interest to the image.

You can position the flash anywhere you want for effect as long as it is connected to the camera with the cord (some cameras allow complete auto exposure with wireless flash units—check your camera manufacturer's flash options). I have shot with a direct side light (see the daylight section for ideas about light direction—they also apply to flash), a top light, a bottom light (for an eerie effect), and a background light (where I aim the light more at the background than the subject). Once again, the LCD review of your camera will quickly help you see what light direction works best with your subject.

BOUNCE FLASH

Bounce flash is probably the best and easiest technique to get better photos of your subject, especially people. You can tilt a flash with bounce capabilities up or sideways so it is aimed at a white ceiling, wall, or even a reflector. You can also aim an off-camera flash at those reflective surfaces. The flash bounces off the surface, which spreads out the specular light of the flash and makes it more diffuse. The bigger the area of light that is bounced, the more diffuse the light becomes.

This is a good example of the bounce flash technique. The flash creates softer shadows and a more natural look, especially in a portrait.

This gives the same effect as clouds as described in Chapter 5. The light spreads out across the surface of the subject and makes shadow edges less distinct. This creates pleasing, natural light for most subjects and avoids the typical harshness of direct flash.

Bounce flash can be a directional light depending on where the bounce surface is in relation to the subject. If it comes from a large white surface to the side of the camera, you can get a nice 3/4 or side light on the subject (you may need a reflector, though, for the shadow side if you are in a room that is dark or walls that might reflect are far away). If it comes from above, be careful of light that is too much directly over the subject—this creates dark shadows under the eyes.

Challenges come from the amount of light that is absorbed by the bounce surface. Some surfaces absorb more light than others.

Plus, as the flash gets farther from the surface (such as a high ceiling), the light is spread out more on the surface and it uses up more power going the distance. Both of these can cause insufficient light problems. You can increase the ISO setting of your camera, but that can make it more sensitive to the existing light (which may have inappropriate colors, such as the green of a fluorescent that shows up in light colored hair).

If you like bounce flash (and most photographers who use flash a lot do), you will need one of the larger accessory flash units. These have more power and give you more options and control over bounce flash exposures.

Be careful of the color of the surface where the bounce is coming from. Even a faintly colored wall can change the color of the light enough to make the color balance of the photo look bad. Bounce your flash off of neutral colored surfaces unless you are trying for a specific effect.

FILL AND BALANCE FLASH

Briefly discussed in the section about built-in flash, fill flash is a very easy and important technique to learn. Today, any photographer can do it with almost every digital camera on the market. A related technique is using flash to balance existing light.

The key to using fill flash is to use flash to balance the light on your subject with the surrounding, natural light. Outdoors that usually means balancing shadows to sunlight. A flash can lift the brightness of a shadow so you can see into it, while allowing you to expose for the best color and tone in the bright areas.

It's easy to see casual photographers miss an opportunity to gain better photos by not turning on their flash. Bright sun lights up the scene and their family members in the photograph, but hat brims make the faces dark. Those faces will always look dark ("was that Jason or Ryan on the left?"). Adding fill flash would make those faces recognizable at the minimum.

The only difference in the above images is the background lamp. It is on in both photos, but in the top image the flash overpowers it. In the bottom image, a slower shutter speed captures the lamp light.

You can also use fill flash on days with dark, moody light, such as a day threatening rain. This brightens colors and lifts tonalities, making your subject look better. This is basically balancing the flash to the light of the scene. Indoors, you can use this same technique to get rid of "flashed" pictures where every bit of light comes from the flash and any natural light is overpowered. You can balance the flash to the existing light of a room so you gain light from both (though you may need a slow shutter speed for the room light that can lead to blurs if you are not careful).

Fill flash can be used by first telling the camera flash or accessory flash to stay on and flash with the exposure. With compact and point-and-shoot cameras, this usually means pushing the flash button until the flash icon appears. On D-SLRs with built-in flash, it means popping up and turning on the flash. With accessory flash, it simply means turning it on.

With some cameras, this will give exactly the exposure needed, but others will need additional steps. The camera needs to balance the flash exposure with the sunlight (or existing light) exposure. When the flash is turned on in some cameras, the camera

automatically sets one shutter speed for the flash, which might not be appropriate for the conditions. Check your camera manual to find out what settings balance the existing light with the flash.

If you really can't figure out what the camera is doing, just try it with different settings. You'll find something that works and you can always try that in the future. You can also set your camera manually, if it has a manual setting, for the sun light as an example, and then turn the flash on. The camera will usually set the flash appropriately.

The distance to your subject affects how strong the flash is. Many small cameras don't have enough flash power to really do much beyond five or six feet, for example. Experiment to see what works best for you.

On more advanced cameras, you can often set the flash for more or less exposure (flash compensation, +/- exposure) to help you better balance the flash to the overall exposure.

You may also find you have a setting on your camera called something like night flash. This automatically balances the flash to the

existing light. Otherwise, you can shoot in manual exposure and try different shutter speeds until you get the right balance (shutter speeds affect the existing light part of an exposure, not the flash).

USING SIMPLE FLASH MODIFIERS

Flash modifiers are anything that is placed in the light path to change the light. Commercial photographers use all sorts of modifiers in their studios, but you can use some simple modifiers to get better light from your flash.

You can buy attachments for your flash that spread the light out slightly. These are either diffusers or special white "bounce" surfaces that literally attach to the flash. They do work to spread the light some and take out a bit of the specular harshness of a flash, but because they are small, they typically do not modify the flash a lot, and have most of their effect up close to the subject.

A diffuser is great for modifying the flash light. This shot uses a folding diffuser with the flash pointed through it. Folding diffusers are inexpensive and can make a big difference in your flash photography.

A quick and easy way to modify your flash is to use a reflector. You can have someone hold a simple piece of FomeCor for you to bounce your flash into. This can be placed anywhere for a nice directional and gentler light if you are using a cord with your flash. You can also buy folding reflectors that fit in your camera bag to give the same effect.

Another way to modify your off-camera flash is to use a simple diffuser. You can attach some tracing paper to a frame to try this out, but you will find folding diffusers available that make this much easier. You just have to have someone or something (keep some small clamps with you to help) hold the diffuser between the flash and subject. The larger the diffused light source, the gentler the light and shadows.

FLASH RECYCLING

When a flash goes from its initial burst of light to being ready to fire again is called the recycling time. Recycling time is very important to every photographer because you can't use a flash if it is still recycling, even if you are ready to take the picture. Some flashes make an effort then, but the light will be weak and under-expose the scene.

The basic flash recycling capabilities are built into the flash circuitry. However, you can influence how fast a flash recycles by:

1. Using fresh batteries. Older batteries will increase the recycle time.

2. Using NiMH (nickel metal hydride) batteries. On many flash units, these batteries increase recycling speed.

3. Keeping the flash "conditioned." When a flash is rarely used, its capacitor loses some of its capabilities. This causes it to take longer to recycle. You can often improve the flash's speed by setting it off manually four or five times at full power (i.e., letting it recharge fully each time) to condition that capacitor. It also helps to turn off the flash when it is fully charged when putting the flash away.

4. Using the flash closer to the subject. This allows the flash to use less power, letting it put the extra power back into recycling.

8 CHAPTER

Lenses

The lens on your camera controls what the sensor sees; how much of the scene is included, what is sharp or not sharp, perspective, and so on. It is a critical part of any camera, regardless if you can change the lens or not. Digital SLRs (D-SLRs) allow you to change lenses for specific purposes. Most other digital cameras use a built-in zoom lens so you can change effects for specific purposes, too. A few cameras have a single-focal-length lens that does not change in any way, but even then, it is affecting the scene in unique ways.

Understanding a bit about lenses will help you better use any lens you own (even if it is the one permanently attached to your camera), as well as help you choose new ones as you need them. Lens choice is a very personal thing and varies considerably from photographer to photographer. This chapter will give you some ideas on how to best work with a lens to meet your photo needs.

FOCAL LENGTH

What is it: The focal length of a lens refers to the distance between its optical center and the focal plane (the sensor in a digital camera) when it focuses at infinity; it is measured in millimeters (mm).

What does it do: Different focal lengths change the size of the subject at the focal plane.

Where is it found: Every lens has at least one focal length (zooms have multiple focal lengths over a range of mm).

How does it vary: More millimeters of focal length magnify the subject size and as they increase, create a telephoto lens. Fewer millimeters make the subject smaller and as they decrease, give a wide-angle lens its focal length.

Important fact: Focal length by itself affects the size of a subject at the focus point, but has no relationship to the relative magnification of a subject within the picture area. You must know the format or sensor size to determine subject magnification in the image area.

The focal length of a lens is a critical element of lens use in photography. We choose and use a set of varied focal lengths (one lens or many) for different photographic purposes. Lenses change what a subject looks like and how it is portrayed in a photograph. They affect perspective, depth of field, color relationships, and much more.

An advanced zoom digital camera's lens combines several focal lengths into one lens, making it portable and versatile.

ZOOM LENSES VERSUS SINGLE-FOCAL-LENGTH LENSES

Lenses have many variations on common features, but there are two specific types of lenses that you should know about: zooms and single-focal-length lenses (also known as prime lenses). A zoom lens is one that can change focal length or "zoom" in and out on a subject. A prime lens has one focal length that cannot be changed. While zoom lenses are very popular today, and deservedly so for their tremendous versatility, both types of lenses are quite important for the photographer.

Years ago, zoom lenses were decidedly inferior in quality compared to prime lenses. You may still hear that idea, but it doesn't have much truth in today's industry. Quality lenses, whether zoom

or prime, capture excellent sharpness and detail, and no one is going to pick out photos made with one compared to the other.

That doesn't mean you can't find lower-quality zooms that won't compare with quality prime lenses. While that is true, this is very

Different lens types will give you different results. Telephoto lenses can bring distant subjects closer, isolate them, and restrict what is seen in the frame. Wide angle lenses show a larger view of a scene, as in this example.

misleading. Low-priced, lower-quality prime lenses simply aren't marketed today. In the budget lens category, just about the only lenses you can buy are zooms.

Note that I did not say poor quality zooms. I have used many lenses, from the budget type offered by all manufacturers to elite

Lenses with many focal lengths are available, as well as prime lenses, which have only one focal length. A prime lens offers speed, and a zoom offers convenience.

pro lenses. Sure, the budget lenses do not have the image capabilities of the pro lenses, but less expensive lenses are quite good today. Modern computer design and manufacturing techniques allow companies to build very good lenses quite economically. If you can't afford a pro lens, you can still get excellent images from lower-priced optics. Where you find distinct differences are in the finishing—pro lenses are built to tougher standards so they can keep on working when pros abuse them in day-to-day shooting.

So what are the advantages of prime lenses, then? Why should a photographer even consider them if zooms work well? Those are good questions. The key benefit of a zoom is that you get many focal lengths in a single lens. That can be a big deal. It means you can change from wide-angle to telephoto, for example, without changing a lens. It allows you to travel with fewer lenses. It gives you the ability to precisely frame a subject even if you can't easily move to or from that subject.

There are several advantages of prime lenses. First is their fast maximum aperture. Single-focal-length lenses are almost always faster than zooms, even fast zooms – that can be a real benefit when shooting with telephoto lenses. They are also smaller than zooms of equal focal length and f/stop. Of course, a whole set of primes that matched one zoom lens' range would be considerably

larger than the zoom, so there is a trade-off between portability and convenience.

Pros pick primes when they need lens speed and when they can afford to travel light with one or two focal lengths. They choose zooms when they need the ability to constantly change focal length to match subject activity.

ANGLE OF VIEW OR RELATIVE MAGNIFICATION

Most photographers first buy new lenses for the angle of view they get. In fact, the name, such as wide-angle, reflects angle of view (telephoto does not—it refers to a type of optical design). This is an important consideration. You will find a wide-angle lens useful to see more of a landscape or town scene. A telephoto, with its narrow angle of view, will bring in distant subjects such as wildlife.

Focal lengths for a specific camera are typically described as wide-angle, mid-range (also called normal), and telephoto. This is important to keep in mind. Without the camera and its sensor size in mind, it is impossible to know from just the focal length whether a lens is wide-angle, mid-range, or telephoto.

This has always been part of photography. Take, for example, a 90mm lens—what kind of a lens is it? You have no idea without referencing it to a film or sensor size. The same 90mm focal length is a wide-angle for a large-format, 4 x 5-inch camera; a mid-range lens for medium-format, such as 6 x 6 or 6 x 7 cm; a short telephoto for 35mm; and a moderate telephoto for the old APS film. In digital, that 90mm is a short telephoto for the so-called "full-frame" sensors, but is a moderate telephoto for the smaller APS-C size sensor (APS-C sensors are smaller than the 35mm-equivalent or "full-frame" sensors). If you could mount that lens on a compact digital camera, it would act like a big telephoto.

The reason for this is that the angle of view, what is seen by the sensor, changes based on both the focal length and the sensor size. The smaller the sensor, the smaller the angle of view, and

the more telephoto a lens acts. The larger the sensor, the larger the angle of view, and the more wide-angle a lens acts. Consequently, you need a smaller focal length for a small sensor to equal the angle of view seen by a larger sensor with a larger focal length.

This has created all sorts of confusion about focal lengths and digital sensors, and this confusion is exactly why manufacturers state a "35mm equivalent" when talking about focal length specs. It eliminates the sensor size variable and states the focal length in familiar numbers, if you are used to shooting with a 35mm SLR camera.

Wide-angle lenses show a wide, encompassing view of a scene, showing more of the subject and its surroundings. Extreme wide angles, often called fish-eye lenses, show the widest view, and create some distortion in straight lines and around the edges of the frame.

There was a time that people would say a focal length was multiplied or changed when used on a camera with a smaller sensor. For example, they might say that a 100mm lens on a full-frame sensor became a 150mm lens on an APS-C size sensor, or a 200mm lens on a 4/3 sensor. That is impossible. Focal length cannot change—it is built into the optics of the lens.

The angle of view, however, does change. This results in a relative magnification of the subject in the image area. I have heard all the arguments about how this is really just cropping the image when the same lens is used on two cameras with different sensor sizes. In a strict sense, that is true; but then, are all image formats (35mm, 6 x 6 inches, 6 x 7 in, 4 x 5 in, 5 x 7 in, 8 x 10 in; these are all real formats) simply cropped versions of 11 x 14 in film? That's a bit extreme.

In each of these formats, that "cropping" results in a larger subject size in the format image area. By definition, when one looks at the size of an object and it changes, getting bigger, it is enlarged or magnified. This is a relative magnification, true, but for photographic purposes, it is very real in its application (no one who looks at your print is ever going to say, "but what size was that bear on the sensor?").

This is why APS-C or small-format D-SLR cameras gain an effect over a full-frame camera that, in effect, magnifies the subject in the image area. You will see cameras with a "crop" or "magnification" factor. A camera with a 1.5x factor will make a 100mm lens act like a 150mm lens on a full-frame sensor—more telephoto. It will also make a 28mm lens act like a 42mm lens on a full-frame sensor—a lot less of a wide-angle.

If you want to show both the foreground and background, a wide-angle lens is a good lens choice.

If you look at the actual focal length of compact digital cameras, you will see some numbers that may seem impossibly small if you are used to 35mm cameras. They work for these cameras because the sensors are so small.

So keep this in mind when looking at any classification of a focal length into wide-angle, mid-range, and telephoto categories. Using such a classification for a specific focal length may only apply to a specific image format size. Still, we do need to be able to

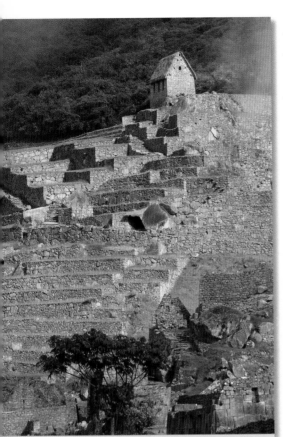

Telephoto lenses not only bring in distant subjects, they also compress distances within the frame.

talk about how lenses work in terms of wide-angle, mid-range, and telephoto, so here is what they do:

Wide-angle: Wide-angle lenses pick up an increasingly wide angle of view of a scene so that more of the subject and its surroundings are seen as the focal length shortens (occasionally you will hear wide-angle lenses referred to as short lenses). The result is that the subject size decreases in the viewfinder. The term "wide-angle" is used when a lens is shorter in focal length than a so-called "normal" lens in the mid-range focal lengths.

Mid-range: Mid-range focal lengths see the world in a moderate way, neither very wide nor very telephoto, and include the "normal" focal lengths. Normal varies from format to format, but in general refers to lenses that "see" the world in a perspective similar to how we see a scene with our eyes. With 35mm, this was typically considered to be approximately 45–55mm. In APS-C size digital formats, this normal is about 30-37mm. Mid-range includes a little more than the pure normal focal length, including slight wide-angle and slight telephoto. This is largely because of zooms. Years ago, there were no such focal lengths available in the lenses made for cameras.

Telephoto: Telephoto lenses see an increasingly smaller part of the scene so that the subject is magnified in the image area as

the focal length increases (you often hear telephotos referred to as long lenses). The term "telephoto" is used when a lens is longer in focal length than a so-called "normal" lens in the mid-range focal lengths. Telephoto also refers to an optical design. Years ago, long lenses were all long indeed, as long as their focal length. A telephoto design compresses the size of the lens so that it is physically shorter than its focal length.

PERSPECTIVE AND FOCAL LENGTH

One very important use of focal length is to change perspective in a scene. Perspective in a photograph relates to how objects in a scene change in size as they move closer or farther from the camera; it comes from a relationship of size and distance.

The best way to understand this is to consider an example. Imagine that you hold two identical basketballs in your hands. If you bring one close to your eyes and keep the other at arm's length, the one closer to you looks

bigger. If you hold them at the same distance, they are the same size. A painter will create the appearance of depth in a painting by changing this relationship—when the artist puts these balls onto a plain background, he or she can make the balls look the same size or radically different size, changing how you see the distance between them. This relationship of size and how we perceive distance is what perspective is all about.

By changing focal length and your distance to a subject, you can change the perspective in a photograph. This can be a very powerful effect and is possible with even the simplest point-and-shoot camera with a zoom lens. But it is important to understand that perspective control over a composition comes from both distance and focal length.

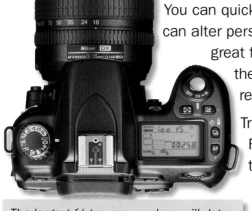

You can quickly see how using a zoom lens can alter perspective. A digital camera is great for this because you can see the effects immediately when you review the photos in the LCD.

Try this exercise in perspective. Find a subject a little distance in front of a distinctive background. You don't need a strong subject and background for this effect; they just make the effect easier to see.

The largest f/stop on your lens will determine the smallest depth of field you can capture in your photos.

Now go to the widest zoom setting of your lens. Get close enough to your subject that it fills most of the distance from the top to the bottom of your photo and take a picture. Next, zoom into the most telephoto setting of your lens. Then back up until your subject once again fills most of the distance from the top to the bottom of your photo—you are trying to keep your subject approximately the same size in each shot. Take the picture.

Try out different perspectives with your lenses. Some very creative images come from the willingness to experiment. Use your LCD to check your results.

When you compare the two photos, you will immediately see a change in the background. Even though you know the distance between the subject and background did not change, it looks like it did. The wide-angle shot has a background that looks much farther away from the subject than the telephoto shot. The wide-angle image has a deeper perspective, and the telephoto has a flatter perspective.

This is something that pros use all the time. If they have a subject that is surrounded by a lot of other objects that are important to the photograph, but distract from the subject, they can choose a wide-angle and get close to the subject. This makes the surrounding objects smaller because perspective has been stretched.

A wide-angle lens, or short lens, increases what you can include within your frame. You can put your subject in the foreground with a supporting background, or you can put your subject in the background with a supporting foreground. The above image is a good example of the latter.

On the other hand, if a photographer wants to make the subject look like it is packed in with other things, he or she can use a telephoto to compress the distance between them. Strong telephoto lenses make objects look like they are right on top of each other when, in fact, they are not in real life. This is a Hollywood trick used in movies to make it look like the hero is about to be run over by a truck, for example, when the truck really isn't that close.

You can use perspective control for creative effect, or you can use it to simply make a livelier and more interesting photo. A sun setting over the mountains may look fine with a mid-range focal length, but change to a strong telephoto and the mountain ridges become more dramatic against a larger sun. Or with a really wide-angle lens, you can get up close to a subject and make it totally dominate the rest of the image.

As you may have guessed, you can also use perspective to "lie" about a scene. Many people have worried about what image processing programs such as Adobe Photoshop might do to the truth of a journalistic image. They may be worried about the wrong thing. A photographer can do far more damage with the use of lenses, then make people believe the image is "true" because no changes were made in Photoshop software.

Here is an example to further illustrate the power of perspective control. Imagine two photographers taking pictures at a politician's rally. One likes the politician and one does not. The pro-politician photographer steps back, puts on a telephoto lens and compresses the distance within the rally, making it look like a packed event full of energy and enthusiasm. The photographer who dislikes the politician finds an area of empty space, puts on a wide-angle lens, gets close to that space, making the rally seem lightly attended, an event that didn't interest many people and was probably rather dull. While both photographers capture images that are superficially true, neither is probably really representing the event truthfully in the final photographs.

DEPTH OF FIELD

Depth of field is the amount of acceptable sharpness from foreground to background within a photograph. While it shares the idea of depth with perspective, the two photo controls have nothing else to do with each other. Depth of field affects only perceived sharpness in depth. Perspective deals with size changes in depth.

Three things affect depth of field:

1. Aperture or f/stop

2. Focal length

3. Focusing distance

We covered depth of field a bit in Chapter 4 in relation to f/stop or aperture. This is also part of a lens, as is where a lens focuses, so in a sense, all three things are controlled by how you choose and use your lenses. You can check back to Chapter 4 to review f/stop effects. Here we'll look mainly at focal length and focusing distance.

The shorter the focal length of a lens, the greater the apparent depth of field. (I have to qualify this because technically, it can be demonstrated that actual depth of field does not change, but this is a rather esoteric idea that comes from shooting two scenes from the same distance with different focal lengths and cropping into the wide-angle shot, not something we normally do.) Conversely, as you increase the focal length of a lens, apparent depth of field decreases.

This is a very significant effect in a photograph. If you want your background to be seen more clearly behind your subject, you might change to a wider-angle focal length. If you want that background to diminish and be somewhat out-of-focus, you could change to a longer focal length.

This is often used for some specific types of photography. Landscape photographers, for example, often shoot with a wide-angle lens to gain more of a feeling

This image shows a large depth of field, which supports the composition nicely. The greater depth of field connects the viewer to all the elements in the photograph.

This photo's shallow depth of field focuses the viewer's attention on the intended subject. It is a good contrast in this image, as the subject is surrounded by similar objects and colors. Contrast is an important compositional element (see Chapter 10 for more on composition).

of depth (from perspective) and sharpness (from more depth of field). People photographers, on the other hand, typically do just the opposite and shoot with a telephoto lens to make the subject stand out from the background because of less depth of field.

Distance to the subject changes depth of field as you focus closer or farther away. A close focus distance will make depth of field shallower. Focusing farther away will make depth of field greater. This is why close-up or macro photography can be challenging for sharpness—depth of field gets extremely shallow no matter what you do. On the other hand, you can focus on mountains in the distance and not worry much about depth of field. They will pretty much be sharp no matter what you do.

All of these work together, of course: f/stop, focal length, and distance. Your smallest depth of field comes from a wide aperture

used on a telephoto lens at a close distance. The largest depth of field comes from a small aperture used on a wide-angle lens that's focused at a distance. The chart below shows this relationship.

Two extreme examples of sharpness control are selective focus and hyperfocal distance. Selective focus allows you to very pre-cisely define focus on a subject (or part of a subject) and make everything else out-of-focus. This is done by using a wide aperture on a telephoto lens and being close to your subject.

Hyperfocal distance, on the other hand, refers to a focusing distance, f/stop, and focal length combination where everything is in focus to infinity from a certain point in front of the focusing distance. This used to be something more easily accomplished when manufacturers put depth-of-field markings on their lenses. However, you can use the idea of getting everything in focus from close to far by choosing a small f/stop on a wider-angle lens and a focusing distance that is at a moderate distance from the camera.

Depth of field	Aperture or f/stop	Focal length	Distance
Less	Wide (e.g., f/2.8)	Telephoto (or long focal lengths)	Close
More	Small (e.g., f/16)	Wide-angle (or short focal lengths)	Far

That distance is the tricky part and often means you have to set a focus distance behind important parts of your subject. This is be-cause depth of field extends both in front of and behind the focus point. If you merely focus on the closest part of your scene, you have two problems: first, you have wasted depth of field in front of the focus point, and second, depth of field is smaller because of the closer focus distance. You may have to try this and check your

LCD review, magnifying the image to be sure important parts of your subject are in focus.

USING DIFFERENT FOCAL LENGTHS

Now that you know a little about how lenses affect an image, and that those effects extend far beyond simply getting more or less of a scene in the photograph, you might want to consider how you can use these ideas on various subjects. Here are some typical uses of focal lengths you might think about (these are only meant for reference and not to restrict uses of lenses to any of these subjects):

SPECIAL LENSES

Special types of lenses are available to help photographers with certain types of photography. They aren't needed by every photographer, but are worth knowing about:

Macro lenses: True macro lenses are specifically designed for high sharpness at very close distances and focusing from infinity down to a 1:1 ratio without accessories. 1:1 simply means that the subject is the same size on the sensor as it is in real life—obviously that means getting very close to your subject! Most so-called macro zooms and telephoto lenses are actually close-focusing lenses that do a fine job but aren't optimized for close sharpness

Uses of Wide-Angle Lenses	Uses of Mid-Range Lenses	Uses of Telephoto Lenses
◆ Landscape photography	◆ Landscape photography	◆ Compressed landscape effects
◆ Travel scenes	◆ Travel scenes	◆ Wildlife photography
◆ Connecting subject with surroundings	◆ People photography	◆ Sports photography
◆ Making scenes look deeper	◆ Making scenes look normal; avoiding dramatic effects (documentary-style photography)	◆ Portraits
◆ Dealing with small interior spaces		◆ Isolating subject from surroundings and especially background
◆ Capturing groups of things or people when space is limited	◆ Connecting subject with surroundings	◆ Flattening scenes
◆ Creating dramatic deep space and perspective effects		◆ Making large spaces seem smaller
		◆ Creating dramatic compressed space and perspective effects

This image taken in China shows the effects of a telephoto lens. The photographer was able to use the lens to bridge the gap between the camera and the subject, and the scene is slightly compressed so that it's difficult to estimate distances.
Photo © Jack Reznicki

the way a true macro is. Macro lenses come in different focal lengths which affects the same things as discussed previously about wide-angle, mid-range, and telephoto. In addition, focal lengths affect distance to subject. A shorter focal length macro gives more depth of field and a deeper perspective, but it also means you have to get closer to the subject. Telephoto macros put some distance between you and skittish or hazardous subjects.

Teleconverter lenses (also called tele-extenders): These lenses fit in between your D-SLR and prime or zoom lens, and multiply the focal length of that lens. They are a relatively inexpensive way of increasing the magnification of a telephoto lens (they don't work well with wide-angles and often can't be physically attached to a wide-angle without damaging the lenses), plus they are much smaller than carrying along another big lens. However, they are only as good as the lens they are mounted to. They can only magnify what the original lens is or is not capable of—they will definitely magnify its flaws. For that reason, most lenses work best with a teleconverter if they are stopped down below the maximum aperture of the lens.

In addition, they tend to work best with prime lenses as compared to zooms, though that depends a lot on the specific lenses involved. Finally, they effectively reduce the light coming through the lens. A 1.4x converter, for example, multiplies the focal length by 1.4 but it also reduces the light by an f/stop. A 2x converter drops that light by two f/stops, which can limit your shutter speed and will often affect auto-focusing.

Accessory lenses: Accessory lens is a term that refers to add-on lenses for compact digital cameras that don't have interchangeable lenses. These can be very effective in giving your camera added wide-angle, telephoto, or macro capabilities. Accessory lenses are usually pretty affordable because they are simply lenses and have none of the features needed by an interchangeable lens such as a focusing mechanism, f/stops, and so forth, because the camera's original lens provides that. These lenses are also quite compact, and when combined with a compact digital camera, make a very portable package.

LENS FEATURES TO KNOW

As you look into lenses for your camera, you will run into a number of features that can qualify how well a lens will work for your specific needs. Not all lens features are available in all lens types and focal lengths, nor are they needed for all photographers. However, when you do need them, they are worth considering.

Maximum and minimum f/stops: The concept of maximum and minimum f/stops can be confusing, but they have a very strong effect on how a lens can be used. The maximum f/stop is the widest aperture possible with a lens; for example, f/2.8 or f/4. The minimum f/stop is the smallest aperture that can be set on a lens; for example f/16 or f/22. With compact digital cameras, you may find a minimum of f/8 or f/11. The reason for this is that as the aperture gets physically smaller, something called a diffraction

Large f/stops, which create shallow depth of field, bring the focus of the image straight to the subject. Large f/stops are good for portraits.

effect occurs, making a lens less sharp. Compact cameras have very small lenses, and this means their f/stops are physically very small, too. The result is that lens designers run into diffraction effects faster as the lens is stopped down to smaller f/stops. This limits them to f/8 or f/11 when lenses for D-SLRs can go down to f/16 or f/22 or lower.

Special lens elements: Uncorrected lenses have aberrations that cause sharpness and color problems. All camera lenses are highly corrected to deal with these aberrations that might cause color fringing (false colors appearing along the edges of dark objects near the outer borders of the image) and softness (due to blurring of highlights) among other things. There used to be a large gap in lens quality from the budget lenses to the most expensive pro models, but that is no longer true. Still, more expensive lenses, and even newer low priced lenses, often have special lens

elements to give even better lens correction. These include APO, low-dispersion glass, DO, and aspherical lens elements within the lens itself.

APO-designated lenses most often refer to telephotos. Telephotos are more susceptible to different colors focusing at slightly different points, called chromatic aberration, resulting in blurring and less sharp images, especially at wide apertures. APO lenses add elements to better control these colors and bring them all into focus at the same point. Such lenses are not simply sharper even at wide f/stops, but they are usually more "brilliant," meaning they give crispness in the photo due to sharp, well-defined highlights.

Low-dispersion glass is often used as part of a lens' construction to give better image quality, to bring a lens to APO correction. This is called by many names, including super-low-dispersion (SLD), extra-low dispersion (ED) and super ED glass. Designers add individual lens elements to the overall lens design using this type of glass to better control how different colors of light are focused. Fluorite lens elements traditionally did this job even better yet, but were very expensive to produce, plus they had problems shifting with temperature changes. The latest versions of low-dispersion glass approach fluorite correction with much lower cost and more structural strength and stability.

DO, or diffractive optics, is a relatively new lens technology. The story is that only computer design and manufacturing made them possible. These lens elements change the actual cross-section of a lens using a technology that essentially duplicates the curve of a lens in tiny sections that are flattened out into a rather thin lens. The result is a lens that is both shorter and lighter than an equivalent standard lens, so it is typically used for telephotos.

Aspherical or aspheric lens elements also change the cross-section of a lens. Usually, lens elements have a continuous spherical or concave surface, depending on the type of optic. Aspherical lenses have a contour that changes across the face of the lens. This complex surface shape changes the way light goes through the

Longer focal lengths allow you to get closer to finicky subjects, such as animals and insects, without disturbing them. Most wildlife photography is done with telephoto length lenses.

lens, helping eliminate a type of lens aberration (called spherical aberration) that is a challenge for wide-angle and zoom lens designs. A single aspheric lens element can do the duty of what would otherwise require a more complex multi-element lens assembly.

Aspheric lenses used to be very expensive and only found in the priciest of lenses. Then computer-aided manufacturing and lens molding techniques allowed this type of lens to be used with even very inexpensive lenses. The result is much higher quality optics for even cheap point-and-shoot cameras.

IF (internal focus): A relatively recent development in lens design (compared to the history of lens manufacturing) is internal focus. Originally, all lenses focused by moving part of the lens closer or farther from the focal plane in the camera. The lens then got physically larger, which could really change the form and balance of a large lens. Internal focus uses optical mechanisms buried inside the lens to allow focusing to occur with no change in the outer dimensions of the lens. In addition, this allows the lens to focus without rotating the front element, making certain filters (such as polarizing filters) easier to use.

Image stabilizing lenses: During the mid-1990s, Canon introduced a type of lens to still photography called an IS (Image Stabilization) lens. It had an internal mechanism to shift lens elements to compensate for camera/lens movement during exposure. This allowed for sharper images at slower shutter speeds. Nikon later introduced the VR (Vibration Reduction), Sigma introduced the OS (Optical Stabilization), Panasonic the OIS (Optical Image Stabilization), and Tamron the VC (Vibration Compensation) that all did the same thing even if manufacturers felt they had to have original

names. These technologies really work and help photographers handhold lenses at slower shutter speeds than normal.

Tripod socket: This might seem like an odd thing for a lens chapter, but actually, it is very important. As lenses increase in size, they add a bit of weight to the camera. If you then mount such a camera/lens combination by the camera tripod socket, the whole thing is put out of balance (plus it stresses the camera lens mount) and can contribute to image vibration, even though it is mounted on a tripod. Many larger lenses have tripod sockets or collars that allow them to be mounted directly to the tripod, providing a much better balance and potentially sharper photos.

Lens hoods: Lens hoods now come with most lenses, yet many of photographers don't use them. True, they can be awkward to store and they do add length to a lens, but they also add tremendous benefits for the photographer.

You gain two important forms of protection from a hood—protection from bright lights and physical damage. Bright lights, such as the sun, can throw a lot of light into a lens even if the lights are not in the composition. This extra light bounces around inside the lens and causes flare, weakened contrast, and diluted color. A lens shade limits the angle where light can get into the lens so that this internal bounce light is restricted, making your images look better.

A lens hood also keeps things like fingers, branches, and rain off of the front of the lens. This is far better than a "protective filter." A filter can get damaged and dirty, so even though it protects the glass element of the front of a lens, it can give poor results. A lens shade actually keep things away from any optical surface so that there is no damage or dirt on the front of the lens.

Filters

The camera sees a particular view of the world that doesn't always match ours. Filters are simple lens attachments that screw into or fit over the front of a lens to alter the light coming through the lens, helping the camera better capture the scene.

Filters are also used creatively to change what the camera sees through the lens into something that is not real. Filters can create fantasy and special effects as well as make corrections to how a subject is photographed.

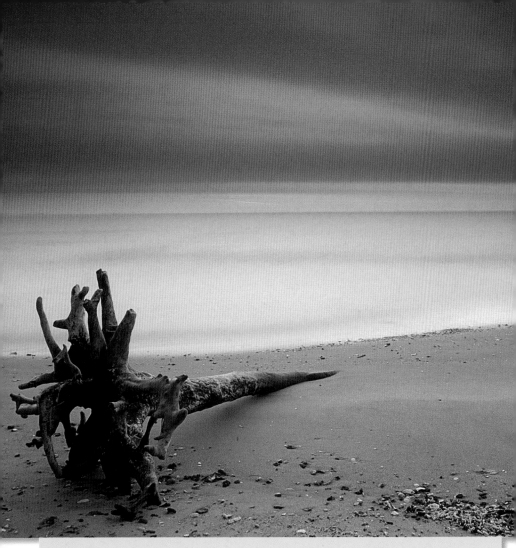

Filters are still worth using, even with digital technology. Not everything can be done in the computer, nor does it need to be. The above image was shot using a graduated neutral density (grad ND) filter. See page 240 for more on ND filters. Photo © Ferrell Mc Collough

FILTERS IN A DIGITAL AGE

As more and more photographers switched from film to digital, they discovered there were many more controls available in digital photography. Because filter effects could be mimicked, many photographers began to think they didn't need them at all. This started to become an idea expressed by "experts" who could

show you what computer processing could do that filters couldn't.

That's more than a bit misleading. Digital changes some of the things we need from filters, but some things stay the same. For the photographer who really wants the best control over his or her image, filters are still important accessories.

It is worth noting that filters were never an absolute necessity. I have known many photographers who never use them and they have done just fine with film or digital. They work around situations that might need a filter. So, if filters are more trouble than not for you, don't bother with them.

For most of us, though, filters provide a real service to our photography. They can help us get photographs that would be very challenging without a filter. There are a number of advantages to using a filter with a digital camera, including:

1. Filters bring extremes into range: The digital camera sensor is only capable of capturing so much of a range of tones. Graduated filters, for example, allow you to shoot in situations that would challenge the sensor without them.

2. No computer needed: Filters allow you to control tones and colors at the camera rather than in the computer, allowing you to

make better photos directly from the camera or memory card at home, or from a lab. At the very least, you can make a good print faster from the computer.

3. Less work: Filters affect tonality and color in the image so that less work is needed if you do bring the images into the computer. They can give an image that is much closer to a finished result than without filters.

4. See what you are getting: With a filter, you can the effect of the filter see as you shoot. There is no guessing as to what you "might" be able to do later in the computer.

5. Filters encourage an attitude of craft: The more you can get the photo right in the first place, while you are there with the subject, the more likely you will have the best image possible when you work on it in the computer. That level of craft comes from thoughtful use of filters as much as choosing the right shutter speed and f/stop.

Polarizing filters change the way light hits the sensor, and they let different light waves in at different angles. Turn your polarizer to get different effects.

TOP TWO FILTERS FOR ALL PHOTOGRAPHERS

If you asked a lot of different photographers for their favorite filters, you would receive a variety of answers. After all, a photographer's approach to a certain subject can be very personal and affect preferences for any gear, including filters.

However, you would find two filters that would come up consistently. I believe these are two filters all digital photographers should own, even if they have no others. They are the polarizing filter and the graduated filter (or split ND).

The polarizing filter is a very useful filter because of the way it deals with colors (it also affects tonalities, but the color effects are so pronounced that tonal effects are often missed). A polarizer, as it is often called, changes the way light hits the sensor. Technically it filters light waves so that only those with parallel form can get through. The physics are not as important as understanding that

A polarizing filter was used to make the above photograph. The sky is a more saturated blue and makes the greens and yellows on the plant stand out.

rotating the filter then changes which light waves can get through. Therefore, a polarizing filter always has to be rotated for its effect.

Polarizing filters do four key things:

1. Darken blue sky at certain angles and create contrast with clouds: A polarizing filter will make blue skies darker, but the effect is variable depending on the angle to the sun. The maximum effect occurs at 90° to the axis of the lighting direction, which happens when your subject is lit from the side (the sun comes directly to your side as you are photographing). The minimum (to no) effect happens when you are photographing directly toward or way from the sun.

This can be a problem when using polarizers with wide-angle lenses, as they often capture an uneven sky from seeing too much of this effect. Also, you may find that at higher altitudes in the mountains, skies get too dark (almost black—which can be used as an effect if you want drama, but it can make a scene look rather harsh).

2. Remove reflections: When you see unwanted reflections in windows and on water, you can often remove them with a polarizer. You may find, however, that the effect is too strong when the glass or water "disappears" making the photo look odd (a good thing to watch for in the LCD review). You can rotate the filter so some of the reflections return.

3. Enrich colors by removing glare: A polarizer removes glare from shiny objects, allowing their underlying color to come through. Specular reflections, the direct glare of a bright light off a shiny object, are not affected. It is only the so-called diffuse flare that comes from bright, diffuse light, such as the sky, that sees the greatest effect. This can be a very dramatic effect, especially when

photographing landscapes with shiny leaves that reflect the sky. The greens really pop with a polarizer as it removes that sky reflection.

4. Cut through haze: Polarizing filters reduce the effect of light haze and make the image look more contrasty. However, they can't do miracles and remove haze altogether, nor do they have an effect on heavy haze or foggy conditions.

There are two main types of polarizer—circular and linear. You will mainly use a circular polarizer with digital cameras, though you may run across linear polarizers in older gear (or with a photographer who likes their effects). These are simply polarizers that affect the light waves a little differently. Again, the physics is not as important as the effect. Most autofocus systems and many autoexposure systems have problems with the way light comes through a linear polarizer and give irregular to wrong results. Circular polarizers do not have that shortcoming.

However, a linear polarizer generally has a slightly stronger effect and some photographers chose one for that reason. In return, they have to be careful with exposure and autofocus.

To use a polarizer, hold it up to your eye and rotate it to see the effect. Decide then if it is worth using or not. It is not a good idea to leave the polarizer on all the time—it significantly reduces exposure, and makes the viewfinder much darker on a D-SLR. Put the filter in front of the lens and rotate it to the best effect. Also check the results immediately on your LCD and compare the image with and without the filter.

Graduated filters are useful when you are shooting into a bright sky. Rotate the filter so that the darkest part is over the sky, and then make your exposure.

GRADUATED FILTER (SPLIT ND)

The graduated filter gets its name from a graduated tonality through its middle. Half of it is clear, the other half is dark, and it is blended in tone across the middle. When the dark half is a neutral tone, it is also called a split ND filter (which stands for split neutral density). These filters are often simply called grads, too.

These filters really help balance the light in a scene. Landscape photographers commonly use them to moderate extremes in tonalities between bright skies and dark ground. By rotating the filter (and sliding it in its holder if it is rectangular), the dark part of the filter can go against the sky, the clear part across the ground. The result is that the bright sky is reduced in tone, yet there is no effect on the ground. You can get these in sky blue colors to enhance skies or sunset colors to enrich sunrise or sunsets. Strong yellow grads are very popular with travel photographers because it

helps them get a warm, romantic sky even if it doesn't exist in real life.

Graduated filters come with different blends across the middle. The most common is a soft edge that blends the dark and light parts of the filter quite nicely—these are very easy to use. Just put one over the lens, move it up and down until the scene looks right, and take the picture. Check the exposure on the LCD if you aren't sure of your results. If it isn't quite right because of either the filter or the lighting conditions, make an exposure adjustment and try again.

Another common grad is the hard-edged split. This has a sharp edge across the middle boundary between light and dark and can be used when there is a distinct edge between light and dark areas in the image. You do have to be careful that a hard-edged split does not awkwardly show up in an image shot with a lot of depth of field (it can make the edge appear).

All grads can be rotated so the dark and light can be used in

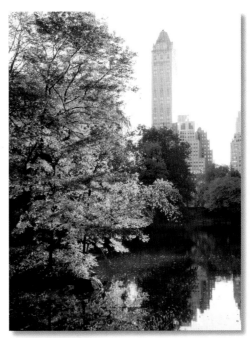

The image taken without a graduated filter (top) has overexposure problems as compared to the image taken with the filter (bottom).

different places on the scene. For example, you could put the dark down to reduce the brightness of a sandy beach in front of darker water. Or you could rotate it over a bright window to knock that brightness down compared to the rest of the scene. The possibilities are endless.

OTHER USEFUL FILTERS

A neutral density (ND) filter darkens a bright scene so that the photographer can use slower shutter speeds for various effects.

Go to any photography store and you will see a wealth of filters. Try any you like. Obviously, they work for some photographers. But there are too many filters with too many specialized uses to cover in this book, so here are three more that are especially useful with digital photography:

ND or neutral density filters: These are neutral, dark filters, sort of like gray filters, yet they are really black with different intensities. They reduce the overall light going into the lens for exposure effects. Mostly they are used to limit the light enough that you can use slow shutter speeds in bright conditions. This can allow for creative blur effects on moving objects, from runners to birds to cars. It also allows for that smooth water effect that comes from long exposures on moving water (you are actually photographing flow patterns). Remember to use your tripod.

Soft-focus filters: Soft focus filters soften the sharpness of a lens in quite a predictable and consistent manner. They are used for a "romantic look" on landscapes, travel scenes, and flowers, but their prime use is for people. They take the edge off of a too sharp face that might be unflattering. And they are often used for wedding photographs.

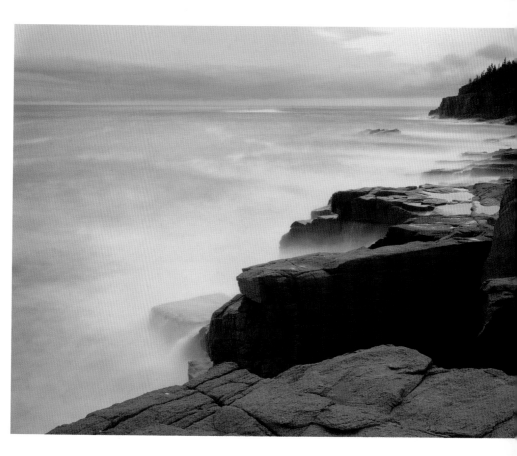

Star filters: Star filters are not for everyone, but they can add a bit of glamour and drama to a shot. Even if you've never owned one, you've seen the effects on televised events when these star patterns appear from bright lights. They work quite well in those situations, giving glamour to things like high school concerts, church events, and so on. They work very well at night by adding a dramatic light pattern around all the bright lights.

Note: During the day, you can get a star pattern around the sun (and bright reflections) by stopping your lens down to its smaller f/stops and shooting so the sun is near something dark (so the light pattern shows up). The small f/stops create what is called a diffraction pattern as the light diffracts along the aperture opening.

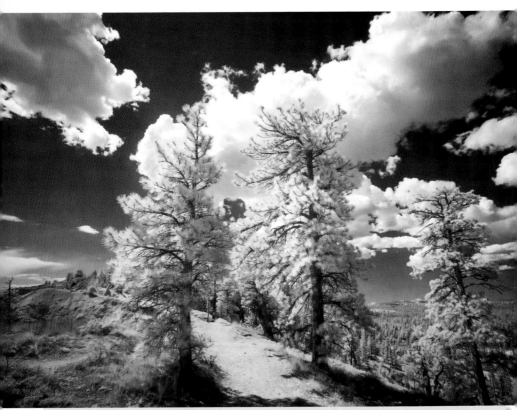

Infrared images may look like black and white at first, but notice the foliage of the trees. Leaves appear white because the sensor is sensitive to the infrared light waves given off by the chlorophyll layers in vegetation. Photo © Joe Farace

INFRARED (IR)

Digital photography has brought a whole new interest to infrared (IR) photography. It was always possible with film, but it was a pain. IR filters were impossible to see through, yet you had to use them to block out all but the infrared light. IR film was unpredictable in its response to light, and it had to be loaded into cameras in total darkness. Yet, the results were striking enough to make it worth trying for at least some photographers.

Digital sensors naturally see infrared light. With the right IR filter, the results can be spectacular with few of the problems from infrared film. Plus, with the LCD, you can immediately see results.

However, camera designers often put an infrared blocking filter over the sensor to limit IR interference with normal photos. This is true of most D-SLRs and some compact digital cameras. It doesn't mean these cameras can't see infrared, it just means very long exposures.

There are ways around this:

1. Check out a point-and-shoot camera for IR: Many of them will see infrared just fine. The way to tell is to turn on your camera and have someone point a television remote at the camera. Push buttons on the remote and check the LCD for light appearing from the front of the remote. If you see something, the camera sees infrared and it may be worth a try. Results can be variable and exposures can be very long.

2. Find an old Minolta Dimage 5 camera: This camera was (and still is) a popular IR camera. (Newer versions of the Dimage had IR blocking filters.) Results can be very good and exposures can be quite long.

3. Have a D-SLR modified: Older D-SLRs can be purchased fairly inexpensively compared to a brand new model. It is easily modified; have the IR blocking filter removed from in front of the sensor. A number of specialty camera modification companies do this. The disadvantage is that once modified, the camera can only shoot IR. The advantage is that the camera functions fairly normally; a clear viewfinder and faster shutter speeds are possible because you don't actually need an infrared filter over the lens.

The IR filter is a very dark filter, nearly black. It can be used with digital cameras that have not been modified and some work quite well with it. You will need to put the camera on a tripod and experiment a bit with exposures. One nice thing that photographers like about non-SLR digital cameras that see IR well (such as the Minolta Dimage 5 camera) is that the LCD is live, so it shows you what the sensor is seeing through the filter.

PROTECTION: DO YOU NEED IT?

Many photographers use a "protective" filter over the front of their lenses. Now, that seems like a no-brainer. Put a clear filter over the front of an expensive lens to keep it from getting scratched. A cheap filter is easier to replace than an expensive lens, right?

Yet many pros have very expensive lenses and cannot afford to have problems with them, and they almost never use protective filters. Why? There are some good reasons for considering keeping filters off your lens until you really need one:

1. Expensive lenses are highly corrected. An inexpensive filter can throw that correction off and make the lens less sharp.

2. Every filter added to the front of a lens adds potentially reflective surfaces that can result in flare (filter-created flare is a common problem).

3. Stacking filters one on top of the other can decrease sharpness and cause flare problems, plus this can result in vignetting (darkening at the corners of the images).

4. A "protective" filter can give a false sense of security; photographers without a filter in front of the lens often take better care of those lenses.

LENS HOODS

Pros typically use a lens shade at all times on the lens, not just to protect the lens from stray light, but also to keep fingers, twigs and other things from even getting close to the front of the lens.

If you really feel uneasy about unprotected lenses, then follow these guidelines:

1. Buy the best filter possible. Don't use cheap filters.

2. Use a lens cap. Do not leave the lens filter exposed without protection.

The graduated filter used to make this photograph gives the above scene a calm but moody quality.

3. Remove the protective filter when you are adding other filters.

4. Treat the filter as an important optical element and keep it clean.

FILTERS FOR BLACK AND WHITE

Many digital cameras allow you to create a black-and-white image directly from the camera (without any further processing). One of the biggest challenges of black and white is how colors are translated into gray tones. Any camera that changes color to black and white is interpreting those colors. Should green be light gray or

Because many digital cameras have a monochrome mode that will translate a photo from color into black and white, black-and-white filters are still used. They come in several colors that translate certain colors into varying gray tones.

dark gray? Should red be dark or light? Should blue be dark and red light or the other way around?

Camera manufacturers create an "average" change of colors to black and white that fit most scenes like black-and-white film did. But just like black-and-white film, digital black-and-white images can often be improved with filters (these can be actual filters or

internal processing algorithms in the camera, which are discussed below). Filters change how colors are translated into grays. A filter makes colors that are the same or close to the filter's color a lighter gray; colors that are radically different become darker shades of gray. Here are common black-and-white filters with how they are typically used:

◆ **Yellow:** This filter keeps yellows and greens light and makes blues a little darker. Many photographers use this as a standard filter for slight increase in contrast.

◆ **Red:** This is a very dramatic filter. It makes reds light, darkens greens a bit, and really darkens blues. It strongly increases the contrast of a scene. This is especially dramatic in landscapes where skies get nearly black and clouds pop out. It will make red flowers light in a field of dark green grass. It makes light skin tones even lighter.

◆ **Orange:** This is an in-between filter, with more drama than yellow, but not as much as red. It is often used in black-and-white photography to portray beautiful blue skies with white cumulus clouds.

◆ **Green:** This filter is often used for tree-covered landscapes, as it enlivens the green leaves. It is also used for photographing people. It makes skin tones darker and richer, and gives contrast to red lips. These filters can be used with any digital camera that allows you to shoot in black and white. The neat thing, once again, is the LCD. You can immediately see the effects of any given filter and decide if it does the job you want or not.

Many advanced digital cameras and D-SLRs now offer internal processing to mimic these filters. You can usually find settings for at least red, yellow, and green. They don't work exactly like a filter, but they can be very handy when shooting black and white to get better interpretations of color translation to gray tones. You may find these do enough of the job that you don't need other filters. Or you may find the filters give stronger effects.

You can pretty much go with the exposure your camera meter gives you when photographing through a filter. However, there are some things you need to consider about filters' effects on exposure and why you might make some alterations in exposure for certain conditions:

Most filters darken the scene: Your meter largely compensates, but the result is slower shutter speeds, wider apertures, or both. You may be limited in what you can do in handholding a camera or using certain f/stops. Polarizing filters drop the light through the lens by up to two f/stops. Dark black-and-white filters reduce the light significantly, depending on the filter. ND and IR filters make a huge difference in the light to the sensor.

Grad filters may need exposure adjustments: Sometimes you can use a grad over your lens and just use the meter reading. In

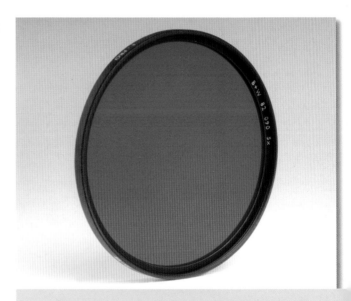

A red filter for black-and-white photography creates interesting and unexpected results. It will blacken skies and make reds appear as a light gray tone.

other situations, you need to reduce the exposure (underexpose from the camera's suggestion) to get the best results. Check your LCD and histogram to confirm what is needed.

Polarizing filters can give misleading exposure results: While it is true that a linear polarizer can cause exposure problems, another issue comes when shooting a composition with a lot of sky. In that case, the sky could become so dark that it fools the meter into "thinking" more exposure is needed, resulting in overexposed clouds and other bright parts of a scene. Be aware of this and look for problems in your LCD review and histogram.

10 CHAPTER

Composition

I n the days of George Eastman and the first Kodak cameras, the average photographer was excited about getting any picture, let alone being concerned about composition. Photography had been invented only about 30 years before (imagine that!), and no one had photo books (photographs weren't commonly published in any sort of publication until the early 1900s). Pictures were a novelty for most folks.

Of course, there were pros working with large view cameras and glass plates for "film" who cared a lot about composition. They wanted photography to be seen as an equal to painting and other fine arts. Composition was always an important part of art, so these early photographers studied fine art as a way of refining their compositions.

Today, good composition is essential if you want people to really look at your photographs beyond being happy to see a picture of a friend or relative. Our world is saturated with photographs in magazines, newspapers, on billboards, in ads, on posters ... you would have a hard time walking anywhere in a city or town without quickly seeing photographs.

Your photographs have to compete. That may sound harsh, but it is true. Photography has become a ubiquitous form of communication, but it communicates poorly without some attention to composition. In addition, composition is what attracts a viewer to your photos, helps them see new things in subjects you have captured, and is what helps them say, "Wow! What a great photograph!" And you want folks to do that at least some of the time!

MAKING A PHOTO (NOT SIGHTING ON A TARGET)

This seems a bit like a "duh" moment, right? Well, don't judge that too fast. Better composition comes from the right attitude toward taking a picture and it starts right here, keeping one thing in focus. You are making a photograph, not sighting on a target.

What happens all too often with snapshooters is that they use the camera's viewfinder or LCD screen to encircle the subject, in essence, using these aids to picture-taking as sighting devices. That means the subject is captured, to be sure, and a picture is taken, but no photograph has been made.

There are many ways to make a good composition. Do not copy something you've seen, but do learn from the images that you like. What attracts your eye?

Ansel Adams used to make a big deal about this in his very famous books about photography written many years ago (and still in print today). He talked about how important it was for a photographer to create a photograph by paying attention to photographic craft—things like exposure choices, lens selection … and composition.

The digital camera makes it simpler to create a photograph than when everyone shot film. All of the ideas covered in this chapter are much easier for digital photographers to achieve for one reason—the LCD screen. This is a huge breakthrough for the average photographer. Think about it—in the past, when you took a picture, you could not be sure of what it looked like until you got the film back from the processor. You could only appraise your image and its composition at that time—hours or days later.

The LCD lets you see exactly what you are getting as a photograph. This can come from a live LCD (always on to see what the lens sees) or LCD review.

Use this as an opportunity to see a photograph. Does that image in the LCD look like a photograph you would like? Or is it just showing how the subject was surrounded by the edges of the picture? Does it look like a picture you would enjoy sharing with others because it is a photograph and doesn't simply document a subject? Would you put this photograph on your wall? Start thinking, "make a photograph," and you begin to see images rather than simply subjects.

DON'T TRY TO COPY A SCENE

There is a tendency for many photographers to want to copy a scene with their camera. They like the scene or subject and want to capture that in a picture. Sometimes people obsess on this possibility, always trying to buy better cameras and lenses in the hopes of getting a better copy of the world.

The repetition of a common element in the above photo gives the viewer's eye something to focus on and come back to. The color contrast is also an effective compositional tool.

Unfortunately, the world doesn't copy that well. This was expressed by that very common expression of film photographers, "I hope my pictures turn out." And when they picked up the film from the processor, they were often disappointed because the pictures did not really capture the beautiful scene or great subject.

The real world and a photograph are two very different things. All an image can do is interpret our world in conventions we understand, but that interpretation is something totally different than the subject. The great French painter, Magritte, expressed this in his famous pipe painting that included the words, "This is not a pipe." It wasn't—it was a painting of a pipe.

Why is this important? Think about how we experience the world. We see movement, experience depth and space, hear everything

around us, smell all sorts of things, and so on. All of these add up to create an experience that cannot be duplicated by a photograph that cannot show movement (though it can interpret it), cannot give real depth and space (though the photographer might try to give a feeling of both), and can offer no sounds or smells.

If you walk through a sunny spring woods, you are greeted with sun and shade continually changing on your face; wonderful sounds from birds, chipmunks, and other animals; amazing smells of the awakening forest; changing space and perspectives as you move among the trees. You see a wealth of detail all around you, from dark shadowed tree trunks to bright wild-flowers. All of this creates an impression that cannot be captured in a photograph.

Or go into a bakery on a Saturday morning. The smells are wonderful. There are sounds of friends and neighbors chatting as they sip coffee and eat muffins. The smells actually change as new baked goods

Notice that no one object is centered in the above composition. It is an easy and clear image that engages the viewer.

come in from the kitchen and as folks move past you with different drinks of coffee and tea. Again, no photograph can capture this.

So the effort to "copy" a scene is always futile. You just can't do it, so any attempt will frustrate you. To get a good image, you must find the photograph in the scene. The world is filled with swirling, changing visuals, colors, lights, and spaces. You have to find the photographs in there. Follow the ideas in this chapter and you will recognize these potential images.

Work within the limitations of the camera, and try using those limitations to make better images. You have to look for the prime moment of action because you can't show it all. You have to use focal lengths to change the appearance of depth in a photo. You have to use composition techniques to arrange what you see through your viewfinder or on your LCD into interesting visuals. You have to ignore sounds and smells. (If you think that's obvious, just consider the times you hear people talking about their snapshots and imply a whole number of things they remember from the scene that are not in the photo).

GRABBING (AND HOLDING) THE VIEWER'S EYE

One of the real challenges you face when photographing a scene is to find a way to make your image show off the scene in a way that the viewer understands and wants to look at. The world is a pretty random place—you can find photographs everywhere, but you can also find lots of random stuff that doesn't make a good photo. Part of finding a photograph in the real world is finding ways to use what you frame in your viewfinder and LCD that makes sense or adds interest.

The rest of this chapter looks at compositional techniques that help you to do just that. In addition, how you look at a scene, choose what to photograph and what not to photograph influences how interested your viewer is in your image. Here are some things to consider that grab a viewer's attention:

◆ **A clearly seen subject:** If you have to explain a photograph, then the subject is not clearly seen.

The star effect in this image is created by using a very small f/stop. Bright points in an image immediately draw the viewer's attention.

◆ **Dramatic light:** Dramatic, interesting light on your scene always gains attention as long as it complements and enhances your subject.

◆ **Unusual subjects:** An unusual subject immediately gains attention as long as it is clearly seen in the photograph. If you have to point it out or circle it with a magic marker, then it isn't an effective photograph.

◆ **Uncommon angles:** One quick way to set your photographs apart from others is to show your subject from an angle that people don't usually see. Get that camera down low or up high. Look at the side or back of the subject instead of only from the front.

Now let's look at some compositional techniques that can help you find a photograph in a scene, a photograph that is interesting and inviting to a viewer. Keep in mind that these are meant to be ideas on how to get better compositions, not absolute rules of photography. Use them as they work for you and your subject.

CREATE RELATIONSHIPS

As you compose a photograph, look at the subject and its relationship to the rest of the photograph. There are always visual relationships. They can make the subject easier to see and understand, they can be very confusing and make it hard to understand, and they can be bland and unappealing, neither making the subject look better nor worse, but definitely making it forgettable as a photograph.

You will often hear that one should never put the subject in the center. I believe you can do this, as long as you do it deliberately and that the visual relationships of everything surrounding that centered subject support such a position. Often, though, a centered subject just ended up there because it was easy to center it in the viewfinder or LCD to ensure it got in the picture. That's not

There is a clear center of interest in the above image of the cactus flower. The bright sun in the background is a nice visual balance to the strong, yellow flower that dominates the foreground.

creating an interesting photograph. Here are a couple of things you can consider when looking at your potential photograph that can give it interesting relationships:

Center of interest: When a photograph has a strong center of interest, it grabs the viewer's attention and makes the image easier to understand. Usually, the subject is that center of interest, though you can have a photograph of pure subject (such as a landscape), where the center of interest is a strong and visually arresting detail.

You create a center of interest by making sure the subject is clear and removing other competing visual elements from the photo. A common mistake of many amateur photographers is to try to do too much in a single image. They want a little of everything from the scene. The real world has lots of things to look at, but our focus is constantly changing. The photograph freezes that activity and forces the viewer to see just what is in the photograph, focusing all attention on what is in that frame. When several "important" things are in the same image, they often compete and weaken the composition.

You can direct attention to your center of interest by the use of light as well as what supporting elements are in your photograph. Lines that head toward the center of interest or colors that isolate

a subject, for example, help emphasize a center of interest. You actually have many options, but two things are critical—first, you must decide what is the center of interest for your photograph, and second, you need to look over the entire composition to be sure it is the center of attention within the image.

Rule of thirds: This really should be called a guideline of thirds, but that's a bit awkward. I have found many serious photographers acting like the photo police will come and get them if the rule of thirds is broken. I mention this first because I really want you to see this compositional aid as just that, an aid, and not a law.

The rule of thirds creates an imaginary grid over the scene to help determine where to put strong parts of the composition, including the subject, the horizon, strong lines in the scene and so forth. To use this aid, imagine putting lines across your photo at the thirds, just like a tic-tac-toe grid, i.e., two horizontal lines at the one-thirds and two-thirds points from the top, then two vertical lines at the one-thirds and two-thirds points from the sides.

Colors often attract our attention first, especially when they are surrounded by more subtly-toned environments.

These lines intersect at four points, and these points are great places to position your subject (or a center of interest). These locations help get the subject out of the middle of the frame, but more important, each position gives the subject a spatial

relationship with the rest of the photograph. Spatial relationships give a composition stronger viewer involvement because a viewer's eyes now move comfortably about the image.

This grid can also help you position the horizon or any other strong horizontal line. Horizons that go through the middle of a photograph are often awkward, and even confusing for a viewer because there is no clear definition of what is more important, for example the ground or sky. With a high horizon, the ground gains emphasis and with a low horizon, the sky.

A small depth of field is an excellent way to separate your subject from its surroundings. Make sure you have the best focus possible on your subject. This will keep your viewer's interest.

Finally, strong verticals, such as a tree or the side of a building, also work well when they are matched up with the vertical thirds. This again creates a visually more interesting image with a defined structure easy for a viewer to relate to.

It is important to understand that the world doesn't always neatly fit these thirds. Arbitrarily trying to fit every scene into this scheme can cause problems. It is simply a useful aid to place the subject in different parts of the composition.

ISOLATE YOUR SUBJECT

When you look for ways to isolate your subject, you are making the image more understandable to your viewer and you are creating a photograph. Subjects blend all too easily with their surroundings. One reason that a subject may seem easy to see in the real world, but be hard to see in a picture, is movement. When anything moves, we instantly perceive it as separate from the non-moving world. In addition, as we move our head around, the placement of objects against their surroundings changes, also allowing us to better see them. None of this can physically happen in a photograph.

There are many ways to make a subject stand out from its background. Basically, you look for contrasts between the subject and its surroundings. Here are some you might try:

◆ **Brightness contrast:** Move so your subject is against a background that is lighter or darker than it is. This can be a very effective way of making a subject really pop out in a photograph.

◆ **Color contrast:** Whole books have been written on colors and how they contrast with one another. The key is to look for colors that are different in the subject and background.

◆ **Sharpness contrast:** Use depth of field to make your subject sharp and everything else soft in focus.

◆ **Use a telephoto lens:** With a longer focal length, you can often separate your subject from the rest of the world simply by making your subject larger in the frame and eliminating distractions.

◆ **Use a wide-angle lens:** Put on a wide-angle lens and get up

close to your subject. This makes your subject big and its surroundings small.

◆ **Get your subject away from the background:** Having a person move away from the wall is easy, but what about subjects that don't move so easily? Find a different angle to your subject to change its relationship to the background. For example, getting low to a flower will often let you find an angle that puts the background farther away from it.

SIMPLICITY

A simple composition can have big effect if the included elements are harmonious.
Photo © Bob Krist

There is value in keeping a composition simple. It makes it easier to deal with visually, plus it is always clearer to your viewer. The world is a complex place, which is another reason why a photograph doesn't do a very good job of "copying" it. Part of the job of a photographer is to simplify that world to make it more understandable for others, to help them see things that they otherwise would have missed.

There are two key things to consider when you are working to simplify a composition: use only what is needed and get rid of everything else.

What do you really need of the subject and its environment to make a photograph work? This is a very different question than what a lot of photographers "ask" when they take a picture. Often they simply consider how much of the subject they can frame with its surroundings, and did they frame it right.

But you don't need everything. You can get away with just a subject, just a subject and a simple background, or just a subject with a couple of background elements that have a strong relationship to that subject. Look for angles to the subject, for focal lengths, for depth of field, and other techniques to help you refine your image to make it simpler.

Eliminate anything in that composition that doesn't help or support the subject. Things frequently end up along the sides of a photograph or in the background just because the photographer didn't see them when he or she took the photograph. They were concentrating so hard on the subject that these distractions just didn't register.

You need to train yourself to always scan the whole image area. Look for anything that doesn't belong and try to get rid of it. This isn't simply distracting things, like a stop sign whose red overpowers the subject. You may need to get rid of colors that fight with the subject, or space that has no real value to the picture. You might move the camera left or right, up or down. Or maybe you have to move so something can block the view of that distraction. A little creative thought reveals ways of eliminating unnecessary elements.

Another term you will often hear about composition related to simplicity is unity. Unity means that everything in the photograph belongs. Every element, from foreground to background, creates an overall whole for the photograph. Nothing is too distracting; everything that is in the composition has a distinct relationship with the entire photograph.

A photograph easily loses power when the photographer has not looked to simplify and unify the composition. Two key areas that

often cause problems are the background and the edges of the picture. The background supports the subject. It should not in-

clude anything that competitive with the subject, otherwise the photograph is weakened and loses a viewer's attention.

Stuff sneaks into the edges of photos all the time. I am not talking about little things at the extreme edges—with many cameras you will miss them totally as you take a picture because the viewfinder and/or LCD does not show the full image frame. I am talking about major distractions, like someone's hand or an out-of-focus branch. These are problems. As you compose your photograph, quickly scan the edges and look for unwelcome distractions. Teach yourself to do this automatically.

USE COMPOSITION TO COMMUNICATE

What is your photo about? Every photograph is about something, whether you think about it deliberately or not. When you don't clearly decide what your photo is about, you are not communicating to your viewer. Composition can help you better communicate.

Why do most of us photograph? It can be fun, sure, but that answer for many photographers is that it gives them a medium for creative expression. That's fine, but if the photograph isn't communicating to the viewer, not much expression is going on.

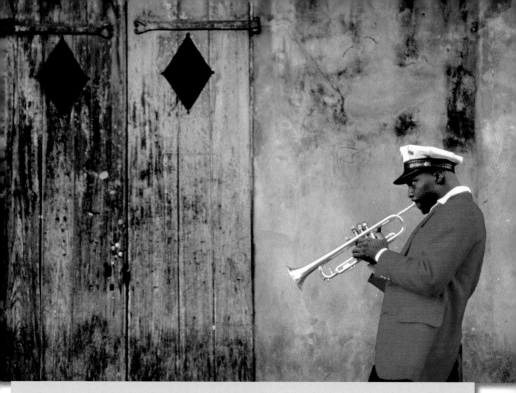

Sometimes a simple composition can say more about a place than one with a lot of visual information. Photo © Bob Krist

Photography is used to share our views of the world with others. We like people to see our kids, to relate to fun areas we have visited, to really appreciate a great scene in nature. This is all about composition and communication.

I have seen a lot of weak or unsuccessful photographs because the photographer had not clearly decided what the image was about. The biggest mistake is adding too much (the photograph is about the subject … and another subject … and the colors of the building … and the texture of the old road … and so forth). All these different things make it very confusing for the viewer.

When you decide what a photograph is about and how you want to use it to communicate, many of your choices in taking the picture are defined for you. You don't have to think about the rule of thirds, for example, because you find there is one really solid way of composing the photo to communicate something special about

the subject. You don't need complicated or sophisticated reasons for a photograph. You may simply communicate that you love a certain sunset's colors or the way a kid smiles. Just make sure to use the techniques in this book to clearly emphasize just that.

FRAMING THE SUBJECT

A simple and effective technique for defining a composition and giving it visual interest is to frame the subject in some way. This is a classic technique for directing the viewer's eye and structuring the relationships in a photograph.

The framing used in this image is very effective in focusing the viewer's eye. Photo © Bob Krist

Basically, look for something in the foreground that can be used along some edge (or edges) of the photograph to give depth and visual change to the image. This can be a tree branch, a person in the foreground, an overhanging eve on a house, and so forth. Anytime you use a frame, you immediately create a relationship from foreground to subject to background. A dark frame can also add drama to an image. An out-of-focus frame can create depth.

When you use a frame, you must not simply treat it as a less important, secondary picture element. You must really look at it. Does it have the right visual shape and elements to it? Does it fight with the subject? A frame with a lot of detail can look like it is the subject and really cause problems with the composition.

A related technique is to use a strong foreground element in a wide-angle photo. This foreground element is typically used toward the bottom of the photo, good places being related to the rule of thirds. It needs some visual interest and relationship to the background. It is usually not the subject, but in conjunction with the background, creates a strong photo that communicates something special about the scene.

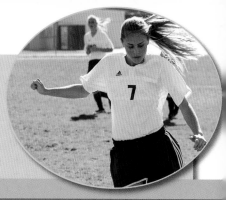

Shooting Action

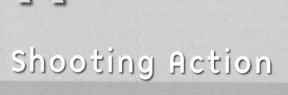

The world is full of action and movement, from running to flying, dance to sports. Yet photography cannot show movement. A photo can represent or interpret movement, but it cannot actually show it. So how can we photograph action effectively?

In the days of George Eastman, action was difficult to capture. Film and shutters in the first Kodak cameras were very slow, plus you really could only take one picture at a time. Look at photographs from the late 1800s, and you see a lot of people frozen in poses that might represent their activities, whether that was a bike rider holding a bike or a dancer poised in a key position. Even family photos were stiff and formal because action was just hard to deal with.

With even the most basic cameras, it is possible to capture action today. When small digital cameras first came out, they had a terrible shutter lag, which meant that there was significant time between when you pressed the shutter button and the camera actually took the picture. The result was that action was missed or the timing was off. That is not a problem today with most cameras, though less expensive cameras still react a bit slower than more advanced, pricey cameras.

INTERPRETING ACTION

There are three basic ways of interpreting action in a still photograph: stopping action, blurring movement, and combining both in the same image. All three techniques work, though not everyone likes them all.

Keep in mind that any representation of movement has to be an interpretation. You cannot show the actual movement in a photograph. This may seem obvious, yet a lot of photographers who get frustrated with action photography are really getting frustrated with the medium's inability to show actual movement. If you work within its limitations and use the action techniques described in this chapter, you can get some great action photos.

STOPPED ACTION

Stopping action is the most common way of dealing with action. But to be effective, a photograph of stopped action must really show that action stopped. Any slight blur and you lose the effect, if you want the drama of frozen movement. And it can be very dramatic. We love to see stopped action in newspapers and magazines, especially of sports. Sports photography is strongly based on the frozen moment of a key play, a great catch, a blocked goal, and so on.

When high-speed action is stopped mid-stride, photographs gain a whole new fascination because we can see things that are not visible with the unaided eye, such as the wing beat of an insect or the point of impact of golf club and ball. Such photos grab and hold our attention because they always show us fresh things about the world around us.

BLURRED ACTION

Blurred action is also an important technique. This relies on slow shutter speeds that allow movement to occur while the shutter is open. Not everyone likes this technique, but it effectively conveys a feeling of movement. Stopped action offers the potential of movement (and the implication that movement occurred before and after the shutter clicked), but it does not actually show the movement itself. Blurred action does show that movement and flow—you capture an image of movement over time that can't be seen in the frozen shot.

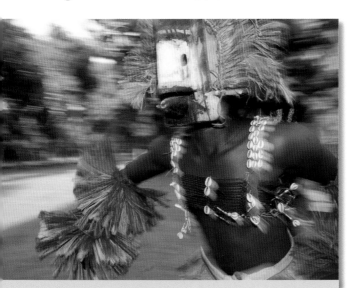

Flash blur is just one technique used to depict action. This image shows a great example of flash blur paired with panning the camera. The flash stops the subject and the rest of the exposure is blurred from the camera panning with the subject. Photo © Bob Krist

Blurred action can be lyrical and quite beautiful. Or it can be confusing and unattractive. Unfortunately, it can be hard to predict, so you have to try a lot of shots. Luckily for a digital photographer, the LCD review helps refine your blur technique.

A COMBINATION OF BOTH

The combination of blur and stopped action is a relatively recent technique. It most often occurs through the use of flash (which stops the action) combined with a slow shutter speed (which allows the blur).

The rest of this chapter covers the techniques you can use to capture stopped action or create beautiful blurs. First, we'll look at stopping action, then go to blurs.

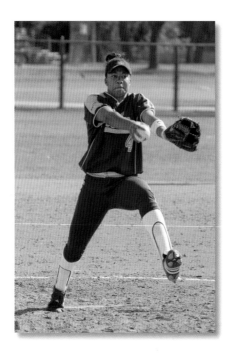

SHUTTER SPEEDS FOR STOPPING ACTION

Fast shutter speeds stop action—that's a pretty obvious statement. But how fast a shutter speed do you need and what can varied shutter speeds do for you?

Shutter speeds can only freeze action if the action is moving slower than the shutter speed. Faster, and you will get a blur. This is highly dependent on the subject, as well as your angle and distance to the subject. So, fast subjects need faster shutter speeds. Some subjects, such as a hummingbird, may need faster shutter speeds than you have available in order to freeze the wings. Others, such as a snail in your garden, can use a much slower shutter speed, slow enough, for example, that you may be more likely to get blur due to camera movement than snail action.

Here is a chart that deals with some of the challenges of shutter speed and action:

Shutter Speed Needs: This part of the chart looks at shutter speeds from a slower/faster aspect rather than specific needs. It shows that you can use slower shutter speeds in one direction for the chart and faster in the other, all in relation to the other elements of the image that are also charted, such as the angle to the subject, distance, speed of action, and so forth. This is

variable and not tied to a specific shutter speed, so I put the examples of actual shutter speeds away from this column at the other end of the chart. You can't arbitrarily choose shutter speeds without knowing more about the conditions of the action.

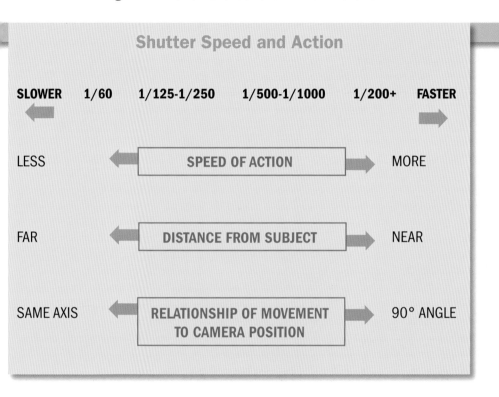

Angle to Subject's Movement: As you change your angle to the subject's movement, you need to adjust your shutter speed. A runner heading right toward you, for example, can be captured more sharply with a slower shutter speed than one that is crossing right in front of you from left to right. You always need the fastest shutter speed when action is going across your field of view, parallel to the back of your camera.

Distance from Subject: The closer you are to a moving subject, the faster the shutter speed needed. With distance, you can get away with slower shutter speeds. Be very aware of this when action is moving fast and close—use the fastest shutter speeds possible then.

Speed of Action:
Obviously, the faster the action, the faster the shutter speeds you need. A running dog is going to need a much faster shutter speed than a strolling cat, for example.

Example Shutter Speeds: In the chart are examples of shutter speeds that might be used in different conditions. Use these as a guide in choosing a shutter speed, but not as a rulebook. You always have to adapt your choice to the conditions of the action.

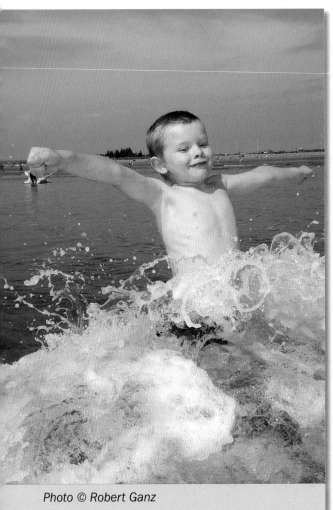

Photo © Robert Ganz

STOPPING ACTION FOR IMPACT IN YOUR PHOTOS

One of the quickest and easiest ways to use technique for visual impact is to use fast shutter speeds. Stopping fast action with a high-speed shutter always gets the viewer's attention.

Gaining impact through the use of shutter speed, though, is not about simply choosing the "right" speed for the subject. It is about using shutter speed to create images not usually seen, hence their

impact. A fast shutter speed is normal for sports, so it has to be a speed used to capture something the average viewer would have missed.

Here are some tips on using shutter speed as a technique for impact:

◆ Experiment with your very fastest shutter speeds and high-speed action. This may mean you have to shoot your lens wide-open or with a higher ISO, which goes against the grain for many photographers. Yet, if you want impact, you have to go "against the grain" because impact comes when you aren't doing the "usual."

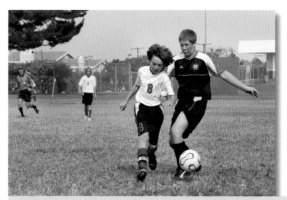

Fast shutter speeds are a good option for action photography, especially outside on a bright day.

◆ Shoot high-speed action with a continuous drive setting and hold the shutter down through the peak of the action. This uses up your memory card fast, but it can really help get that special shot. It helps to have a large memory card if you are shooting digital.

◆ Shoot high-speed action one shot at a time, watching and anticipating the peak of action. This is just the opposite of the previous tip. This can result in a lot of missed shots, but with practice, you may find you are more likely to hit the peak of action than any other technique, especially if your camera is not particularly fast.

◆ Take lots of pictures, and review them often to refine your technique in capturing peak action. This can really help with timing (covered later in the chapter).

AUTOFOCUS AND ACTION

Autofocus (AF) is an amazing technology. It allows the camera to focus on your subject without you touching the focusing control. Today's digital cameras have incredible autofocus capabilities.

Still, action is a challenge with it. A moving subject means the camera has to find the subject, focus on it, then track the movement to keep the subject in focus, all the while taking pictures as the photographer presses the shutter release. That's a lot of work and requires a bit of processing power in the camera.

This is why certain cameras are designed specifically for speed. Pro digital SLRs (D-SLRs) and specialized digital cameras can have AF systems optimized for action. If you shoot a lot of action, and if action photography is important for you, you may need to look into these cameras.

Most photographers can use their camera and its autofocus for action if they understand how to work with its limitations. Here are some things to try:

1. Start your autofocus early: Press the shutter lightly to get the autofocus going before you need to capture the shot. This is really important—otherwise your camera only starts to focus when you need it to be taking pictures. Some cameras have custom functions to assign focus to a button on the back of the camera. Many sports photographers use this to help them start AF before they need to shoot.

2. Use continuous AF settings: On many cameras, you have the choice of single-shot and continuous AF. Single-shot AF only takes the picture when it thinks the subject is in focus. Continuous lets you take pictures whenever you want, even if the AF doesn't find focus. While that means some photos will be out of focus, it also gives you more shots total, and many will be in focus (the camera often catches up with AF as you shoot). There are some cameras with an automatic switching AF setting that allows the camera to

choose when to uses single-shot or continuous. While this helps in some situations, usually such a setting adds delay to the process while the camera "decides" which to use, a delay that may cause you to miss the shot.

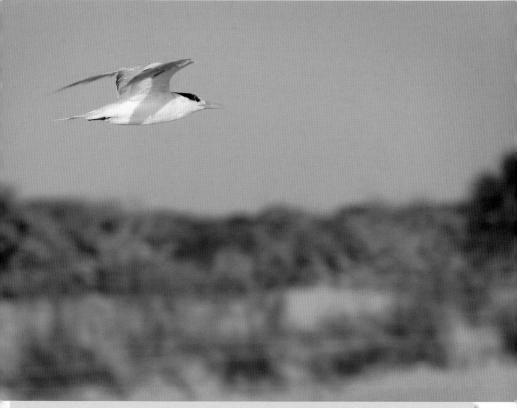

Use continuous autofocus for fast-moving subjects and shoot several pictures. Check your LCD review to see which image captured the best focus for your subject.

3. Know your camera: Take a lot of pictures with your camera's autofocus. Try it with moving subjects, such as a running dog or traffic on a nearby street. You need to know what your camera can and cannot do with certain types of action. Then you will know what to expect when photographing action that counts, plus you will have an idea for how you might best use the camera to capture that action. It is frustrating to try to get a camera to do

Anticipating where the action will be is key for many types of action photography, especially for sports photography. The goal in a soccer match, or home plate in a baseball game, are good places to look to for peak action shots.

something it can't do when important action is happening in front of you. If you know, for example, that the camera has trouble tracking action moving directly toward you, you might look for a position to photograph that action that avoids such movement.

4. Anticipate action for AF: If you know a certain action is likely to occur in one location, point your camera there and press your shutter to "pre-focus" in anticipation of that action. Baseball is a good example of this where plays happen at standard locations, such as the home plate.

5. Turn off AF when needed: You may find that your camera's AF just can't cut it for specific action. You may need to turn its autofocus off. This prevents the camera from suddenly searching for focus at the wrong moment. It also helps slower cameras be ready for action if they don't have to also autofocus. This requires some practice. If your camera has manual focus on the lens, you can pre-focus on where you think the action is most likely to happen, then follow that action manually. (This is not an easy task, but it can be done with practice—all those shots of footballs flying through the air perfectly sharp in NFL films were first done totally with manual focus.) If your camera has an awkward manual focus system (and some digital cameras do work this way), try focusing on a place where the action is likely to happen (such as in front of the goal at a kids' soccer game).

KNOW YOUR SUBJECT

You can buy the camera with the fastest shutter speeds, the most advanced AF, and the latest technology in digital photography, but the number one way of getting great action shots is to know the subject. The more you know the subject and the characteristics of its action, the more likely you can capture that.

There is no area where this is more evident than sports. I can guarantee that if you don't know the sport, it will be difficult to get good action shots. I can also guarantee that anyone who really understands a sport is going to get consistently better action photos.

This doesn't mean you have to be a student of baseball in order to get great baseball action shots. It does mean you have to know how the game is played, then watch it enough that you can start to predict where certain action will occur. You need to know when a runner on first might try to steal second. You need to understand how a pitcher deals with runners on base. You need to have an idea of how a batter might hit the ball.

One of the best training grounds for dealing with action is a high school track meet. These are lengthy affairs with constant and varied action to practice on. There is the deliberate and graceful movement of a discuss thrower, the intensity of a sprint, the rhythm of hurdlers, the changing pattern of a triple jumper, and so on. Even if you know nothing about an event, there are always warm-ups and continuing events that repeat action so if you miss it once, you can get it the next time.

In addition, track events tend to be very positive and supportive of all the athletes, so a photographer is generally encouraged as part of that atmosphere. In addition, you can usually wander around most meets to find new angles for the photography as long as you do not get in the way of any event, watch out for dangerous events like the shot put and discus, and keep off the track during an event. Make friends with one of the coaches (there are usually several) and offer to give the team photos.

Knowing your subject is important for any activity. Wildlife can be a very active, high-action subject. The reason why action shots of wildlife are so dramatic and full of impact is, in part, because they are so difficult to get. You must understand something of the animal you are photographing in order to be there when the action happens.

Kids are another great subject for action photography. Most kids are always on the go, and knowing a little about them also helps you predict when and where they might do something interesting. Still, you have to be constantly ready to take the shot as they will change directions in a hurry.

TIMING

A key element of any action photography is timing. Without timing, you get movement of a subject, but not a high-action photo filled with impact. Often the difference between a casual photo and one

filled with drama is in the timing. In fact, timing your shot is not just for action and sports photographers. Timing makes the difference for any type of photography.

The impact of many action photos comes from very precise timing of the shot. Sure, many fast action shots rely on a bit of luck— you can't always "see" the action as it happens. You have to react quickly and be sure your shutter button is pushed! However, a random image from a sequence of rapid-fire shots might not give you the best shot.

This is especially true for sports with peaks of action, such as the high point of a pole vaulter's arc or the tag of a base runner at second. With many cameras, the speed of the continuous shooting option is not fast enough to get the shot at the best moment. That best moment often occurs in-between shots.

I often shoot action one shot at a time, and do not simply hold down the shutter for rapid-fire shooting through action. I admit that this is an old habit from learning to shoot action before motor drives were common, but it points out that if you know your subject and can read the action, you don't need a high-speed camera to get just the right timing.

I'm not saying that this is always the best way to deal with timing action shots. I sometimes forget to use the high-speed drive capabilities of today's cameras when they really do help and so miss the shot. But if you know the action and can time your shooting for the action, even with a rapidly shooting camera, your images will more likely hit the timing needed for impact.

Here are some tips for hitting fast action at its peak impact:

◆ **Know your action:** I know this is repetitive, but its importance makes it worth mentioning again with timing. Even if you don't know the sport that well, watch it if you can, and look for peak moments that might be worth photographing. The worst thing to do is just start randomly shooting with your finger pressed to the shutter. You'll get a lot of action shots, but you'll be less likely to get those timed for impact.

◆ **Start autofocusing early:** Just a reminder from what was discussed above.

◆ **Anticipate the action:** Shoot just before you think the action is going to happen. Sure, you'll capture odd stuff that way, but you're more likely to get the action you really want compared to shooting as soon as you see the action. If you are seeing the action occurring before you have started taking pictures, you have missed it. You must be shooting as the action occurs and not reacting as it happens. Our reaction time is just too slow to allow us to get a shot as soon as we see it when action is happening.

◆ **Know your equipment:** If you are fumbling with settings or turning on a camera that went to sleep, you will miss your timing

In sports photography, the peak moment is all about timing and anticipation. A good way to get the peak moment in sports photography is to start shooting right before the peak and hold your shutter button through the action. Most likely you will have a shot that is usable.

completely. Especially check your "sleep" settings. Be sure your camera is not going to sleep during lulls in action. At the least, press the shutter to power the camera up anytime the action is getting intense.

SHUTTER LAG AND ACTION

When digital cameras first became available, there was a terribly long delay between the time you pressed the shutter release and when the shutter actually went off. This is called shutter lag, and it makes action photography very challenging.

Luckily, that is no longer the issue that it was. It was a real problem to try to take a picture of even the slowest action, such as

the action of a chess match. That might seem a bit facetious, but it is actually true. I once worked with a camera that had a half-second shutter delay which froze the LCD in the viewfinder so I had no idea what I was getting.

No cameras have that sort of lag today. All cameras pretty much take the picture when you press the shutter release. But when you are photographing action, it is important to know that most cameras usually have a fractional delay. This often comes from the autofocus (the camera wants to be in focus before allowing the shutter to release).

This varies considerably from camera to camera and can affect your photography of peak moments or fast action. You may think you are photographing right at the impact of a kick in a soccer game and find that the photo misses the ball altogether (this is also often a combination of personal reaction time and shutter lag).

If action is really a key part of your photography, you may need to invest in a camera that is designed for speed. This includes no shutter lag, top-notch and high-speed AF, plus fast drive speeds.

Photo © Bob Krist

If that is not possible (or you just don't shoot action enough to justify such an expense), here are some things to try:

Know your camera: Know what its shutter lag is and work around it. I once knew a soccer dad who got wonderful shots of his daughter in action with a digital camera with significant shutter

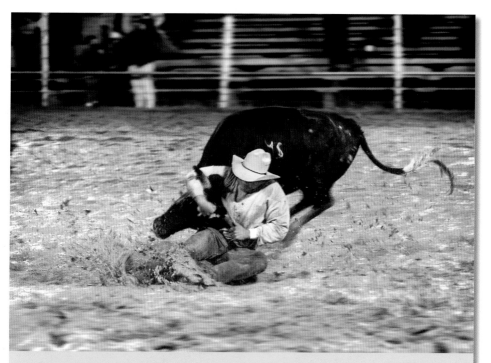

Many effective action shots have both sharpness and blur. The combination of the two gives the image a feeling of movement, but is clear enough for the viewer to understand immediately.

lag that no one would have believed could work for action. He got great shots because he knew the camera and what it could and couldn't do. He always anticipated action. Sure, that meant a lot of worthless shots, but those cost nothing and are easily deleted. But he got enough great shots to make it worthwhile.

Anticipate: Anticipating action is key to getting good shots when the action is fast. Be prepared to take the picture before the action hits its peak so you can actually react at that moment. If you wait to see the action, you will invariably click the shutter too late. If your camera has shutter lag, you need to anticipate even further and release the shutter before the peak action.

AF: Autofocus affects how quickly your camera can shoot. Remember to start autofocus before you need it. If your autofocus is too slow for a particular action, try manual focus.

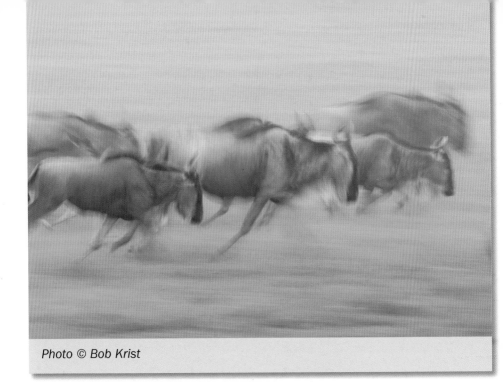

Photo © Bob Krist

Pre-focus: Your camera reacts much faster to your subject if it is not searching for a focus point. Use the tips in the autofocus section to help.

Work on your reaction lag: With practice, your reaction time gets better. If you only try to shoot action once in a while, your percentage of good action shots is going to be lower. You'll learn more about your own reaction time and discover ways of dealing with its lag behind the action.

Use continuous shooting mode settings: Most advanced digital cameras and all D-SLRs have at least one continuous shooting mode (high-end cameras often have more). While not a cure-all for action, they can really help when shooting action that is constantly changing and moving around, such as sports like basketball and soccer. You just have to remember to start shooting before the peak action occurs and hold the shutter button down until after the action is done. There is a tendency among amateurs to simply shoot very short bursts near the action rather than continuously shooting around the action. The latter will give you better results.

SHUTTER VS. APERTURE PRIORITY FOR ACTION

You can shoot on automatic exposure with action and get very good results. The advantage is that it adjusts to compensate for different lighting conditions as the action moves in and out of shade, for example. The disadvantage is that dark or bright backgrounds can throw it off, but if you check your histogram occasionally, you can adjust for that. When the action is constant in one location, manual exposure is helpful since it allows you to keep exposures consistent and at high shutter speeds.

When shooting autoexposure for action, generally avoid Program (P). This setting gives you very inconsistent shutter speeds and often chooses speeds inappropriate for action. The exception to this is the Sports Program Mode if your camera has it. This auto setting aims to keep shutter speeds high, but it also increases the ISO setting whether you want it set higher or not.

Mostly, you'll select Aperture or Shutter Priority for action. Shutter Priority might seem the obvious choice, because action shots are highly dependent on shutter speed. In cases where you need a very specific shutter speed, Shutter Priority is the way to go. You select the specific speed and the camera chooses the appropriate f/stop. If you can't use that speed because of the light levels, most cameras won't let you take the picture (though some will alter the speed to fit the conditions).

In many cases, Aperture Priority is a better choice for action because you can always ensure the highest possible shutter speed for any given shot. Many pros work this way. How is this possible? Aperture Priority lets you set the lens to its widest f/stop, the maximum aperture available, and the camera uses the fastest shutter speed possible for the conditions. The nice thing is that as light changes, the camera continues to choose the very fastest shutter speed possible for the conditions. That max aperture ensures that.

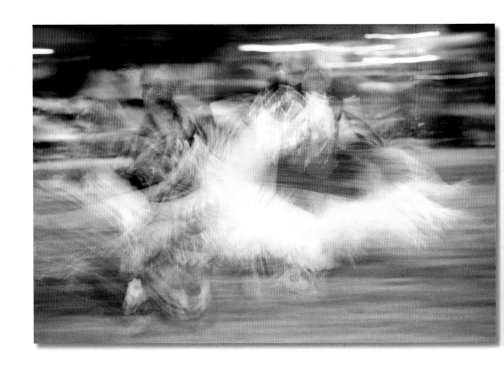

ACTION BLUR

A completely different way of dealing with action is not to stop it at all, but to let it blur into moving strands of color and form. What you are photographing is motion over time by using a slow shutter speed. Motion blurs give a feeling of movement and speed that a sharp action photo does not.

Photographers have described these blurs as poetic, mystical, lyrical, and so on, but to most photographers, they are a great way of creating new and exciting photos. Just a warning—not everyone likes them. I once did an assignment for an art director doing a brochure on a moving company. I experimented a little with motion blur showing the movers really in action. The art director loved it. The client at the company thought the people looked out of focus.

But for most people, the motion blur is an important tool for the photographer. It allows expression of movement that cannot be done in any other way. It is difficult because of its unpredictability;

you can only experiment and try different exposures until one works for you. The great advantage that the digital photographer now has is that LCD review. You can try a shot at a particular shutter speed and see what it looks like. Is the blur attractive or something unusable? You decide, then change shutter speed accordingly.

One thing to look at when choosing shutter speeds is what kind of blur you prefer. Do you want blur with recognizable features or complete blur with soft colors and nothing with an edge (in the movement)? This is affected by shutter speed and the speed of the movement. A slight blur where the subject is completely recognizable, yet a little fuzzy usually looks like a mistake. You generally want enough blur that the viewer knows you wanted that effect. As the shutter speed slows down, the subject becomes less and less recognizable until it is a shadowy color form, striking for its color and flow more than the actual subject itself. There is no right or wrong here, only what you like or dislike.

Although nothing in this image is sharp, you can tell what the subject matter of the image is.

To get slower shutter speeds, start by selecting the smallest f/stops on your camera (f/16, f/22, for example). You can't always get the shutter speed you want with bright conditions, so often you need to try blurs when the light is not a strong. Low light conditions can mean difficulty in getting action-stopping shutter speeds anyway, so why not experiment with slower shutter speeds?

You can reduce the light to the sensor, therefore allowing slower shutter speeds, by adding dark filters in front of the lens. You can start with a polarizing filter, which takes out about two full steps of light. This is where a neutral density (ND) filter can come in

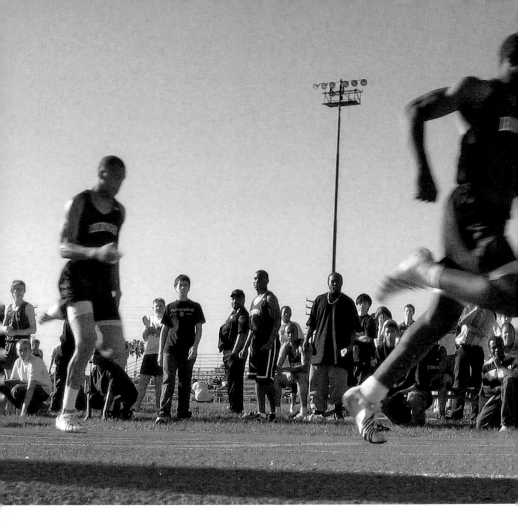

handy (read more about filters in Chapter 9). You can get them in very strong densities that reduce the light by three steps and more. Variable density ND filters can give you more flexibility in how much light you block coming through the lens.

For these techniques to work well, you generally need to mount the camera to a tripod. Otherwise you will get the movement of your camera bouncing around in your hands and not the movement of the subject. Exceptions to this include the use of flash with blur and panning, both described later in the chapter.

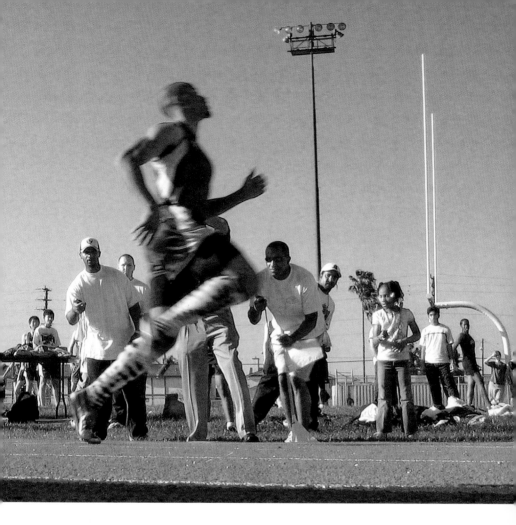

PANNING

Panning is a great technique to use with subjects that are moving through an area, such as a runner, a bird, or a car. You simply move the camera with the subject as it moves, taking the picture as the camera is moving.

This creates a very interesting effect. With very fast subjects, this can be the only way to get them sharp. Panning with the subject makes it "slower" in relation to the camera, so a slower shutter speed can freeze its action. The background, however, will usually be blurred because the camera is moving across it.

Very interesting effects come from using slow shutter speeds with

panning. As the shutter speed slows down, the background blurs more, until it becomes streaks of color and tone. Slow the shutter speed even more and the subject itself starts to blur, first along the moving edges, then over the whole thing. There is a whole range of interesting possibilities as you change shutter speeds.

It is important that you move the camera continuously through the exposure. Start panning the camera with the subject before you press the shutter, and then keep moving the camera even after the shutter has closed. It is important that you don't stop suddenly—you will get odd patterns in the blurs from sudden movement.

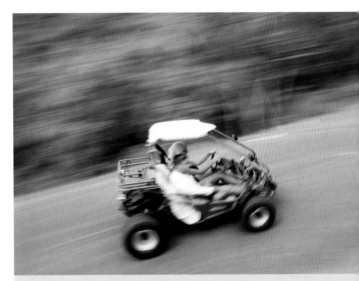

Here is an example of panning and how it can be an effective action photography tool. The background is blurred by the camera movement, and parts of the subject are sharp. Photo © Bob Krist

BLUR SHUTTER SPEED TIPS

Here are ten tips for shutter speeds you might try with different action (and this list might give you ideas on subjects, too):

1. Running water: Water blurs start to really flow and give that streaming look starting at about 1/2 second of exposure. Longer exposures blur the water more, and it starts taking on a milky look with exposure times of several seconds.

2. Waves in big water: Wave blur creates interesting patterns; breaking waves have a mist-like appearance with long exposures. Waves on big water need very long exposures to get interesting results. You'll find that several seconds are usually the minimum, and that long exposures of 10-20 seconds or more give most interesting results.

3. People at walking speed: You can get some nice blurred effects at around 1/4-1/8 second, especially if you pan with the subject. Longer shutter speeds create interesting patterns, even to the effect of "ghosting" parts of the body (they literally disappear).

4. People running: Runners need faster shutter speeds, and panning is almost always the best way to go. Try speeds starting around 1/8-1/15 second, then experiment with slower speeds. With panning, you will be surprised at the fascinating (and unpredictable) results you get at slower shutter speeds.

5. Dancers: You can get some incredible effects with dancers at slow shutter speeds. This varies depending on the speed of the dance. Start with 1/4-1/8 second, and then experiment with slower speeds until you find something you like.

6. Running animals: Animals at speed make for great pan-blur shots. Animals run differently, so the blurs will look different with different species and require different shutter speeds. Try 1/4 second with panning to start, and then go faster for faster animals, slower for slower animals. Speeds as fast as 1/15 second can be very effective with animals with fast moving legs and a lot of up-and-down movement.

7. Fast cars: A classic shot for high-speed automobile racing is the panned shot with the car sharp and the background blurred. You need to have a shutter speed fast enough to give the car good sharpness, yet slow enough to provide interesting blurs to the background. This, of course, is affected by the speed of the cars and your angle to them. Try something around 1/15-1/30 second to start.

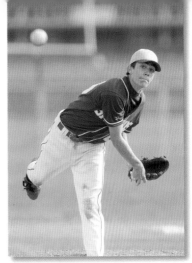

8. Night street scenes: Long exposures many seconds long give fascinating streaks of light from cars. Set up your camera for an interesting night scene with the road going through the composition. Wait for a set of cars to come and start your exposure just as they reach your composition. You will see white streaks from headlights, red streaks from taillights. It depends on your scene as to how long an exposure you need—generally you want an exposure that will let at least some cars to go completely through the scene or you will get chopped off streaks.

9. Blowing leaves: A fascinating use of blur is to photograph trees and grass in the wind. You get some great patterns, colors, and tones. Shutter speed is entirely dependent on the wind. On a very windy day, a speed of 1/2 second might be plenty. On another day, you may need 1 second or more.

10. Fireworks: Fireworks are motion blur great subjects. Photography of this action is described in detail in Chapter 6. You generally want an exposure long enough to allow the fireworks to create a nice pattern of colorful streamers. Typically, several seconds is about right.

CONTRASTING BLUR AND SHARP

A terrific way of expressing action is to combine something sharp with blurred movement in a single photograph. This is dramatic and helps define the movement, give some great visual contrast, and structure the composition.

The easiest way to do this is to find something stationary with moving action around it. A common subject is a blurred stream with a sharp rock (this also works for moving waves in big water).

Look for rocks that add interest to the blurs; in other words, not any rock, but a rock positioned to contrast well with the actual movement. Look for other things that aren't moving, such as a tree, driftwood, and so forth.

Be very creative with this contrast. Think about sprinters blurring past the timers with stopwatches, the latter perfectly still watching the finish line. Or a busy street corner with flowing people all around a stationary street vendor.

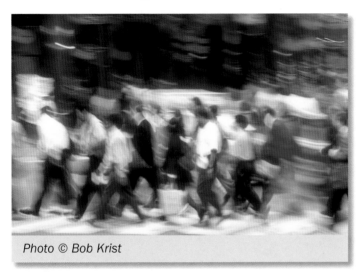

Another way to combine sharp and blur together is to use flash with a long shutter speed. The flash gives sharpness to the subject, while the long exposure blurs movement. This can be used with all sorts of moving subjects. It is an interesting technique when the camera is locked to a tripod so the environment of your subject is sharp, along with the flash image, while the subject's movement is blurred. Yet another way to do this is to shoot handheld so the flash image is still sharp, but everything else is blurred from the long shutter speed.

Photo © Bob Krist

For the flash/blur technique, use shutter speeds appropriate to blurring a subject as suggested in the section on shutter speeds and blurs above. The flash will almost always be fast enough to capture the subject sharply, but the long exposure (which is based on the ambient light conditions) will make any movement blurred. Balancing flash and ambient light in one exposure is discussed in more detail in Chapter 7.

12 CHAPTER

Close-Up and Macro Photography

In the early days of photography, close-up work was a novelty for most photographers. The early Kodak camera could not focus up close at all. In fact, most point-and-shoot cameras could not take close-ups until digital cameras became available.

There were two problems: focus and parallax. When you get close to a subject, focus is critical. The earliest cameras had very limited or no focusing capabilities. It was impossible to get sharp photos up close.

Even if you could get focus, there was another problem: parallax. The lens and the viewfinder saw two different images. Far away, that wasn't really a problem. But as you got close, the two optical systems were not aligned to see the same thing, so parallax, the apparent change in position of an object when viewed from two different positions, became a real problem. You could not line up your close-ups correctly.

There have always been cameras that allowed proper close-up work, such as view cameras, but it wasn't until the popularity of the SLR camera that close-ups really became possible for every-one. With that camera, you could see exactly what the lens saw, so no parallax and no focus problems. All non-SLR digital cameras offer the same possibilities, seeing exactly what the lens sees when the LCD is used as a viewfinder.

CLOSE-UP PICTURES HAVE IMPACT

Close-ups let you explore a world that the average person does not regularly see. Photographers who find and capture that close-up world in a picture can immediately show off images that will surprise and delight the average person just because the subject matter is stuff that is largely unseen.

Kodak has always done research to discover how people photograph to better understand their photo needs. An interesting bit of information came from their examining photographs going through photo labs; most were taken from a distance of 6-10 feet (people pictures) and infinity (scenic and such images). Very few photos showed subjects photographed closer than two feet from the camera.

What does that mean? Well, if nothing else, taking close-ups will

give you a set of photographs that will stand out from most everyone else's. You can get those oohs and aahs without having to travel to far way places.

THE BEST PART OF CLOSE-UPS

The best part of close-up photography is something I've covered in other publications, and it is well worth repeating here, because it is very exciting for the photo enthusiast. That is the fact that close-up photography is always possible, in any place, at any time, in any season, indoors or out. You don't have to go some place special, and you can take pictures whenever you have time if you look for the close-up.

There are always bits of the world that can be photographed—the iced tea that comes in a clear glass when you go out for dinner has amazing colors and forms when examined with the close-up lens; a piece of rock found in an outcropping alongside the road shows off abstract patterns in close focus that could hang in the Museum of Modern Art; a frosty window in the depth of winter brings close-up delight to

Close-up photography puts the viewer into a world that is usually not seen from the human eye. Focus is extremely important for images shot at such close proximity.

cabin-fevered northerners; and so it goes.

This is very exciting for me because I love photography. It means some photography is always possible. Opportunities are yours, just for learning to photograph the close-up.

MACRO OR CLOSE-UP: WHAT'S THE DIFFERENCE?

You may hear the terms macro and close-up thrown around a lot. What is the difference? Is there an important difference?

Close-up photography is a more general term. It refers to any image that gives the viewer a close view of the subject. The term close-up is used in the film industry to refer to the shot that gets in and shows details of the subject, so that, for example, an actor's facial expressions can be emphasized. In still photography, the term has come to mean images taken close-up in distance, from about 2-3 feet and closer, with normal focal lengths.

Macro photography is more specific. This generally refers to extreme close-ups that show off subject details not normally seen. You will see a variety of definitions of macro, but you can call anything that is getting close to 1:1, or when the subject is magnified, a macro shot.

The number 1:1 is a ratio that says the actual size of the subject is captured at that same size on the digital sensor. Any use of that image magnifies the subject since you probably won't print or display it at the size of your sensor.

Depending on how big your print is, for example, you will be magnifying any close-up subject much before you reach 1:1, but 1:1 is one of those "tipping points" for photography. At this point, optics start to change and affect how well a lens can work, which is why

Camera movement and subject movement are important things to consider when you are shooting up close. Very little movement from either can make a big difference in your final image.

a true macro lens is corrected to give optimum results at this point. This, however, does not mean that a macro lens is the only way to get great close-ups.

HOW TO GET THE CLOSE-UP

One of the really neat things about the change to digital is the ability for everyone to try close-up photography. It used to be that you had to have special equipment and an SLR camera. Now, most digital cameras have built-in close-up capabilities so you can take close-ups with a point-and-shoot right out of the box.

There is plenty of gear on the market aimed at the close-up photographer, from lenses, to flash units, to diffusers, to subject clamps.

When it comes to digital SLRs (D-SLRs), many people think macro lenses are the only way to do close-ups. While an effective close-up tool, a macro lens can be limiting if that is your only way to get close-ups. I am going to give you a number of possibilities for close-up photography; they all work and can give you options to best fit your needs.

Close-focusing cameras: As I mentioned, most small digital cameras have a close-focusing feature built into them. A universal icon, denoted by a flower, accesses this feature. Since you can see what the lens is getting by viewing the LCD, you don't have a problem with composition or focus. These little cameras are a great way to experiment with shooting flowers, since you can try different close-up shots

Flowers make great close-up subjects. They move very little and have amazing features that are not readily seen from a casual glance.

in a hurry and see each one as captured when played back on the LCD monitor. It can be surprising how good the results can be from these little cameras. One problem you may find is that they are often limited in close-up capability to the wide-angle end of the built-in zoom. This makes it awkward for certain close-ups because you have to be very close to the subject with the possibility of you and your camera's shadow appearing on the subject.

Digital cameras with foldout and tilting LCDs: This is a special sort of close-up gear that can offer some amazing results. A number of advanced compact digital cameras have an LCD that swivels out and rotates, plus there are several D-SLRs that offer a live LCD though only one has a tilting LCD. For close-up work, this means you can get the camera into all sorts of angles to your flowers, yet you can still see what the lens is seeing; simply pivot the LCD until you can see your image. You can put the camera

down to ground level, even looking up at a flower against the sun, and still see the composition. You do have to train yourself to see the LCD in bright light, though the latest models work very well. You may have to shade the screen from direct sun.

Close-focusing lenses: Most zooms on the market today for D-SLRs focus quite closely without added attachments. This makes close-up work quite convenient and is a great way to get close-ups without having to carry extra gear. You will sometimes hear this described as macro focusing for a zoom. That is misleading; rarely do these zooms truly focus to macro distances, and if they do,

You don't have to buy expensive macro equipment to take good close-up shots. A telephoto lens, extension tube, or even a zoom lens can achieve similar results.

they are not really optimized for sharpness at these distances like a true macro lens. The close-focusing feature often only works best when the lens is used in the middle range of f/stops (such as f/8 or f/11). In addition, these close-focusing zooms are often

set up so that you can only use a certain part of the focal length range of the lens for close-ups (usually either the wide-angle or telephoto end of the zoom, and rarely all the focal lengths).

Close-up accessory lenses: Sometimes called close-up filters, close-up accessory lenses screw into the filter threads at the front of your camera lens and enable it to focus closer on your subject. They make close-up photography very easy. As long as they fit a lens, they can make any lens focus closer and without complications. They can make a zoom focus close at all focal lengths, plus they can be used with compact digital cameras that accept screw-in filters. These close-up lenses come in two types: inexpensive single-element lenses often sold in groups of three, and more expensive, highly corrected, multi-element lenses. The inexpensive close-up lenses are a quick and economic way of getting in close to flowers, but their image quality is not very good and may make photos look soft (which can also be an interesting effect).

The multi-element, highly corrected lenses—often called achromatic close-up lenses—are available from a number of manufacturers. These lenses also attach to the front of your camera lens, but offer very high quality images. This is obviously dependent on the quality of the underlying lens, but results can be as good as with other close-up gear.

Extension tubes: I think extension tubes are a necessity for anyone who wants to do close-up work with a D-SLR. These are simply empty tubes with no optics that fit between your lens and D-SLR camera body to make your lens focus closer (they also con-nect the two electronically as needed). As you shift a lens farther

from the focal plane (where the sensor is), it focuses closer. Optical technology is not involved, so the cost of extension tubes is low. Image quality is excellent, but is dependent on the quality of the original lens. Some lenses simply do better than others for close-up work, regardless of their quality at normal distances.

Extension tubes come in different sizes, from small to large. They do not work equally on different focal lengths. When used with a wide-angle lens, a small tube can put you right on top of a subject, while the same tube may have hardly any effect on a telephoto lens. As a lens is moved away from the camera on a hollow tube, less light reaches the sensor. This requires an increase in exposure that is corrected with the camera meter, but reduces your shutter speed if you keep the same f/stop.

Tele-extenders: Sometimes people confuse tele-extenders with extension tubes. Tele-extenders (also called tele-converters) also fit between camera and lens on a D-SLR, but they have optical elements. They magnify the image seen through the lens and bring the subject closer, though they do not allow the lens to focus any closer. They can be used for close-ups because of that magnification, though image quality is typically less than with extension tubes or high-quality achromatic close-up lenses, plus you lose light.

Macro lenses: Macro lenses are specifically designed for optimum quality at close-focusing distances down to 1:1 or 1:2. They are not the same as so-called macro-focusing zoom lenses (described above), which are rarely as sharp close-up. Macro lenses offer the highest quality in close-up work, and one great feature is that they allow continuous focusing from infinity down to 1:1 or

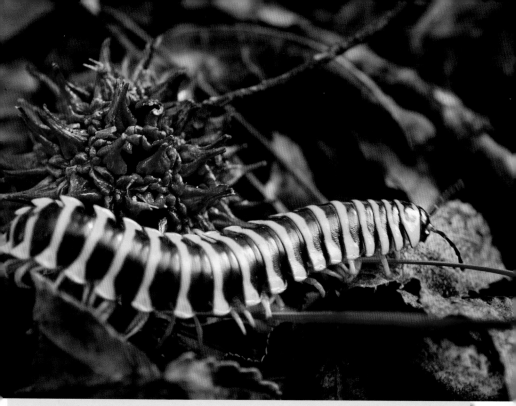

The closer you get to a subject, the more light you lose, and the harder it can be to find focus. For good quality images at very close distances, a macro lens is the best choice.

1:2 (since 1:1 means the subject is exactly the same size in real life as it is on the film or sensor; 1:2 is half size). Macro lenses can be expensive. Just like extension tubes, they lose light at the focal plane as they focus closer.

FLASH FOR CLOSE-UP PHOTOGRAPHY

When you add flash to your close-up gear, you expand your possibilities dramatically. You can control the light on your subject, photograph in all sorts of conditions not dependent on the existing light, and you can guarantee high sharpness when you want it. Modern electronic flash is already very fast, but as you get close, electronic flash burst speed increases dramatically. With these flash burst speeds, it isn't unusual to have a shutter speed of

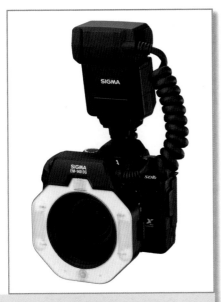

A ring flash is a common flash unit for close-up and macro photography.

1/10,000 or faster. That means you don't have as many camera movement problems, can get high sharpness, and you can use smaller f/stops for more depth of field.

Flash used to be intimidating, but with automatic TTL systems built into digital cameras, flash can be a valuable part of every photographer's close-up kit. You can use any built-in flash to start (or if you don't have another flash with you). You may suspect that the flash is too strong up close, however, but since you are shooting digital, you will know it immediately. You can usually put something translucent over the flash to diffuse its output, including some special accessories available at your camera store. If you want to experiment, try a Styrofoam cup. It cuts the light and spreads it out a bit, giving a very nice light for close-ups. On a small camera, you can just tape a bit of the cup over the flash.

For more control, you will need a separate, external flash unit and a dedicated flash cord. All D-SLRs, and some advanced compact digital cameras, can use an external flash this way. The cord is a simple and helpful accessory; it is a connection between the camera and flash that allows both to communicate with each other for proper exposure and more. With this cord, you can hold the flash at different positions relative to your subject. You can move it left, right, top, or bottom, giving your close-up a different look each time.

Hint: Aiming your flash at your subject can be a challenge. You can solve this by using a special flash bracket to hold your flash in position (most camera stores have them), by having a companion hold it for you, or by simply handholding it. (See Chapter 7 for more on flash photography techniques.)

Another advantage of a corded flash is that you can do something called "feathering" if the flash is too strong. Your LCD comes in very handy for evaluating how much flash is needed. Sometimes a big flash is too strong for close-up work, so instead of pointing it directly at the subject, point it a little off from the subject so only the edge of the light hits it. You can also point the flash completely away from the subject to brighten a background and not affect the subject.

When buying an accessory flash for close-ups, you do not need the biggest, most powerful flash because the flash is generally close to the subject. You can often get away with a compact unit that isn't very expensive, either.

Wireless capabilities for close-up flash can be very useful. These allow you to set off a flash that is not connected to your camera (though you often need a camera-connected flash as a controller, even if it is built-in). With a wireless remote flash, you can put the unit anywhere in relation to your subject without worrying if a cord is going to get in the way (and sooner or later, they do). You can usually use more than one flash, giving you the chance to have a backlight, fill light, main light, or background light with your subject.

Feathering your flash, or using another flash diffusion technique, is a good way to tame your flash in close-up situations.

DEDICATED CLOSE-UP FLASH UNITS

Many camera systems, as well as independently manufactured flash systems, include flash units specifically designed for close-up work. You don't need these in order to use flash for close-ups, but they do offer unique features to make close-up work more efficient and consistent that can make them a worthwhile investment if you do a lot of close-up and macro work.

Close-up flash is generally one of two types: ring flash and twin flash. Ring flash is a flash that literally rings your lens, which places light into every nook and cranny of your subject. Not everyone likes the look creatively (it does look very much the same

from picture to picture) but it is useful when photographing certain subjects that need to have all of their details revealed. Dentists use this for teeth; entomologists love it for featuring insects' colors and patterns; photographers shooting jewelry find it has great possibilities.

Twin flash uses two small flash units on either side of the lens that attach to the camera by a ring mount. They are positionable for different lighting effects. In addition, the individual strengths of the lights can be varied for more creative possibili-

A special close-up flash unit is important if you do a lot of close-up work. Ring flash units and twin flash units are the most common, and they will fill in every shadow on your subject.

ties. A lot of people use the lights on opposite sides of the lens, slightly above, at about the 45° position on both sides. This is okay, but when the lights are equal, it is a lot like a ring light, but does not completely fill the subject with light. You will get more pleasing results with these lights if you don't keep the two flashes at the same power. Also, experiment with positioning, again, to give more lighting control.

Much of great close-up photography is done with standard focal lengths. But you will discover some excellent possibilities when you try focal lengths outside the "normal" or expected for close-up and macro work.

Telephotos for close-ups: A telephoto lens can magnify your subject at a distance, letting you get close-ups without needing to get physically close to the subject. This is important if the subject is flighty and won't let you get near (like a butterfly), or if it bites or stings. A telephoto for macro work is important if you have shading problems that can occur when your lens and camera are too close to the subject.

If you frequently experience these challenges, you might look into a telephoto macro lens. Otherwise, a set of extension tubes is probably the best accessory to have with you as they will let any telephoto lens or zoom focus closer. An achromatic close-up lens sized for your telephoto or zoom can also help get quality close-ups.

Wide-angles for close-ups: Most photographers don't think of wide-angles for close-up work. Wide-angle lenses change your perspective and depth of field and give your viewer the feeling that they are right in there with the subject. You can get some amazing shots of close-up subjects seen in their environment, with their surroundings visible. Using a short extension tube with a wide-angle lens or zoom helps it focus closer (even moderate-sized extension tubes rarely work); achromatic close-up lenses also work but you need to get them big enough or you will get vignetting (darkening) in the corners of the photo. There are a few wide-angle lenses that normally focus

A telephoto lens can get you very visually close to a subject without being physically close. It is also good for close-up work if you have shading problems when you are close to a subject.

close. A very easy way to make wide-angle close-ups is to use a compact digital camera. As described earlier in the chapter, these cameras often have close-focusing settings that only work with the wide-angle part of their zooms.

DEPTH OF FIELD AND CLOSE-UPS

As you focus closer and closer, depth of field starts to become a real challenge. It shrinks steadily so that when you get to macro conditions, it can be less than a fraction of an inch. That means you must focus very, very carefully or the wrong parts of your

subject will be in or out of focus.

If you think a bit about depth of field, you might consider using the smallest f/stop possible with your lens in order to get the deepest sharpness possible. Yet small apertures up close can actually result in less sharpness. Here's why:

Small apertures can mean slow shutter speeds: As you stop that lens down for more depth of field, shutter speeds get slower. This compounds the problem that some close-up equipment loses light at close distances (such as macro lenses and extension tubes). Slow shutter speeds mean more possibility of unsharpness due to camera movement, and all close-up work is more sensitive to camera movement than normal distance photography. It doesn't take much movement of the camera during exposure to create sharpness problems when the area being photographed is so small.

Small apertures can cause diffraction effects: Something happens optically to your lens when you focus at and near macro distances. Diffraction of light starts occurring as it passes through very small lens openings. This diffraction can cause significant unsharpness. This is especially common with non-macro lenses, though nearly all lenses will exhibit sharpness decline in

The focal plane gets smaller as you get closer to a subject, making depth of field very important.

It seems like a simple solution to increase depth of field, but smaller f/stops mean slower shutter speeds, and this can also create challenges for sharp focus with close-up photography.

conditions when f/stops such as f/16 or f/22 are used at close distances.

So with less depth of field available, your possibilities are restricted. However, here are some ideas to help you get the most out of whatever depth of field you have when shooting up close:

1. Use a higher ISO setting: Modern digital cameras work very well with ISO settings of 400 and even 800 (depending on the camera) and have minimal increase in noise. If you don't mind the increase in noise (do some testing to see), you might even try higher ISO settings. This can make the difference between a shutter speed that gives sharpness and one that doesn't.

2. Use a tripod or other support: This isn't always possible if the wind is blowing your subject in and out of focus, but for indoor

subjects and non-moving subjects of any kind, this will always ensure the best sharpness.

3. Shoot multiple shots with the continuous shooting setting: This is an interesting technique that often works when you must shoot at a slower shutter speed. Choose continuous as the shooting mode and take a burst of shots. One in that set will probably be sharp even if the others are not. This can also help if the subject is moving in and out of the small area of focus.

4. Watch the plane of focus: The plane of focus for your shot is parallel to the back of your camera (for the typical camera and lens). Tilt your camera so that it parallels the main surface of your subject or some important plane that needs to be in focus. This can give a strong appearance of sharpness even when your depth of field is very shallow.

5. Use a flash: A flash freezes camera movement up close, improving image sharpness.

6. Try a specialty lens: There are lenses that can be tilted away from the plane of the camera, such as tilt-shift lenses or LensBabies. These allow you to move the plane of focus to better capture the critical areas of your subject with less depth of field. They can also be used creatively to give very strange and fascinating sharpness effects by moving them away from the planes of the subject.

7. Use mid-range f/stops: If you are using extension tubes, for example, with a lens to allow it to focus at macro distances, try using f/8 and f/11 as your f/stops.

It may seem from all this that if depth of field is so limited, it might not really matter what f/stop you use. Actually, it does. Even if something is out of focus, its look changes with different f/stops and depth of field. Plus, often just stopping a lens down a couple of stops will change your subject from an abstract sharp-and-blur composition to a recognizable rendition of that subject. Try different f/stops and see what they do.

On most D-SLRs you can use a depth-of-field preview button to preview your sharpness effects (this can be a hard tool to learn because it makes the viewfinder so dark, however, it is much easier to use with close-ups). On all digital cameras, you can always check the LCD review to see what is happening with sharpness throughout the image.

Close-up photography presents many technical challenges, but digital cameras are equipped with higher ISO settings, faster autofocus, and higher quality lens choices. These all work to the photographer's advantage. Even if you don't have expensive equipment, you can most likely try some kind of close-up work.

Focusing technique needs some adjustment if you are to consistently get the best sharpness in close-ups. Since depth of field is so shallow up close, you must be sure critical parts of your subject are in focus, because you probably won't be able to get it all in focus. A photograph of a grasshopper that emphasizes its

remarkable head, for example, just looks bad if the focus is on its legs.

There are a number of things you can do to ensure you are getting the best focus on your subject. Here are some tips:

Know what is important: Sure, that seems a bit obvious, focus on what is important in your subject, but it isn't always easy. The grasshopper example is clear; focus on the head and eyes (eyes of any animal always are an excellent place to focus). But what about a larger flower shot very close? Do you focus on the petals, the stamens (the yellow, pollen-bearing parts), or the pistil (the central part in the middle of the stamens)? There is no simple answer to that; it depends on what you are trying to communicate with your photo.

Close-up photos do not have to be photos of very small objects. Getting closer to your normal subjects will change how your images look.

With any close subject, you will have to decide what one specific thing is key and must be sharp, and what other areas can be less sharp or not sharp at all. If you aren't sure, take the picture and look at the LCD to decide if you made the right choice or not. You can even try several shots at different focus points.

Use manual focus: Autofocus (AF) is a problem up close. It will grab whatever seems to "focus" best at the distance, but that is often not the best focus point on the subject. In addition, you will see the AF shift its focus point as you press the shutter, and too often, to the wrong point way behind your subject. With manual focus, focus is locked to one point and can be more precisely set on your subject. This is important when shooting at the minimum

focus distance of your lens, because the AF system will frequently focus farther away than that minimum distance.

All D-SLRs, and most advanced compact digital cameras, include manual focus capabilities (though some compacts have somewhat awkward systems, they still can help). If your camera does not have

There are several techniques you can use to adjust your focus up close, where every millimeter counts. Try manual focus instead of autofocus, focus as close to exact as possible, and move the camera a bit closer or a bit further from your subject to fine tune the focus.

manual capabilities, or you want to keep using autofocus, you can try a technique that relies on the ability of most cameras to lock focus using the shutter release button (or other focus lock buttons). Be sure your camera is set to single-focus AF, then go quickly to

your close-up position. When the camera and lens find focus, lock it by lightly pressing the shutter release button, then move back-and-forth for critical focus (more on this next).

Move the camera: When you are up close, you can get faster and more reliable focus by moving to and from the subject, rather than trying to focus with any lens focusing controls. This does increase the possibility of camera movement during exposure (and lower sharpness) when handholding, but this movement is in a direction that minimizes that. In addition, you will find it is much easier and quicker to move the camera to find or follow the critical focusing point rather than relying on the autofocus system to find critical focus.

MAKING YOUR SUBJECT THE STAR

It might seem that once you are close to your subject and master the challenges of sharpness, you can rest easy, knowing you will have a unique photograph that most people don't take. While there is some truth to that, you are likely to be disappointed if you don't look for some ways to make your subject stand out visually from the rest of the scene. It can be so exciting to see that subject up close in your viewfinder or on the LCD that you don't see some problems with how it blends with its surroundings.

Creating contrast is an important part of making any kind of photography, and maybe even more so with close-up photos. Here, the focus creates a visual contrast, and separates the subject from the background.

Luckily, there are three easy ways to create visual contrast between your subject and its background:

1. Find tonal contrasts: Anytime your subject is brighter or darker than its background, you immediately gain a big jump in clarity. A nice thing about close-ups is that they cover such a small area of the world that often only a minor tweak of your angle to the subject can totally change what is behind the subject. If you have a dark subject, look for something bright behind it, and for a light subject, look for something dark.

Light is a great way to gain tonal contrast. Usually you can get your subject in the light, then move slightly and find a shadow behind it to gain some contrast. If that fails, look for ways to create

your own shadow behind the subject. That is as easy as putting something solid between the light and the background. Anything from a piece of cardboard to your jacket on the tripod to a friend or family member will work.

Another interesting technique for this contrast is to shade the subject and leave the background bright. This can create dramatic silhouettes and near silhouettes.

Backlight is another good way to gain tonal separation for your subject. Backlight can create a very nice band of light along the edge of your subject that can be used to contrast with the background. Backlight usually has a lot of shadows to work with, too.

2. Use deliberate sharpness contrast: You already have to deal with limited sharpness up close, so this might seem like you get it already. But you can often do more than what you find from your first approach to the subject. As mentioned above, out-of-focus objects do look different depending on how much "sharpness" reaches them. To create a really nice look for a close-up, try to get your subject very sharp against a very blurry background. There are several ways of doing this.

One way to do this is simply find an angle to your subject that puts the background farther behind it. The closer the background, the more defined it will look, even if it is not in focus. For many subjects, that means getting down to its level. If you shoot a low subject from above, the ground behind it is fairly close. If you get down to its level, the ground can be quite a bit farther away. Also, sometimes a slight change in left/right angle to the subject will remove parts of the background that are too close.

Secondly, you can use a telephoto lens and a wide f/stop. This can selectively highlight the subject by making it sharp while everything else in the frame is out of focus (which is why it is called selective focus). Long telephoto lenses with extension tubes, for example, can give dramatic sharpness effects that really grab a viewer's attention because there is such a strong contrast from subject to background.

3. Try to find a color contrast: Color contrast is a good way to make your subject stand out from its background. This is often a problem in nature, however, because backgrounds often include other objects that are similar to the subject.

Start by noticing how the color of your subject compares to what is behind it. Then look for a background color that contrasts, or is at least different. Here are a few simple ideas for color contrast:

◆ **Complimentary colors:** Look for a color that is completely the opposite of your subject, such as red against green, orange against blue, or yellow against violet.

◆ **Saturation contrast:** Look for a background behind your subject that has a color that is either richer (more saturated) or duller (less saturated). A rich-colored subject against a dull-colored background works best.

◆ **Cold/warm contrast:** If you have a subject with a warm color (orange, red, yellow, and the various combinations), find something in the background that is cool (blue, cyan) for contrast; and of course, a cool subject against a warm background.

You won't find these color contrasts with every subject, though you can certainly use these ideas when photographing close-ups inside where you can control your background. As you start to become aware of these possibilities, you will start seeing them more often.

With a little bit of thought (and sometimes luck), you can combine these effects for even stronger contrasts and really gain a bit of a "Wow!" factor for your close-ups.

The angle of view helps to separate this subject from the similar ones around it.

13 CHAPTER

Digital Darkroom Basics

You have to wonder what George Eastman would think if he had a time machine and could see what computers could do with photos. I suspect he would be a little overwhelmed by all the computer technology, but when it came to working on an image in the digital darkroom, I think his interest would be piqued. While he would have no concept about some things, much of the photo work would match what he knew from the black-and-white darkroom. He would be amazed at how quickly this is done.

This is a spectacular part of digital technology. We can do much of the same traditional darkroom work faster, more efficiently, and with less waste.

Consider how photographers printed a photo a few years ago using a state-of-the-art darkroom. First, they had to find and select the negative (which wasn't always easy because negatives are hard to "read" to know which one is which). Next they had to go into a special darkened room, brush and blow off dust on the film, put it in an enlarger, focus it on an easel that would hold the paper, and figure out a proper exposure.

Then they had to get out some printing paper and align it properly on the easel (with color paper, lights had to be turned off at this point). The paper was exposed and put into processing chemicals. With black and white, generally a minimum of 6-8 minutes was

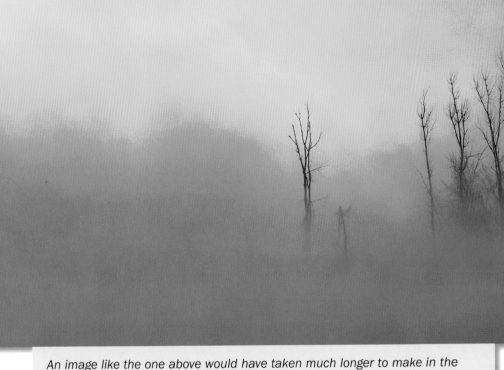

An image like the one above would have taken much longer to make in the chemical darkroom. The digital darkroom has streamlined a photographer's workflow. Photo © Robert Ganz

needed before evaluating the image in bright light (longer for critical work), and about 20 minutes for color. If things weren't right (and first prints rarely were), they'd throw out the print and try another one. Each change to the print required this much time.

With the digital darkroom, change is instantaneous. Time has been cut to a fraction, and first prints often look quite good. Additional prints take much less time and you don't need any toxic chemicals.

TRANSFERRING PHOTOS TO THE COMPUTER

Obviously to work on a photo in the computer, you need to get it into that computer. With a digital camera, that is quite easy. You can connect the camera to the computer and download images

directly, or you can use a memory card reader to transfer the images. There are advantages to each.

Downloading from the camera has the advantage of only needing a cord (or none, if the camera has wireless capabilities). Be sure your batteries are charged, because if the camera loses power during a download, you can corrupt your memory card and lose images. (You can usually reformat the card to get it functioning again, but the images may not be recoverable.)

A memory card reader is a device that plugs into your computer (you can also have them built into a computer, though these can be slow). You remove the memory card from your camera and put it into the card reader for downloading the images. A card reader has some distinct advantages over the camera: it is generally faster (often significantly faster), never needs batteries, and is small enough that it can remain attached to the computer.

Memory card readers are designed to read one or several types of cards, and connect to the computer with either USB or FireWire connections. I have found that USB and FireWire connections work similarly

A browser program is a quick and easy way to look at all of your images and evaluate them.

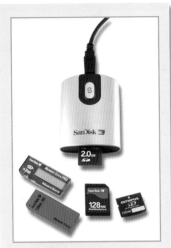

A memory card reader is inexpensive and makes downloading images faster and more convenient. You don't need battery power, and can leave it connected to the computer.

in speed, but this varies by computer (the newest FireWire 800 speed is fastest). Also, faster speed memory cards will download faster if the card reader supports that speed. If you find your unit is not working how you want, try one with a different connection. Borrow one from a friend or buy a new one (return it if it doesn't perform).

When downloading from either a camera or a card reader, your computer recognizes the device as a new drive. There are a number of ways to get those image files onto your computer's hard drive. Most cameras come with software that allow automatic download. Additionally, image browsing, media playing, and image processing software programs often include downloading tools, such as wizard-driven capabilities. When using these, it is very important that you set them up correctly so you know where your images are being saved on your hard drive. You need to be able to access them directly as needed.

These programs are a good way to go if you are not comfortable working with the files on a computer and its drives. The problem with most of these programs, however, is that they require extra steps to get your images onto your computer, especially with wizard-driven programs that require you to go through the wizard every time you want to download some images. There are some programs, though, that allow you to set up your downloading of images so that files are renamed, important information added to the metadata (information about a file that is stored with that file), and even add a copyright notice. For some photographers, these capabilities are very useful.

If you are comfortable with working with the files on your computer directly, you can bypass these downloading programs in favor of a simple and fast technique. You simply drag and drop your files from your memory card (accessed either through your camera or a card reader) to a waiting folder on your computer's hard drive. Here's how you can do this:

Photo © Bob Krist

1. Create a folder on your hard drive for your photos (more on organizing photos below).

2. Open the new folder.

3. Open the camera folder on your memory card and select all of the images.

4. Drag the images from the memory card to the new folder you created for them. This starts the process of copying them from your card to the hard drive.

5. Don't remove the memory card or unplug the camera until all images are copied. If you remove that card during this process, you might corrupt the files and lose your images.

ORGANIZING YOUR PHOTOS

Digital images present a challenge of finding the right photo on your computer when you want to access it. You can set up your computer or use special organizing software that makes it much easier than trying to find a specific shot among your negatives or slides.

There are as many ways of organizing photos on your hard drive as there are photographers. This can be a very personal thing; what works for one person might be totally wrong for another.

Keep in mind that storing photos on your hard drive is like storing prints or slides in a file cabinet. How you set up a file cabinet to best find those images is going to be related to how you like to organize things. Think of your hard drive as a room full of file cabinets, each one seen as a master folder on that drive. Then, the folders inside each master folder are like the drawers and folders inside those file cabinets. Just as with a real file cabinet with drawers and folders, you want to label and organize them to help you find images in a way that fits your needs.

Using a folder system is a good way to keep your images organized. Now that photography is digital, you can keep every photo in one place. Make sure you develop an organizational system so you can find what you're looking for when you need it.

Here is one way that works for many photographers:

1. Create a master folder called Digital Photos or something similar that is for images as they come from your camera. Create another master folder for images that have been processed in the digital darkroom.

2. Set up new folders inside the master folders. For Digital Photos, I like to have folders by year. For processed images, I like to create folders by subject matter. The key is to have a way of grouping your images so that you have a hierarchy of folders to help you find images later.

3. Create new folders inside the year folder as you download a specific group of images from your camera. This is the folder where you download each new set of images. Label these in some way that can help you identify the "shoot," photo project,

or event. I like to label folders by location and date since I travel a lot (for example, TN-Smokies-04-07). You might label by event, (Sam's Birthday), by project (Main Street People), or any other label that helps you.

There is also organizing software that can help you find your images and organize them even further. Programs like ACDSee and iView MediaPro are image browsers and organizers that begin by showing your images as thumbnails in your created folders (they tend to offer the fastest ways of seeing lots of image files). Next they let you categorize and organize your photos with searchable

Photo © Robert Ganz

keywords and into catalogs or albums so you can group photos for access later. You can open images directly from these programs into your image processor (such as Photoshop software), too. Programs like Adobe Photoshop Lightroom and Apple Aperture offer integrated organizing and processing capabilities. You can also utilize free software programs—such as Kodak EasyShare, Picasa, and GIMP—that have some of the same organizational features as their more expensive counterparts.

STORAGE AND BACKUP

Photos have always been vulnerable to loss, but with all of your image files on a single hard drive, you are really risking a lot. Hard drives fail. Some experts in the computer field say it isn't about if you have a drive fail, but when. If you care about your photos, you must back them up.

In addition, you are going to run out of storage space if you are an active photographer, especially if you shoot RAW images with high megapixel cameras. You need to add storage capability that can handle your images, allow for backup, and still make your photos accessible as you need them.

Today, there are many great storage options. I don't have the space to go into them in detail, but I will give you an overview so you have an idea of what might be worth looking into for your needs.

Photo © Bob Krist

Optical disk storage (CD, DVD, etc.): If your computer has a CD or DVD recorder, you can copy your images to these disks (and higher capacity disks such as Blu-Ray and HD DVD promise more potential). Disks don't crash, you can make multiple copies (and store those with critical photos at different locations), and if you get only the highest quality archival type of disk, you are likely to be able to use them for many, many years.

CDs are an older technology with less capacity, but they are pretty reliable and universal to almost every computer. DVDs offer significantly more capacity, but are confusing because they come in different types; unfortunately, there is no guarantee that a DVD made in one computer will open in another. Still, they do offer the capacity to store many photos. The newest disks (HD DVD and Blu-Ray) are not yet common (as this book is written), but they will become increasingly important in the future because of their very large capacities.

CDs and DVDs are good temporary storage solutions, but if you know you will need a lot of storage space, consider an external hard drive.

External hard drives: Most serious digital photographers will want to have at least one external hard drive. You can back up all of your photo files onto these drives that plug into USB or FireWire ports on your computer. Get a big drive. You can get hundreds of gigabytes rather inexpensively. I actually have several of these so that I can have more than one back up for my images. I do not want to lose them. Some photographers even use such drives to keep images at multiple locations for added safety.

RAID systems: RAIDs (Redundant Array of Independent Drives) are a collection of dedicated hard drives that are connected so

that they work together and act, in a sense, like one unit. They provide a huge amount of storage space with fast access and high security. They work by automatically backing up data on "mirrored" drives. If one fails, you simply replace it and the group of drives works together to restore the information. They come in different classifications depending on how they are designed and put together.

Backup software: There are a number of programs available to automate the backup of your files as needed. I would highly recommend you look into this. Simply duplicating your files from your hard drive to your backup drive, for example, is possible, but after a time, becomes a problem (not remembering to backup everything or dealing with constant "duplicate file" messages). Backup software allows you to schedule regular backups, or simply allows you to update duplicate folders on your backup device as needed. The program then compares what you have in both locations and copies over only the new material.

DIGITAL WORKFLOW

Digital workflow is the process between a beginning and an ending that defines how you work with an image. In this book, you have seen how to work with your camera to get the best images for you. In this chapter, I am going to cover digital darkroom workflow. You'll find variations of workflow depending on specific photographer's needs; for example, some photographers need a workflow to handle lots of images quickly while others need a workflow for extensive work on individual images; or some need to deal with a great diversity of images shot under a variety of conditions while others deal with similar images shot in a studio under controlled conditions. Here's a workflow that you may find effective and can be easily modified for most photographers (the processing steps will be covered in more detail next in this chapter):

Photo © Bob Krist

1. Import: Open the photo in your image-processing program such as Photoshop or RAW conversion software.

2. Save As: If you are shooting JPEG, immediately save your opened photo as a new file. You can use either TIFF or your processor's native format (such as PSD in Photoshop software). This protects the original and ensures you do not use the JPEG as a working file. RAW is automatically protected. It must be converted in order to use it, and you cannot save over the original RAW file.

The next three steps can be done in either a RAW converter (with RAW files) or in the image processing software itself (JPEG files). These are overall adjustments that affect the entire image.

3. Crop and Rotate: I am a strong believer in cropping out problems early on. We often get junk along the image edges, for example, and it is worth removing that junk plus fixing crooked horizons. This frees you creatively because you don't have to keep dealing with something that doesn't belong in your photo. In addition, unwanted edge junk can wrongly influence the adjustment of

the overall image. But don't crop to a specific size at this point—that is better done at the end of the process.

4. Adjusting Blacks and Whites: I consider this a key step for prepping a digital photo. Many cameras do not record a solid black in the darkest part of your image, yet a solid black is critical for colors and tones to look their best in a print or on the printed page. Use Levels for the blacks and whites step. Technically, there is only a black or a white tone; however, there are many black and white areas throughout a photo (blacks and whites are then commonly referred to as plurals).

5. Clarify Midtones: Midtones make an image come alive and give a scene a feeling of luminosity. Coming directly from the camera, dark midtones can look muddy and make colors look less than their best. If they are overexposed, they just look washed out. A good way to deal with them is by using Curves.

 6. Color Correction: A wrong white balance or a scene with a strange overall color cast should be fixed at this stage.

Note: Layers is an important tool in Photoshop and other image processing programs. You can use adjustment layers for any of the earlier steps. These don't alter any actual pixels, so you gain a lot of flexibility in making changes when you use them. (See page 351 for more on Layers.)

7. Try a work print: Prints are very different animals from monitors in many ways. You must judge what a print needs based on actually looking at the print as its own image (because that is how it will be seen), not by simply comparing it to the monitor. If a print is your ultimate use of an image, this is a good spot to try a print and see how it looks. Refine adjustments as needed based on your work print.

8. Make Local Adjustments: Usually some parts of your image need to be adjusted separately from the rest. You might need to brighten a dark area without pushing the bright areas of an image. You might want to correct the color of a flower without changing

Photo © Robert Ganz

the color of the sky. The best way to do this is with adjustment layers and layer masks.

9. Cleanup: Fix problems in the image, such as flare, noise, or other unwanted picture elements. If you do this early in the process, later adjustments can cause additional problems with these fixes. Use the clone tool and spot healing brush to remove annoying problems (the key to the clone tool is to use it in steps, change the clone from point as you go, vary the brush size, and practice). For noise clean up, try software made specifically for this purpose.

10. Save a Master: Save your unsharpened and layered file as its own, separate file. This is the file to use to make larger or smaller images; you can have problems changing image size with a sharpened file.

11. Size and Sharpen: Probably the easiest and least complicated way to do size and sharpen is to make and save a printing file for each major print size you need. You will get best results sharpening a specific size. You can now crop to a specific size, too, as you will be able to better evaluate cropping at this point.

12. Start printing: The operative word is "start." Make a print and consider it a work print. Evaluate it as a print. At this point you may discover some odd problems such as unexpected noise in a shadow area, an odd color on water, or an unflattering color cast. Tweak the image for this issue. If the adjustment is major, go back to your unsharpened master.

Workflow should be modified and customized to fit an individual photographer's way of working and personal preferences.

Workflow Chart

1. Import: Open photo

2. Save As: If JPEG, save the photo as a new file

In Photoshop or other image processing software:

3. Crop and Rotate

4. Adjust Blacks and Whites

5. Clarify Midtones

6. Correct Colors

In Photoshop software:

(RAW only step—when you first open your image in Photoshop software, look to see if you need to refine the RAW adjustments)

7. First work print opportunity: Refine adjustments based on work print

8. Local Adjustment: Change tones and colors in small areas

9. Cleanup: Clone out problems, control noise

10. Save Master: Unsharpened and layered PSD file

11. Size and Sharpen

12. Work Toward a Final Print

TEN STEPS TO JUMPSTART *ADOBE PHOTOSHOP* AND *ADOBE PHOTOSHOP ELEMENTS* PROGRAMS

Adobe Photoshop software is without question the premiere image processing software on the market. Photoshop Elements software also offers many of the key controls needed by photographers and is excellent software for the digital darkroom. All of the tips in this section apply to both programs.

A main, over-riding tip for these powerful programs is that you don't have to know everything in them to do excellent work with your photos. You only need to know what works with your photo. Consider that Ansel Adams had a limited range of tools for his work. He could make an image lighter or darker, change contrast, and then do the same for small areas of the print. Yet look at the wonderful images he was able to produce!

The tips in this section are designed to jumpstart the photographer who is challenged by Photoshop software. As you progress with Photoshop software you will probably find you own approach.

Here are my top ten tips for overcoming the early hurdles and challenges of working in Photoshop and Photoshop Elements software (you will notice that many of these points expand on the workflow section; these are key adjustments):

1. Do not be afraid: You can always undo and reset everything.

I have found that photographers get very cautious with their photos when they start working with them in the computer. As long as you don't save over your original file (always work on a copy of your original file, not the original itself), you can go back and change your work. You can undo every adjustment as long as you do this immediately after the adjustment (Command or Apple key + Z) is the keyboard shortcut for "undo" on a Mac computer, and Ctrl + Z for the Windows operating system). In addition, you have the History (Undo History) palette that contains a record of your adjustments. It allows you to go back into that history to an early

The undo control will take you back one step only. Make sure that if you make a change in your image that you do not like you change it before making another adjustment.

stage of your adjustments at any time (up to the limit of history states; 20 is the default).

If you don't know something, just try whatever you think might work and see what happens. Nothing is going to break, no software police are going to arrest you, and you might even learn about some controls for future consideration. You can always find out what any control does by just trying it, then undoing it if it doesn't work.

2. Crop and rotate.

First thing, crop your photo and rotate crooked horizons. Use the Crop tool in the tool palette by clicking in one spot and dragging your crop selection to an approximate size. You can size exactly by moving the sides and corners of the crop box. By moving your cursor outside of the box, it will turn into a curved arrow that lets you rotate the crop box to fix a crooked horizon. Apply the crop by double-clicking inside the crop box or by hitting Enter or Return.

Crop your image early in the process to remove distracting elements.

3. Check your blacks and whites.

Black areas in your photo are critical to contrast and color. Highlights make a photo lively. Levels is the way to do this (Image>Adjustments>Levels in Photoshop or Enhance>Adjust Lighting>Levels in Photoshop Elements). If you hold down the Alt/Option key while moving the left (black) slider in Levels, you'll see the screen go white. As you move the slider to the right, you'll begin to see colors and blacks show up—this is the black threshold screen and shows what is becoming pure black. When they start to appear, release the Alt/Option key to see what the photo is looking like. On most photos, you'll want solid black somewhere, but with some photos, such as a foggy day or soft focus flowers, this would ruin the image. Sometimes you'll quit when just little spots of black appear; other times, you'll want something stronger in your shadows.

The black threshold screen in Levels allows you to see what is happening in the dark areas of the photo.

The white threshold screen shows you where the white areas are.

Do the same thing for highlights, but this time, use the Alt/Option key with the right or white slider to see where they are in the white threshold screen.

4. Adjust the midtones.

After checking blacks and whites, your photo may be too dark or light. Now you need to adjust the midtones. The best way to do this is with Curves, although the Levels middle slider can be used to set midtones. Curves gives more control and can offer better tonal gradations (Image>Adju stments>Curves in Photoshop software or Enhance>Adjust Color>Adjust Color Curves

Curves help you adjust the midtones and overall brightness.

then click on Advanced Options in Photoshop Elements software). If you are unfamiliar with Curves, just try clicking on the center, angled line in the middle. Drag it up to lighten midtones and down to darken them. In Photoshop Elements software, use the middle sliders (this Curves adjustment is only available in Photoshop Elements 5.0 and later—in earlier versions, use the middle slider of Levels for midtone adjustments).

5. Correct overall color.

An easy and simple way to fix problem colors is to use Levels and the gray eyedropper. Open Levels, and click to choose the middle eyedropper (gray color). Now move your cursor over the photo, find something in the photo that should be a neutral color (gray, black, or white), and click on it. If you get lucky, your photo will

Correct color quickly by using the middle gray eyedropper in Levels.

adjust exactly to the colors you always wanted. More likely, you will get colors almost right or wildly off. No problem; undo the adjustment and click again on something else; keep doing this until you hit it right. In most photos, you can find something to click that will give excellent color (for more advanced users, this is a great use of an adjustment layer because you can always tweak the adjustment by turning down the opacity of the layer).

6. Adjust color.

Color is much more than simple color correction. It can range from fixing a problem color that did not record right (blue flowers, for example, are notorious for that) to enhancing color saturation. Learn to use the Hue/Saturation control for many options in adjusting color.

Saturation changes work best when applied to specific colors.

The Hue slider lets you change the color itself, which you probably won't do much. The Saturation slider will increase or decrease your image's color richness; use it carefully. It is rare that an overall adjustment needs more than 10-15 points of change.

Some real power in this tool comes when you click the dropdown menu button to the right of the Master color choice. Now you'll see a whole set of specific colors. Click on one and use the Hue or Saturation sliders to only affect it. You can even tell Photoshop software to be more specific by moving your cursor onto the photo and clicking the color you want. This is a great way to correct specific colors without changing the whole photo or you can even totally alter someone's clothing color.

7. Select and isolate.

Once you've done overall adjustments to your photo, take a look at small or "local" areas that need adjustment separately from

the rest of the image. You need to isolate those areas from the rest of the photo so you can change them without affecting anything else. Layers offer a lot of power for this type of adjustment, though a simple way to isolate special areas in the image is by using the selection tools (they also work with layers for even more control). The Polygonal Lasso, Magnetic Lasso, and the Magic Wand are good places to start to isolate local problem areas.

Add to a selection by holding down the shift key while using the selection tool.

The Polygonal Lasso lets you select from point to point as you click spots on a photo (you can even do curves by clicking spots close together). Use the Backspace (Mac: Delete) key to back up through the click points.

The Magnetic Lasso and Magic Wand are semi-automated selection tools. Click once at the beginning of where you want to select with the Magnetic Lasso and move your cursor around a strongly contrasted edge—the tool will find the edge. Click once with the Magic Wand on solid (or near solid) colors and tones and the whole area is selected at once (change the Tolerance setting if too much or too little is selected).

You can add to selections by holding down the shift key while starting a new selection point and subtract from a selection by using the Alt/Option key the same way. If you have Photoshop Elements software, try out the Selection Brush.

8. Spot and problem removal.

Spots from dust used to be a real problem in the old darkroom. Then they appeared

Enlarge your image to show important detail when correcting problem areas.

on scanned images. Now they show up in images from dust on the sensor. Two tools work well to remove them: the Spot Healing Brush lets you just touch and click your cursor on a spot and it magically disappears. The key to this tool is to size it correctly (use the options bar below the menus to make it close to the size of the defect) and to use it multiple times (do not undo between clicks) if the first try isn't right.

The Clone Stamp Tool also helps you deal with spots and other small problems in an image. The key to using it is also to size it correctly, but you always want it to be soft edged (for better blending). Too many photographers use this like a brush. It is better used like a "stamp" by clicking multiple times rather than once and painting. You

Check your cloning work to be sure there are no obvious artifacts.

need to choose your clone point carefully. If you try it and it doesn't look right, undo the clone and try a new clone point.

It also helps to continually make slight changes to your cloning point as you progress. This reduces cloning artifacts (tiny duplication of details). In addition, change the size of your brush even while doing the same section. It facilitates blending the cloning better.

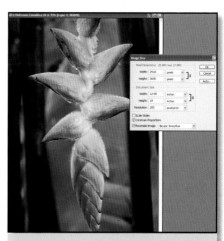

9. Size the photo.

At some point, you will need to size your photo for printing to a printing resolution. The size of the photo affects sharpening, so it is usually best to do sizing at the end of the

To enlarge an image, use Bicubic Smoother when resampling the photo.

process, just before sharpening. Image resolution is different than printing resolution. To set a printing resolution, go to the Image Size (or Resize in Elements) option under the Image menu item.

First, be sure the Resample box is NOT checked. Next, type in a printing resolution between 200-360 ppi (pixels per inch)—use 200 for large prints, 360 for small print. This will tell you how big the image can be printed using the original pixels. If at 200 ppi, it is not big enough, then check Resample, and type in a larger size in the dimensions area. Use Bicubic Smoother (or just Bicubic if you have an older version of Photoshop software) for enlarging photos. If at 360 ppi the photo is not small enough, also check Resample, type in a smaller size, and use Bicubic Sharper.

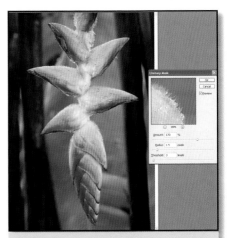

10. Sharpen.

Sharpening should be done at the end of the process in order to minimize certain adjustment problems. Noise is one thing that can be adversely affected if sharpening is done too early in the

Unsharp mask is used for sharpening and includes three control settings.

process. Unsharp Mask is a standard for sharpening (the name refers to a process in the commercial printing industry used for sharpening).

Try these settings: Amount 130-180 (Amount refers to the strength of the sharpening and depends on detail), Radius 1-1.5 (Radius is based on how far Photoshop software looks for tonal differences to affect and depends on image size), Threshold 0-10 (Threshold relates to the tonal difference where Photoshop software starts making changes to edges, and depends on noise in photo; most digital cameras do well with a 2-4 Threshold setting unless there is a lot of noise). Don't oversharpen; you can tell

when an image is oversharpened because it loses subtle tonalities and starts to look harsh. Another sign of oversharpening is when halos appear around strong contrasts in your photo. Use the preview box to view the effect. Take your cursor, move it over the photo, and click on a contrasty edge. It will appear in the preview.

LAYERS 101

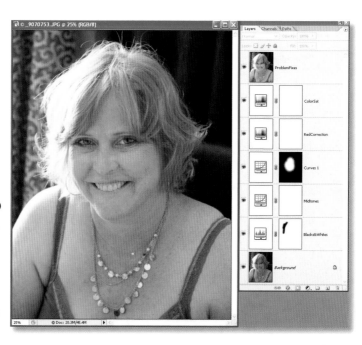

Imagine software that enables you to strongly adjust part of your photo, yet also allows you to go back to that adjustment later and change it. Imagine what it would be like to make changes to your image that are never permanent so you could readjust as needed without losing image quality. All this is possible with almost every serious image-processing program when you use layers.

Layers act just like a stack of prints. You always see what is on top first—top layers block lower layers from being seen (even though everything is still there), and moving one layer affects what is seen below it. The Layer Palette in Photoshop software is simply a stack of things that is always viewed from top to bottom.

Each part of that stack can be affected in isolation, just like you could do something to one photo in a pile of photos without affecting any other photo. Layers can be clear, opaque, or any opacity level in between (opacity is simply the opposite of transparency, but is the word used by Adobe).

Photo © Bob Krist

ADJUSTMENT LAYERS

An Adjustment Layer adds a layer of instructions that affects what is below it, but no changes are actually made to the items below. It is like a filter. If you put a red filter on your lens, the world doesn't change to red, but it will photograph as red. If you place a green piece of plastic wrap onto a photograph, the photograph is not green, but it sure looks green in some areas because of the effect of the plastic. This is the same with adjustment layers.

For example, add a Levels Adjustment Layer (in Photoshop and Photoshop Elements this is in Layers > New Adjustment Layer; click OK when the New Layer box opens, or you can click on the adjustment layer icon at the bottom of the Layers Palette). You will get the familiar Levels dialog box, but you'll also find a layer appears over your photo in the Layers Palette (new layers always appear over the active layer). Adjust the image and click OK.

Now you might add a Hue/Saturation layer to tweak the color of your image. This works the same way: add the layer and you get a familiar dialog box along with a new layer in the Layers Palette. You can add saturation, correct the hue of important colors, and so forth, and click OK. You now have two layers affecting the appearance of the original photo, but the original pixels have not been changed.

As you work an image to make it look its best, sometimes an early adjustment will not look as good later. Maybe after adding a Hue/Saturation layer, the photo looks a little dark. No problem. Double-click on the adjustment icon of your Levels Adjustment Layer (the box with the graph-like icon) and your original adjustments reappear. Now make any new adjustments as needed and click OK again.

To retain your adjusted layers, save your file as the native file format of your program (.psd for Photoshop software). Your images are ready to go to work for you again at any time, even if you shut down the computer in between.

Adjustment layers offer even more for photographers when they are used to affect local areas of a photo. You will use the layer mask that automatically comes with every adjustment layer. It is the little white box to the right of the adjustment icon.

You can use your paintbrush tool with that layer mask in order to turn the effects of any adjustment layer on or off, using white and black. A common expression about this is "white reveals, black conceals." This refers to the fact that white in the layer mask turns the effect of the adjustment layer on and black turns it off. For example, you can turn off the layer's effects by filling the layer mask with black (Edit > Fill, choose black, then OK). The adjustment disappears.

Then you can take a white paintbrush (foreground color white) and choose a soft paintbrush a little smaller than the area you need to work with. Paint this white over the area to turn the adjustment on. If you make a mistake and paint in too much, change the brush to black and paint that mistake right back out.

If you do this step-by-step, layer-by-layer on any photo, you will quickly gain a carefully adjusted image with multiple layers before you can worry about layers. Keep each layer isolated to a specific adjustment. When done, save this layered file as a master image.

BASIC STEPS TO PRINTING

One could do a complete book on printing ... actually, many authors have, including me. However, there are some basics that can get you good prints quickly and here they are:

1. Calibrate your monitor: When your monitor is calibrated, your digital darkroom becomes more consistent and predictable. Prints look more like what you see on your monitor. Calibration tools that actually measure your monitor's output are affordable and easy to use. You also need a consistent environment for your monitor. If the light changes significantly during the day (e.g., sunlight in the room in the morning, incandescent at night), you will have difficulty keeping your monitor consistently calibrated.

Printing is an important step in the workflow process and requires practice to do well. It also requires attention to color and quality detail in your image. Calibrating your monitor makes the process more predictable and leads to better prints.

2. Know the difference between a monitor and a print: A print's color and tones result from light reflecting off its surface and the monitor shows us an image based on transmitted light of glowing red, green, and blue phosphors. In addition, a print is a very different experience for the viewer than seeing a photo on a monitor. It helps to consider a first print a work print, not something to try to match with your monitor (no one will ever ask to see how well your print compares to your monitor).

3. Check your blacks and whites: A print without a black and a white somewhere in the photo will usually look dull and gray and lack the crispness and brilliance modern cameras are capable of capturing. Levels tells us immediately if we have a total range of tones, from pure white to pure black.

4. Color and the "good" print: Good color in a print is color that satisfies you and your rendition of your subject. Evaluate the key colors. Certain colors are important enough that if this color were missing, the photo would not work. These key colors are worth spending some time adjusting. Remove annoying color casts; a picture can pick up color casts from the light (such as fluorescent), the scanning process, or even digital camera bias in certain lighting conditions. A cast may show up more in a print than on the monitor.

Monitor calibration tools help make the color of your images displayed on the computer screen more accurate. This helps to remove some of the guesswork from printing.

5. Use the right image resolution (image file ppi): Image resolution (ppi) is quite different from the printer's dpi (dots per inch). An inkjet printer's dpi is different—it is about how ink drops are applied to the paper. An image's resolution is how pixels are

Photo © Bob Krist

arranged in the photo. Your image resolution should be from 200-360 ppi at the size printed, regardless of the printer used (300 dpi is safe). This resolution number is always referenced against a print size and is meaningless without it. Whether the print is 4 x 6 or 16 x 20, the dpi/ppi should be in the 200-360 range for optimum quality. This may mean resizing your images for a specific print. An unchanged 10 megapixel (MP) image file can print with worse results at 4 x 6 than an old 2 MP camera if the latter has closer to the correct size for the print.

6. Adjust the ppi in an image correctly: Check the resolution in your image processing software. There should be an Image Size or Resize option (check the Help menu if you can't find it). First, uncheck anything that changes the file size and pixels (such as Resample). See what you can get with the original pixels

set between 200-360 ppi (this only changes how the computer reads the pixels). Resolutions above 400 dpi/ppi will actually print worse than 300 dpi because the printer driver doesn't know what to do with the extra data. If your photo needs to be larger, use 200 ppi, check Resample, then change your image size. For smaller, use 360 ppi and do the same.

7. Choose the right paper: Paper choice is critical to getting a print you like. When choosing a paper, there are three qualities that must be considered: weight, whiteness, and surface. Weight affects how a paper feels in your hand and how you can use a print. A print that might be passed around must have a heavy

paper, while one that is only going to be mounted behind glass can be thinner (some very fine plastic papers feel very flimsy). A white paper gives you pure colors and a brighter overall tone for the print. Surface affects colors and use, too. Glossy papers offer the best color, sharpness, and tonal range, but their shiny surfaces can make the image harder to see. Matte papers also offer excellent color, sharpness, and tonal range, but can't show off everything that a glossy can. Luster surfaces are in between.

8. Set the printer driver: The printer driver is a dedicated bit of sophisticated software that controls how the printer works with your image. The wrong driver setting can make a print look terrible. The driver is loaded when you choose the command to print. For the Windows operating system, you must select Properties in the printer dialogue box to get to the important choices. On a Mac computer, most driver settings come up with the print dialogue box.

The critical thing to do is set the paper choice correctly. The printer software will choose an optimum print quality and speed for your paper choice. If you want higher resolution printing or want to make other adjustments, go to advanced or custom settings.

9. Test your print: Printing is mastered by printing out and critically evaluating lots of prints; testing different papers, settings, etc.; and then using those tests to help you refine your printing technique.

10. Try Adjustment Layers: Adjustment layers allow you to adjust what a photo looks like without actually changing the underlying photo. This is a good way to make fine-tuned adjustments to your work print as it evolves into a final print.

These three images show the importance of making test prints. Each image varies slightly from the other two, and studying these differences will help you to improve your printing skills.

There are many software imaging programs available, depending on the results that you are looking for from your images. This image is one example, and was created using HDR software. Photo © Ferrell McCollough

GLOSSARY

aberration
An optical flaw in a lens that causes the image to be distorted or unclear.

acuity
The definition of an edge between two distinct elements in an image that can be measured objectively.

angle of view
The area seen by a lens, usually measured in degrees across the diagonal of the film frame.

aperture
The opening in the lens that allows light to enter the camera. Aperture is usually described as an f/number. The higher the f/number, the smaller the aperture; and the lower the f/number, the larger the aperture.

artificial light
Usually refers to any light source that doesn't exist in nature, such as incandescent, fluorescent, and other manufactured lighting.

astigmatism
An optical defect that occurs when an off-axis point is brought to focus as sagittal and tangential lines rather than a point.

automatic exposure
When the camera measures light and makes the adjustments necessary to create proper image density on sensitized media.

automatic flash
An electronic flash unit that reads light reflected off a subject (from either a preflash or the actual flash exposure), then shuts itself off as soon as ample light has reached the sensitized medium.

automatic focus
When the camera automatically adjusts the lens elements to sharply render the subject.

available light
The amount of illumination at a given location that applies to natural and artificial light sources but not those supplied specifically for photography. It is also called existing light or ambient light.

backlight
Light that projects toward the camera from behind the subject.

barrel distortion
A defect in the lens that makes straight lines curve outward away from the middle of the image.

bounce light
Light that reflects off of another surface before illuminating the subject.

bracketing
A sequence of pictures taken of the same subject but varying one or more exposure settings, manually or automatically, between each exposure.

brightness
A subjective measure of illumination. See also, luminance.

buffer
Temporarily stores data so that other programs, on the camera or the computer, can continue to run while data is in transition.

built-in flash
A flash that is permanently attached to the camera body. The built-in flash will pop up and fire in low-light situations when using the camera's automated exposure settings.

built-in meter
A light-measuring device that is incorporated into the camera body.

bulb
A camera setting that allows the shutter to stay open as long as the shutter release is depressed.

card reader
Device that connects to your computer and enables quick and easy download of images from memory card to computer.

CCD
Charge Coupled Device. This is a common digital camera sensor type that is sensitized by applying an electrical charge to the sensor prior to its exposure to light. It converts light energy into an electrical impulse.

CMOS
Complementary Metal Oxide Semiconductor. Like CCD sensors, this sensor type converts light into an electrical impulse. CMOS sensors are similar to CCDs, but allow individual processing of pixels, are less expensive to produce, and use less power. See also, CCD.

CMYK mode
Cyan, magenta, yellow, and black. This mode is typically used in image-editing applications when preparing an image for printing.

color balance
The average overall color in a reproduced image. How a digital camera interprets the color of light in a scene so that white or neutral gray appear neutral.

color cast
A colored hue over the image often caused by improper lighting or incorrect white balance settings. Can be produced intentionally for creative effect.

color space
A mapped relationship between colors and computer data about the colors.

CompactFlash (CF) card
One of the most widely used removable memory cards.

complementary colors
In theory: any two colors of light that, when combined, emit all known light wavelengths, resulting in white light. Also,

it can be any pair of dye colors that absorb all known light wavelengths, resulting in black.

compression
A method of reducing file size through removal of redundant data, as with the JPEG file format.

contrast
The difference between two or more tones in terms of luminance, density, or darkness.

contrast filter
A colored filter that lightens or darkens the monotone representation of a colored area or object in a black-and-white photograph.

critical focus
The most sharply focused plane within an image.

cropping
The process of extracting a portion of the image area. If this portion of the image is enlarged, resolution is subsequently lowered.

dedicated flash
An electronic flash unit that talks with the camera, communicating things such as flash illumination, lens focal length, subject distance, and sometimes flash status.

depth of field
The image space in front of and behind the plane of focus that appears acceptably sharp in the photograph.

diaphragm
A mechanism that determines the size of the lens opening that allows light to pass into the camera when taking a photo.

digital zoom
The cropping of the image at the sensor to create the effect of a telephoto zoom lens. The camera interpolates the image to the original resolution. However, the result is not as sharp as an image created with an optical zoom lens because the cropping

of the image reduced the available sensor resolution.

diopter
A measurement of the refractive power of a lens. Also, it may be a supplementary lens that is defined by its focal length and power of magnification.

dpi
Dots per inch. Used to define the resolution of a printer, this term refers to the number of dots of ink that a printer can lay down in an inch.

dye sublimation printer
Creates color on the printed page by vaporizing inks that then solidify on the page.

electronic flash
A device with a glass or plastic tube filled with gas that, when electrified, creates an intense flash of light. Also called a strobe. Unlike a flash bulb, it is reusable.

EXIF
Exchangeable Image File Format. This format is used for storing an image file's interchange information.

exposure
When light enters the camera and reacts with the sensitized medium. The term can also refer to the amount of light that strikes the light sensitive medium.

extension tube
A hollow metal ring that can be fitted between the camera and lens. It increases the distance between the optical center of the lens and the sensor and decreases the minimum focus distance of the lens.

file format
The form in which digital images are stored and recorded, e.g., JPEG, RAW, TIFF, etc.

filter
Usually a piece of plastic or glass used to control how certain wavelengths of light are recorded. A filter absorbs selected wavelengths, preventing them from reaching the light sensitive medium. Also,

software available in image-processing computer programs can produce special filter effects.

flare
Unwanted light streaks or rings that appear in the viewfinder, on the recorded image, or both. It is caused by extraneous light entering the camera during shooting. Diffuse flare is uniformly reflected light that can lower the contrast of the image. Zoom lenses are susceptible to flare because they are comprised of many elements. Filters can also increase flare. Use of a lens hood can often reduce this undesirable effect.

focal length
When the lens is focused on infinity, it is the distance from the optical center of the lens to the focal plane.

focal plane
The plane on which a lens forms a sharp image. Also, it may be the film plane or sensor plane.

focus
An optimum sharpness or image clarity that occurs when a lens creates a sharp image by converging light rays to specific points at the focal plane. The word also refers to the act of adjusting the lens to achieve optimal image sharpness.

FP high-speed sync
Focal Plane high-speed sync. Some digital cameras emulate high shutter speeds by switching the camera sensor on and off rather than moving the shutter blades or curtains that cover it. This allows flash units to be synchronized at shutter speeds higher than the standard sync speed. In this flash mode, the level of flash output is reduced and, consequently, the shooting range is reduced.

f/stop
The size of the aperture or diaphragm opening of a lens, also referred to as f/number or stop. The term stands for the ratio of the focal length (f) of the lens to

the width of its aperture opening. (f/1.4 = wide opening and f/22 = narrow opening.) Each stop up (lower f/number) doubles the amount of light reaching the sensitized medium. Each stop down (higher f/number) halves the amount of light reaching the sensitized medium.

full-frame
The maximum area covered by the sensitized medium.

full-sized sensor
A sensor in a digital camera that has the same dimensions as a 35mm film frame (24 x 36 mm).

gray card
A card used to take accurate exposure readings. It typically has a white side that reflects 90% of the light and a gray side that reflects 18%.

gray scale
A successive series of tones ranging between black and white, which have no color.

guide number
A number used to quantify the output of a flash unit. It is derived by using this formula: GN = aperture x distance. Guide numbers are expressed for a given ISO film speed in either feet or meters.

hot shoe
An electronically connected flash mount on the camera body. It enables direct connection between the camera and an external flash, and synchronizes the shutter release with the firing of the flash.

infinity
In photographic terms, the theoretical most distant point of focus.

interpolation
Process used to increase image resolution by creating new pixels based on existing pixels. The software intelligently looks at existing pixels and creates new pixels to fill the gaps and achieve a higher resolution.

ISO
From ISOS (Greek for equal), a term for industry standards from the International Organization for Standardization. When an ISO number is applied to film, it indicates the relative light sensitivity of the recording medium. Digital sensors use film ISO equivalents, which are based on enhancing the data stream or boosting the signal.

JPEG
Joint Photographic Experts Group. This is a lossy compression file format that works with any computer and photo software. JPEG examines an image for redundant information and then removes it. It is a variable compression format because the amount of leftover data depends on the detail in the photo and the amount of compression. At low compression/high quality, the loss of data has a negligible effect on the photo. However, JPEG should not be used as a working format—the file should be reopened and saved in a format such as TIFF, which does not compress the image.

latitude
The acceptable range of exposure (from under to over) determined by observed loss of image quality.

LCD
Liquid Crystal Display, which is a flat screen with two clear polarizing sheets on either side of a liquid crystal solution. When activated by an electric current, the LCD causes the crystals to either pass through or block light in order to create a colored image display.

LED
Light Emitting Diode. It is a signal often employed as an indicator on cameras as well as on other electronic equipment.

lens
A piece of optical glass on the front of a camera that has been precisely calibrated to allow focus.

lens hood
Also called a lens shade. This is a short tube that can be attached to the front of a lens to reduce flare. It keeps undesirable light from reaching the front of the lens and also protects the front of the lens.

light meter
Also called an exposure meter, it is a device that measures light levels and calculates the correct aperture and shutter speed.

lithium-ion
A popular battery technology (sometimes abbreviated to Li-ion) that is not prone to the charge memory effects of nickel-cadmium (Ni-Cd) batteries, or the low temperature performance problems of alkaline batteries.

lossless
Image compression in which no data is lost.

lossy
Image compression in which data is lost and, thereby, image quality is lessened. This means that the greater the compression, the lesser the image quality.

low-pass filter
A filter designed to remove elements of an image that correspond to high-frequency data, such as sharp edges and fine detail, to reduce the effect of moiré. See also, moiré.

luminance
A term used to describe directional brightness. It can also be used as luminance noise, which is a form of noise that appears as a sprinkling of black "grain." See also, brightness, chrominance, and noise.

macro lens
A lens designed to be at top sharpness over a flat field when focused at close distances and reproduction ratios up to 1:1.

main light
The primary or dominant light source. It influences texture, volume, and shadows.

Manual exposure mode
A camera operating mode that requires the user to determine and set both the aperture and shutter speed. This is the opposite of automatic exposure.

megapixel
A million pixels.

memory
The storage capacity of a hard drive or other recording media.

menu
A listing of features, functions, or options displayed on a screen that can be selected and activated by the user.

microdrive
A removable storage medium with moving parts. They are miniature hard drives based on the dimensions of a Compact-Flash Type II card. Microdrives are more susceptible to the effects of impact, high altitude, and low temperature than solid-state cards are. See also, memory card.

middle gray
Halfway between black and white, it is an average gray tone with 18% reflectance. See also, gray card.

midtone
The tone that appears as medium brightness, or medium gray tone, in a photographic print.

moiré
Occurs when the subject has more detail than the resolution of the digital camera can capture. Moiré appears as a wavy pattern over the image.

noise
The digital equivalent of grain. It is often caused by a number of different factors, such as a high ISO setting, heat, sensor design, etc. Though usually undesirable, it may be added for creative effect using an image-processing program. See also, chrominance noise and luminance.

overexposed
When too much light is recorded with the image, causing the photo to be too light in tone.

pan
Moving the camera to follow a moving subject. When a slow shutter speed is used, this creates an image in which the subject appears sharp and the background is blurred.

perspective
The effect of the distance between the camera and image elements upon the perceived size of objects in an image. It is also an expression of this three-dimensional relationship in two dimensions.

pincushion distortion
A flaw in a lens that causes straight lines to bend inward toward the middle of an image.

pixel
Derived from picture element. A pixel is the base component of a digital image. Every individual pixel can have a distinct color and tone.

polarization
An effect achieved by using a polarizing filter. It minimizes reflections from non-metallic surfaces like water and glass and saturates colors by removing glare. Polarization often makes skies appear bluer at 90 degrees to the sun. The term also applies to the above effects simulated by a polarizing software filter.

pre-flashes
A series of short duration, low intensity flash pulses emitted by a flash unit immediately prior to the shutter opening. These flashes help the TTL light meter assess the reflectivity of the subject. See also, TTL.

Program mode
In Program exposure mode, the camera selects a combination of shutter speed and aperture automatically.

RAW
An image file format that has little or no internal processing applied by the camera. It contains 12-bit color information, a wider range of data than 8-bit formats such as JPEG.

RAW+JPEG
An image file format that records two files per capture; one RAW file and one JPEG file.

rear curtain sync
A feature that causes the flash unit to fire just prior to the shutter closing. It is used for creative effect when mixing flash and ambient light.

red-eye reduction
A feature that causes the flash to emit a brief pulse of light just before the main flash fires. This helps to reduce the effect of retinal reflection.

resolution
The amount of data available for an image as applied to image size. It is expressed in pixels or megapixels, or sometimes as lines per inch on a monitor or dots per inch on a printed image.

RGB mode
Red, Green, and Blue. This is the color model most commonly used to display color images on video systems, film recorders, and computer monitors. It displays all visible colors as combinations of red, green, and blue. RGB mode is the most common color mode for viewing and working with digital files onscreen.

saturation
The degree to which a color of fixed tone varies from the neutral, grey tone; low saturation produces pastel shades whereas high saturation gives pure color.

short lens
A lens with a short focal length—a wide-angle lens. It produces a greater angle of view than you would see with your eyes.

shutter

The apparatus that controls the amount of time during which light is allowed to reach the sensitized medium.

Shutter-priority mode

An automatic exposure mode in which you manually select the shutter speed and the camera automatically selects the aperture.

slow sync

A flash mode in which a slow shutter speed is used with the flash in order to allow low-level ambient light to be recorded by the sensitized medium.

SLR

Single-lens reflex. A camera with a mirror that reflects the image entering the lens through a pentaprism or pentamirror onto the viewfinder screen. When you take the picture, the mirror reflexes out of the way, the focal plane shutter opens, and the image is recorded.

small-format sensor

In a digital camera, this sensor is physically smaller than a 35mm frame of film. The result is that standard 35mm focal lengths act like longer lenses because the sensor sees an angle of view smaller than that of the lens.

standard lens

Also known as a normal lens, this is a fixed-focal-length lens usually in the range of 45 to 55mm for 35mm format (or the equivalent range for small-format sensors). In contrast to wide-angle or telephoto lenses, a standard lens views a realistically proportionate perspective of a scene.

strobe

Abbreviation for stroboscopic. An electronic light source that produces a series of evenly spaced bursts of light.

synchronize

Causing a flash unit to fire simultaneously with the complete opening of the camera's shutter.

telephoto effect

When objects in an image appear closer than they really are through the use of a telephoto lens.

telephoto lens

A lens with a long focal length that enlarges the subject and produces a narrower angle of view than you would see with your eyes.

TIFF

Tagged Image File Format. This popular digital format uses lossless compression.

tripod

A three-legged stand that stabilizes the camera and eliminates camera shake caused by body movement or vibration. Tripods are usually adjustable for height and angle.

TTL

Through-the-Lens, i.e. TTL metering.

vignetting

A reduction in light at the edge of an image due to use of a filter or an inappropriate lens hood for the particular lens.

wide-angle lens

A lens that produces a greater angle of view than you would see with your eyes, often causing the image to appear stretched. See also, short lens.

zoom lens

A lens that can be adjusted to cover a wide range of focal lengths.

INDEX